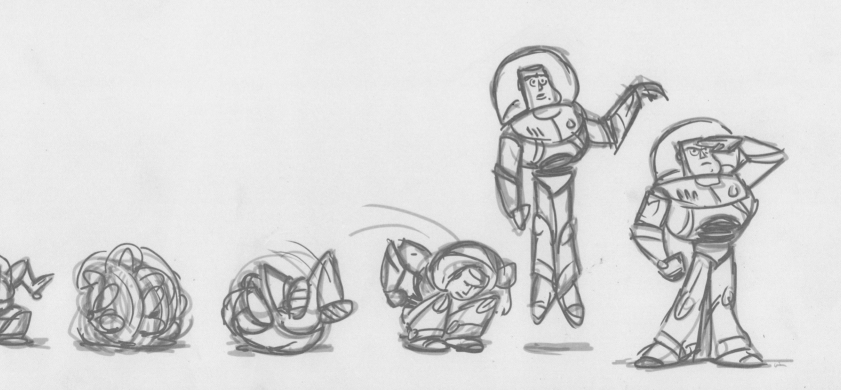

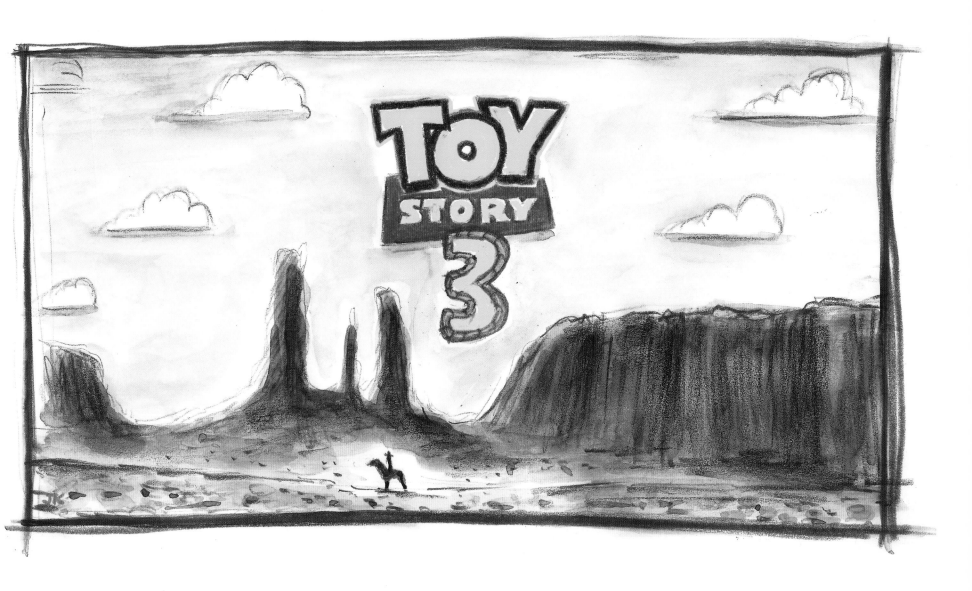

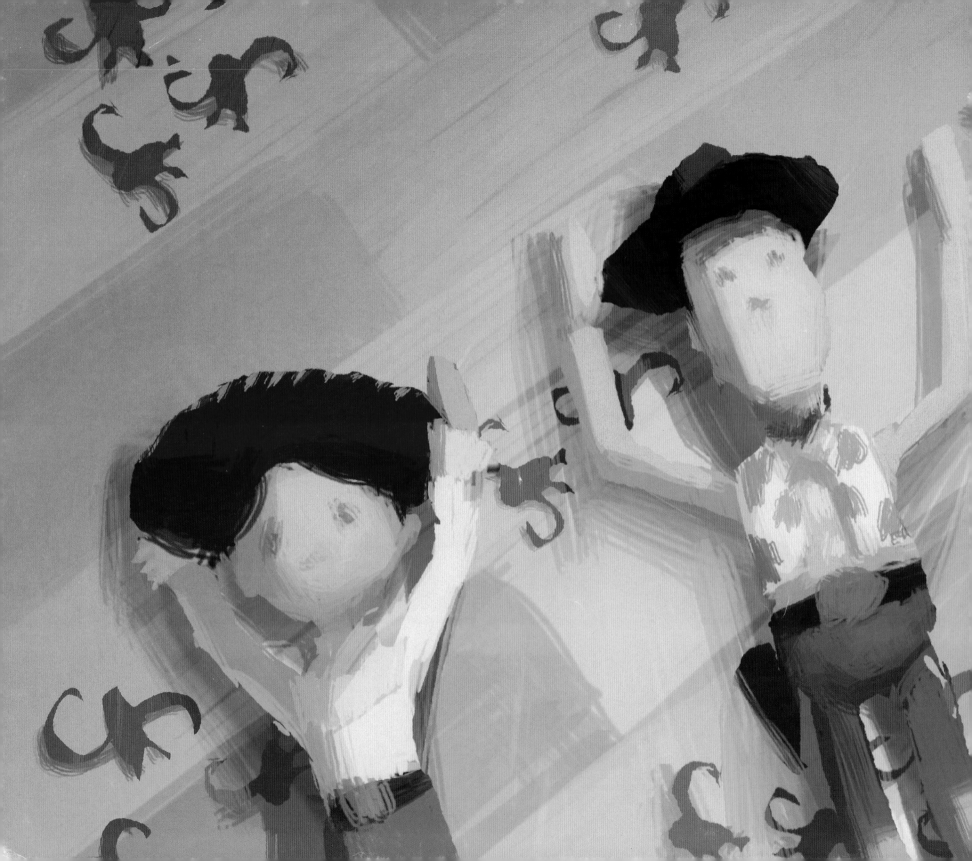

Disney · PIXAR

THE ART OF

TOY STORY 3

By Charles Solomon

Preface by John Lasseter

Foreword by
Lee Unkrich and Darla K. Anderson

CHRONICLE BOOKS

SAN FRANCISCO

To the Memory of Joe Ranft

*In addition to drawing many of the storyboards of Wheezy the Penguin for
Toy Story 2, Joe Ranft provided the character's melancholy, asthmatic voice.*

Thank you to the following day cares and preschools that were visited during research for *Toy Story 3*:
Children's Community Center, Berkeley, CA; Dandelion Cooperative Nursery School, Berkeley, CA;
Duck's Nest Preschool, Berkeley, CA; Osher Marin JCC Early Childhood Education Program, San Rafael, CA;
Step One Nursery School, Berkeley, CA; Sunshine School, Sonoma, CA.

Library of Congress Cataloging-in-Publication Data is available

ISBN: 978-0-8118-7434-2

Manufactured in China.

Designed by Glen Nakasako, Smog Design, Inc.

10 9 8 7 6 5 4 3 2 1

Chronicle Books LLC
680 Second Street
San Francisco, California 94107
www.chroniclebooks.com

Endsheets: Animation thumbnails, **Angus MacLane, Bobby Podesta, Doug Sweetland,** Pencil/Digital, 2009.
Page 1: Storyboard, **Jason Katz**, Pencil/Watercolor, 2006
Pages 2–3: Sequence color key, **Dice Tsutsumi**, Digital, 2009
This page: Wheezy storyboard, *Toy Story 2*, **Joe Ranft**, Pencil, 1998
Page 5: **Tim Evatt**, Pencil/Digital, 2009

CONTENTS

Concept sketch for teaser trailer logo, **Bob Pauley**, Pencil, 2009

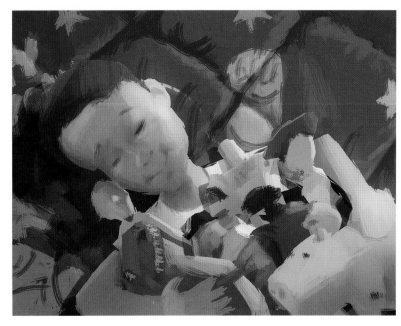

Sequence color key, **Dice Tsutsumi**, Digital, 2009

PREFACE

Toy Story 3 is a movie Pixar had been waiting to make for a long time.

I first had the idea of doing a third *Toy Story* film when we were in production on *Toy Story 2*, over twelve years ago. I wanted our team to go straight from *2* to *3*, while they were still in the groove with the characters and the world, and—even then—I wanted us to make the film in 3D, a format I'd always loved (my wife Nancy and I had our wedding pictures taken in 3D).

Things never turn out the way you plan, though, and many years passed before we were able to return to Woody, Buzz, and the rest of the gang. I knew when we got the green light for *Toy Story 3* that I wouldn't be able to direct the film myself, but I also knew that Lee Unkrich would be the perfect person to take these characters into their third movie. Lee is an incredible filmmaker, and as the editor on the original *Toy Story* and the codirector of *Toy Story 2*, he was more familiar with these characters than almost anyone else. He literally knew every frame of their lives.

None of us were quite sure what to expect when we sat down to tackle the story for this new movie, but it wasn't long before it felt like we had never been gone. And as it turned out, that time in between had been a blessing. Ten years ago, my sons were still little boys. I could never have anticipated how emotional it would be for me to see them leave the house and go off to college. And without that experience, I could never have tapped into the powerful emotion that Woody and Buzz feel in seeing Andy grow up.

A lot has happened to all of us since we first thought of making a *Toy Story 3*. We've gotten married; we've lost loved ones; we've had families and watched our children grow. And all of that has helped us tell a story that we know is the right one for these characters, in a way we could not have done ten years ago.

The art produced for our movies is crucial to the final film, but very few people outside of the studio ever get to see it. That is why our "art of" books are so special to me—I love being able to share this wonderful work with the rest of the world. You can see the deep connection our studio has with these characters in every piece of amazing art that the *Toy Story 3* team created for the film.

We love this movie—and we hope you will love it too.

—John Lasseter

FOREWORD

Color script, **Dice Tsutsumi**, Digital, 2008

At the beginning of 2006, as the ink was drying on Disney's agreement to purchase Pixar Animation Studios, John Lasseter took me aside and asked me to direct *Toy Story 3*. I was in turn excited, honored, thrilled, and flattered. And then I wanted to throw up. John wasn't asking me to direct just any sequel—he was asking me to direct a sequel to two of the most beloved films of all time. No pressure.

Our films are the result of the work of hundreds of people, but at the beginning, there were just a handful of us nurturing our fledgling idea. I won't say that developing *Toy Story 3* was easy; it never is. But we knew we were on to something special when Woody and Buzz and the rest of the gang seemed to take off on their own—happy to be back, they led the way, begging us to follow.

Day by day, as development progressed, I noticed something happening—silently, without fanfare, a team was assembling behind me. Talented artists, technicians, and filmmakers were stepping up to be a part of the movie. Not because they were being assigned to it, but because they passionately wanted to be a part of it. At a studio that has prided itself on originality, there was a groundswell of support for the continuation of the *Toy Story* saga.

The world of *Toy Story* has rich meaning for all of us at Pixar. For some, it represents the beginning of their professional careers. For others, it marks the seminal moment that inspired them to become filmmakers. And, although it makes me feel old to say this, for many at the studio, *Toy Story* was simply their favorite childhood movie.

In the years since we made the first *Toy Story*, we've all gotten a little older, and hopefully a little wiser. We've experienced many life-cycle events: graduations, weddings, births, and funerals. But one thing we have all retained is a childlike sense of wonder—as well as the firm belief that when we're not around our toys really do come to life.

I'm profoundly honored to work with a world-class group of talented artists at Pixar, and I'm proud to share with you a sampling of their work in this book. I thank producer Darla K. Anderson and everyone on my crew for making this the fantastic, rewarding experience that it has been. And a special thanks to John Lasseter, Ed Catmull, and Steve Jobs for creating the studio that has allowed all this awesomeness to happen.

—Lee Unkrich, director

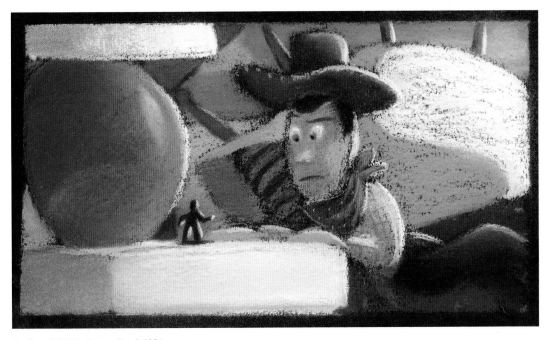

Toy Story, **Ralph Eggleston**, Pastel, 1994

It's been such an honor being involved in the creative process of *Toy Story 3*, and it's always mesmerizing to witness this multidimensional process unfold. The artists on this film, both technical and traditional, were passionate about supporting Lee and his vision to make this third film in the *Toy Story* trilogy the best it could be.

We all got together in Tomales Bay, CA, in March 2006—the very same place that *Toy Story* was conceived—to begin the journey of this film. The whole gang was there: Lee Unkrich, John Lasseter, Andrew Stanton, Pete Docter, Bob Peterson, Jeff Pidgeon, Susan Levin, and me. We drank a toast to Joe Ranft and started on this amazing and daunting journey. The *Toy Story* films have made such an impact on the world that it's a huge responsibility to make a film worthy of the trilogy. Seeing the brilliant vision of Lee and our team unfold every day has been beyond inspirational.

I'm so glad we can share with you our artistic evolution and get you acquainted with some old friends while introducing you to some fresh, new faces. I wish I could find the words to express that it's the art that keeps us all going, the art that sparks the engine of how we make movies at Pixar, but you'll just have to experience it for yourself. Enjoy!

—Darla K. Anderson, producer

INTRODUCTION

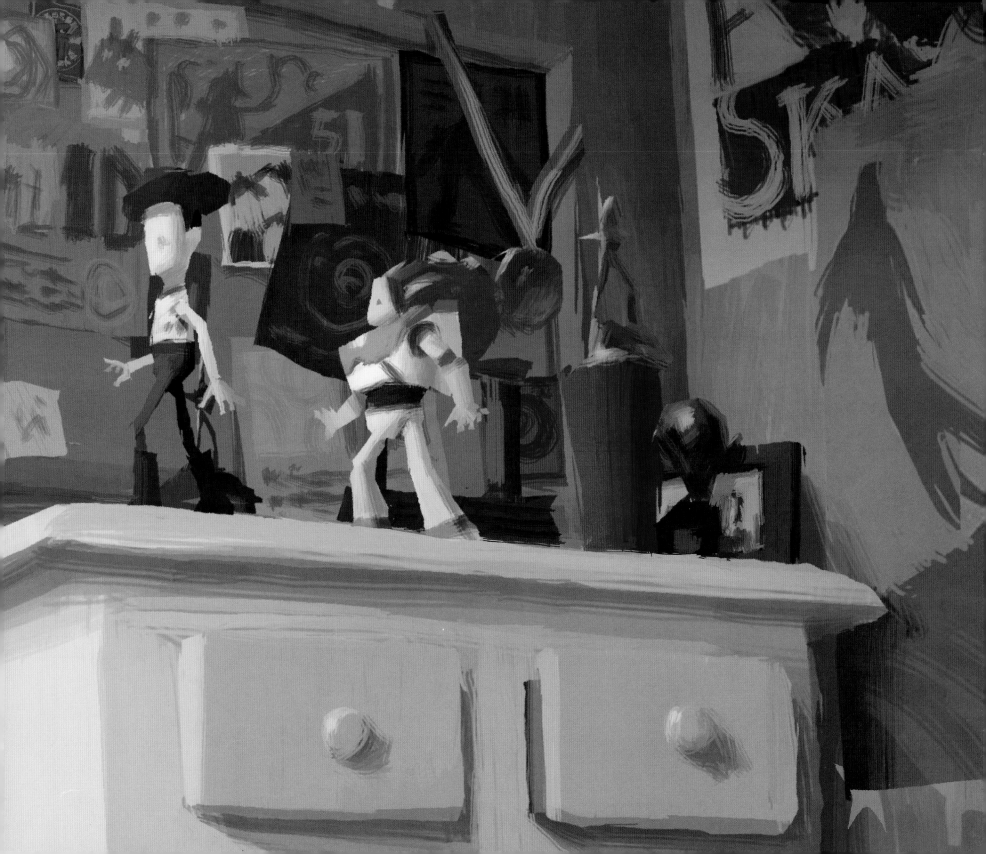

"In *Toy Story 3*, we deal with the point in time that concerns toys the most: being outgrown. They're at the threshold, as Andy has finished high school and is leaving for college. When you're broken, you can be fixed. When you're lost, you can be found. When you're stolen, you can be recovered. But there's no way to fix being outgrown by a child."
—John Lasseter, executive producer

Above: Pizza Planet, *Toy Story*, **Ralph Eggleston**, Pastel, 1993
Previous spread: Sequence color key, **Dice Tsutsumi**, Digital, 2009

THE *TOY STORY* LEGACY

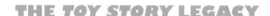

Like Walt Disney's *Snow White and the Seven Dwarfs* nearly six decades earlier, *Toy Story* demonstrated the power of a new medium as both an art form and a popular entertainment. The first feature-length film made using computer animation, *Toy Story* represented a bold departure from the commercials, TV logos, and special effects that computer graphics (CG) had been used for previously. And, like *Snow White*, it capped years of experimentation and discovery, during which the artists had honed their skills, learning the strengths and weakness of their medium by making short films.

"*Toy Story* originally grew out of *Tin Toy*," says *Up* director Pete Docter. "It was going to be a Christmas special—a kind of a Rip Van Winkle story, where Tinny was boxed up, then woke up in the 21st century in the middle of this Toys R Us–type store."

The success of the Pixar shorts led the Disney Studio to try to rehire John Lasseter: he had been an animator on *Mickey's Christmas Carol* and worked on the unproduced feature *Musicana*. Lasseter declined the offer, saying he was having too much fun where he was at Pixar. After *Tin Toy* won the Oscar for animated short, Disney tried again, asking if Pixar would be interested in making a feature for them to distribute.

"We told them that our plan was to do a thirty-minute piece for television next," says Ed Catmull, president, Walt Disney Animation Studios/Pixar Animation Studios. "But Peter Schneider told us if we could do thirty minutes, we could do an eighty-minute feature. It didn't take much to talk us into it."

"That left us in the awkward position of having to figure out what it was we were going to do," adds Docter. "John said, 'Well, why don't we just take the half-hour Christmas special and pad it a little bit?' Because none of us knew what we were doing, Andrew and I said, 'Yeah, okay.' So we started playing around with it, and one thing led to another. The first act was going to be the half-hour Christmas special; then we were going to add on to it."

The story underwent major revisions before the Pixar crew presented it to Disney. "We pitched them the idea for *Toy Story* and they loved it," says Lasseter. "We knew it was something they hadn't done before: typically, a Disney animated film is a retelling of a fairy tale. This was a buddy picture, which was very different, but a proven commodity in Hollywood: *48 Hours*, *Midnight Run*, *The Defiant Ones*—all great pictures.

"When we came up with the idea of a buddy picture with two toys, we started thinking: in a classic buddy

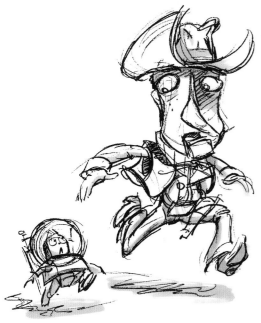

Concept art showing early size relationship, *Toy Story*,
Bud Luckey, Pencil, 1994

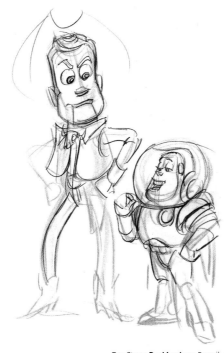

Toy Story, **Bud Luckey**, Pencil, 1994

Toy Story, **Bob Pauley**, Pencil, 1994

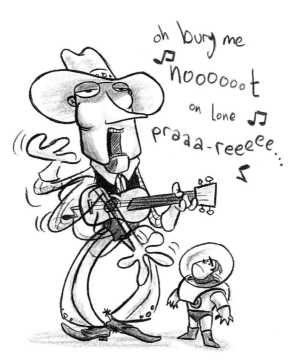

oh bury me
noooooot
on lone
praaa-reeeee...

Toy Story, **Pete Docter**, Pencil, 1994

picture, you take two characters who are opposites and put them in a situation where they have to learn to work together to achieve their goals," Lasseter explains. "Along the way, they grow to like each other and learn from each other: eventually they become inseparable and their goals become the same. We decided to pair an old toy with a new toy, and we wanted the new toy to be a space man. What's the opposite of a space man? A cowboy is about as different as you can get, so we came up with that premise and developed the characters' personalities from it."

"When *Toy Story* came out and became a big hit, almost immediately there was talk of a possible sequel," Lasseter said in a 1999 interview. "The characters were so strong and well developed, we thought of them more like friends or family or fellow employees than we did creations, so we felt a sequel would work."

"There are really only a handful of good sequels out there, so you question why you would want to subject yourself to that kind of scrutiny," added Lee Unkrich at that time. "But people really liked the characters and it seemed a shame to end their story without being able to see what they're up to later on. It's so much fun to see these characters again: it's like getting together with a bunch of old friends you haven't seen in a few years. With *Toy Story 2* we did our best to keep the film as exciting as the original, and along the way I think we gave it even more heart."

Toy Story 2 was originally planned as a modest direct-to-video sequel that would be made quickly on a small budget. Ash Brannon, who was slated to direct the film, recalled, "Disney was convinced that if you made a sequel, it had to come out within two or three years of the first film. We didn't think the direct-to-video was going to be a big project, but then everything good started happening: Tom Hanks and Tim Allen and the entire cast signed on again; we had a great

Early Woody character designs, when he was a cowboy ventriloquist doll (top row and bottom left)

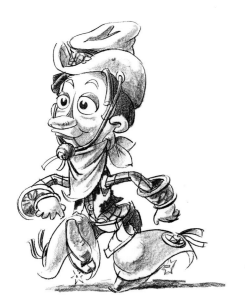

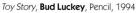

Toy Story, **Bud Luckey**, Pencil, 1994

Toy Story, **Bud Luckey**, Pencil, 1994

Toy Story, **Bud Luckey**, Pencil, 1994

Toy Story, **Steve Johnson**, Pencil, 1994

Woody's defining character sketch, *Toy Story*,
Bud Luckey, Pencil, 1994

premise and the story just kept getting better; the new characters had a lot of potential. So, at that point, we felt the story deserved to be on the big screen."

"We very quickly realized we could not have one set of standards for a feature film and another for DVD," explains Catmull. "We went to Disney and said that we thought it should be a feature film. The problem came after the release date was set: we realized the film wasn't of the quality it needed to be. We didn't really come to grips with that fact until nine months before it was due in the theaters. Just after *A Bug's Life* came out, we decided to start over again. We had eight months in which to remake the film.

"It was an incredible sprint; on paper it wasn't possible to remake the film, but we did," he continues. "In the process, we learned something about our own values and what was important. It was the defining moment for the studio."

Toy Story, **Bud Luckey**, Pen/Pencil, 1994

Toy Story, **Bud Luckey**, Pencil, 1994

Toy Story, **Nilos Rodis**, Mixed Media, 1994

LASTING CHARACTERS

In the four years that elapsed between *Toy Story* and *Toy Story 2*, computer graphics made enormous strides. Computers became much faster, and new software was developed that enabled the Pixar artists to create subtler animation, more believable textures, more realistic lighting, and more complex environments. But these innovations introduced a problem that the artists would face again on *Toy Story 3*: how to take advantage of their new tools and techniques while preserving the look, charm, and characters of the first film.

As *Toy Story 2* neared completion, "We had to be really careful that everyone who came to see the sequel would instantly recognize it as *Toy Story*," explains Brannon. "The characters looked the same, it was the same world. But we had incredible new lighting tools and rendering tools that gave us more realistic depth of field. The textures on the characters were much more

detailed and realistic looking. The movie had a whole new dimension, a new depth to it."

At that time, supervising animator Glenn McQueen sounded a note that would ring again during the making of *Toy Story 3*: "In the first sequence of the film, we tried to get the audience to feel, 'Oh, this is the Woody I remember from *Toy Story*, this is the Buzz I remember. We tried to make the performances capture the essence of Buzz and Woody. Once we reminded the audience who the characters were, we had a freer rein to develop them. Putting Woody with the Prospector, Jessie, and Bullseye, who look and act like him, gave us a great opportunity to push Woody in a different direction than we had in *Toy Story*."

Reminding the audience who Woody and Buzz were was a relatively straightforward task. But bringing back some of the minor characters from the first film posed unexpected challenges. "Woody and Buzz are tremendously complex computer models: we can go

Buzz's defining character sketch, *Toy Story,* **Bob Pauley**, Pen, 1994

Early *Toy Story* character designs and storyboards

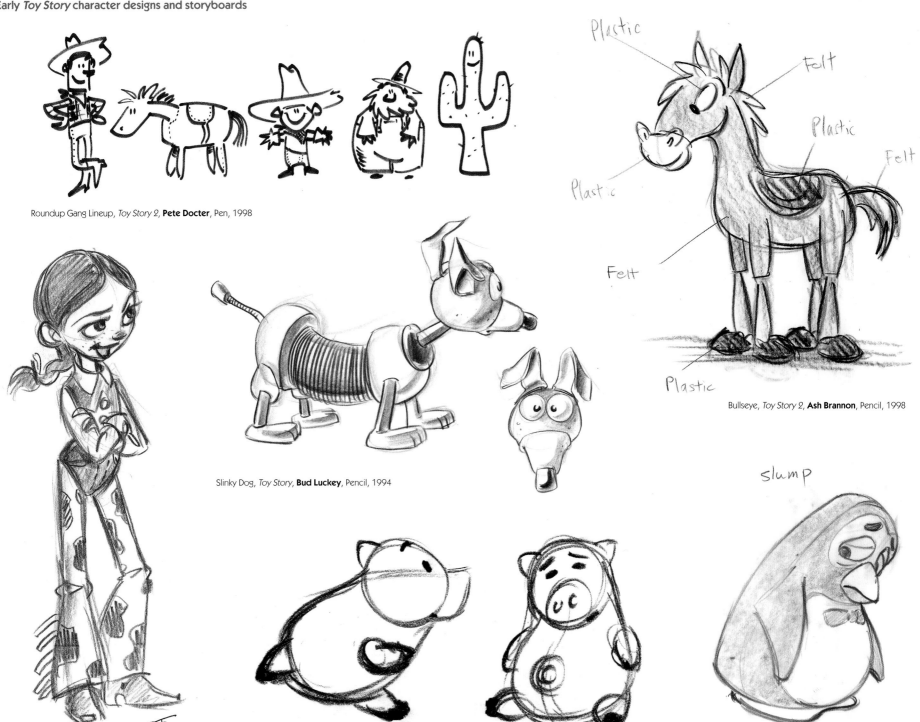

Roundup Gang Lineup, *Toy Story 2*, **Pete Docter**, Pen, 1998

Plastic

Felt

Plastic

Plastic

Felt

Felt

Plastic

Bullseye, *Toy Story 2*, **Ash Brannon**, Pencil, 1998

Slinky Dog, *Toy Story*, **Bud Luckey**, Pencil, 1994

slump

Jessie, *Toy Story 2*, **Jill Culton**, Pencil, 1998

Hamm, *Toy Story*, **Ralph Eggleston**, Charcoal, 1994

Wheezy, *Toy Story 2*, **Nat McLaughlin**, Pencil, 1998

Buzz and Rex storyboard, *Toy Story 2*, **Matthew Luhn**, Pen/Pencil, 1998

Green Army Men storyboard, *Toy Story*, **Joe Ranft**, Pen/Pencil, 1994

Prospector, *Toy Story 2*, **Dan Lee**, Pencil, 1997

in and animate just a corner of Woody's eyebrow to communicate a certain emotion or feeling," McQueen adds. "But we build the simplest characters in a hurry, and they're not really built to support any kind of emotive acting. The Aliens may have had a dozen controls, total; they were made for a very specific purpose in *Toy Story*. When we brought them back for *Toy Story 2*, we looked at the script and said, 'Oh, jeez, we have to make them run across a conveyor belt, and they don't have legs that work!'"

Toy Story 2 became an even bigger hit than *Toy Story* did, with glowing critical reviews, big box office sales, and multiple industry awards. Ordinarily, a film that successful would have immediately been followed by another sequel. But due to the intricacies in Pixar's relationship with Disney, *Toy Story* fans would have to wait more than a decade to see Buzz and Woody on the big screen again.

DRIVING JOHN'S CAR

"Lee has joked that directing Toy Story 3 *is like getting the keys to John's car. That said, these are John's characters, but this is very much Lee's film, and the more you get to know Lee, the more you recognize him in the movie."*
—Jason Katz, head of story

There was clearly a large audience eager to see a third *Toy Story* film and the animators were eager to make one. Disney's purchase of Pixar in January 2006 finally gave them the chance. "We always wanted to make it. It wasn't that we waited ten years and then decided 'Hey, let's make *Toy Story 3*,'" says Unkrich. "What finally allowed us to make it was Disney buying us. Before we even announced the deal to the company, John took me aside and said, 'We're finally

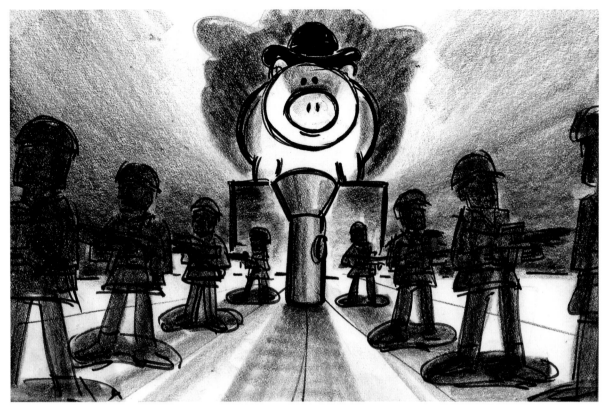

Storyboard (original concept for Evil Dr. Porkchop), *Toy Story 2*, **Matthew Luhn**, Pen/Pencil, 1998

Gag Session Board (initial concept for Aliens), *Toy Story*, **Chris Sanders**, China Marker, 1994

going to be able to make *Toy Story 3*, and I want you to direct it.'

"John wanted me to direct the film because he appreciated what I had brought to the other movies, yet he knew that I'd been playing second fiddle as codirector; he wanted me to be able to say this was my movie," Unkrich continues. "This was about getting to work with characters that I love, but also stepping up to the plate and doing something important for the studio. We needed to make this movie, but John was in no position to direct it, and I was the most logical person to do it."

Lasseter, who directed the first two *Toy Story* films, concedes it was "a little hard" to turn the reins over to someone else. "But," he says, "Lee was so much a part of the creative team on *Toy Story*, being the editor, and then being the codirector on *Toy Story 2*. He knows the characters so well. He was the perfect guy to make this movie."

"The first two movies were John's babies: Lee was very concerned early on about how their relationship would work," says Docter. "Lee's been very selfless about it. John's stretched quite thin these days, so Lee's really tried to channel John whenever he could, using him to get the maximum Lasseter juice into the film."

All the previous Pixar directors began as animators: John Lasseter, Pete Docter, Andrew Stanton, and Brad Bird. But Lee Unkrich was originally a film editor, and his experience in that discipline gives him a unique perspective on the filmmaking process." I've spent a lot of time talking to Bobby (Podesta) and the other animators over the years, and I've learned that we share a lot of sensibilities," Unkrich says. "When I'm editing, I often get down to a very micro level of thinking about all the different elements that are going into a moment in the movie: the rhythm of the music, the cadence of the dialogue, the specifics of the performance, the timing of movements relative to the dialogue. Now, when I direct, I think I have a finely tuned sense of how to get information across to the audience in a very clear way—which is a lot of what the animators are thinking about.

"You can tell a story clearly in the storyboards, but if you don't keep the correct focus in the animation, it can be ruined," he continues. "Any insecurities about whether I have the skills needed for this job are slowly falling away, because I'm realizing I have a lot to fall back on, especially in terms of how to communicate ideas clearly. I don't always have the instincts for what to do technically with the animation, but luckily I'm surrounded by really talented animators. I encourage everybody to bring a lot of ideas to the table; then it's my job to weed through them and make sure we're being clear and entertaining in our storytelling."

The artists working on *Toy Story 3* feel that Unkrich's background gives him an exceptionally clear vision of

the film. Editor Ken Schretzmann says simply, "I feel like he's already cut the movie in his head."

"More than most directors, Lee knows what he wants. He's had a vision of how the film should look from the beginning," agrees Jeremy Lasky, director of photography, camera. "He's already thinking more about it as a real film, rather than just a series of two-dimensional drawings—lots of directors who come from animation start more that way. We're a little farther along by the time it gets to me. It's nice to be able to have that conversation with him and think cinematically. I know his brain's already gone there."

WITHOUT JOE

"It's impossible to work on this movie and not feel the absence of Joe Ranft. His memory continues to inspire us. Joe is a huge part of what we do here, how we think, and how we make our movies. I don't think that will ever change."
—Jason Katz, head of story

As Unkrich noted in 1999, the list of modern sequels that were as good as or better than the original films was short one. And until *Toy Story 2*, there had been no successful animated sequels in the United States: neither Disney's *The Rescuers Down Under* (1990) nor Amblin's *An American Tail: Fievel Goes West* (1991) had been well received.

"The list was basically *The Godfather, Part II* and *The Empire Strikes Back*," Unkrich says. "It was our goal to make a sequel as good as, if not better than, the original, so it was very rewarding when *Toy Story 2* came out, and people compared it to those two films.

Mr. Potato Head story gags, **Jeff Pidgeon**, Pen, 2006

John Lasseter, Pete Docter, Lee Unkrich, Darla K. Anderson, Andrew Stanton, Bob Peterson, and Jeff Pidgeon at Poet's Loft brainstorm session, **Susan Levin**, 2006

19

When I started on this one, I thought, 'Okay, are there any good third movies?' The only one I could come up with was *Lord of the Rings: Return of the King*. I initially discounted that because it's really one giant story being told in three parts. That's when I had my epiphany: we needed to come up with a story that would make viewers feel like these movies were all part of one grand story."

In March 2006, a group from Pixar that included Lee Unkrich, John Lasseter, Andrew Stanton, Pete Docter, Bob Peterson, Darla K. Anderson, Jeff Pidgeon, and Susan Levin went on a two-day brainstorming retreat to a cabin in Tomales Bay, CA. These artists had crafted the previous *Toy Story* movies and many of the subsequent Pixar features. One important member of the team was missing: story man and voice actor Joe Ranft, who had died in an auto accident in August 2005. Ranft had been deeply loved and respected and his absence was keenly felt.

"Poet's Loft is a tiny cabin, situated over Tomales Bay, where the original gang conceived the first *Toy Story*," producer Darla K. Anderson explains. "When it came time to do *Toy Story 3*, a bunch of us went there to work on the conceit for the film for two days. For kismet, good luck, karma, call it what you will, Andrew brought one of the bottles of wine John Lasseter had given as a crew gift on the first *Toy Story*, and we kicked things off with a toast to Joe, calling his spirit to the discussion."

"When we started *Toy Story 3*, especially without Joe, we felt we needed to touch base again," adds Docter. "I've talked to a couple of musicians who've said that when they record they do a similar thing: they go to a specific place that sort of infuses the proceedings. The first day, we were not at all convinced that we had anything. We were thinking, 'There's no *Toy Story 3*. This is not going to fly.'"

"At first we started talking about an idea we'd had rattling around for ten years. But within twenty minutes,

we shot it down, realizing we didn't have a movie. We had an interesting high concept, but not a story," says Unkrich. "That left us with nothing. We had no plan B. It was a frustrating day, because it felt like for the first time, we were letting the fact that we wanted to make a film drive what the story was going to be. We'd always prided ourselves on not making a movie unless we had a really strong idea first. Everyone wanted to make a *Toy Story 3*, but we just didn't have a solid idea.

"We decided to watch *Toy Story* and *Toy Story 2* again. We didn't even have a TV there: we all huddled around a laptop watching movies we'd made ten years ago," he continues. "After watching them, we were *really* in a funk. How could we possibly make another film as good as those two really good ones? But we also felt encouraged, because we were the ones who had made those two really good films. So if anyone was going to pull it off, we were."

On the second day, the ideas began flowing. They decided Andy should now be grown up. An old idea about a corrupt teddy bear surfaced, as well as a long-dormant idea about the toys ending up at a day care. Finally, the artists shifted one of their original ideas—Andy giving away his toys—from the beginning of the movie to the end. "That sequence is really the culmination of the toys' fears in the first two films," Docter adds. "It was all about getting Andy's attention, and if Andy grows up, how does that affect the toys? Suddenly everything fell into place, and we walked away from day two with a pretty clear outline, which Andrew wrote up as a treatment."

Everyone agreed with Unkrich that the third film had to complete the story that had begun in the first two films. Ideally, all three films should seem as if they had been conceived at the same time and executed separately over the years. Anderson says, "Lee's and my goal was to make it seem like we had completed a trilogy."

FROM SCRIPT TO STORYBOARDS

"One of the biggest misconceptions about screenwriting is that it's about dialogue. In fact, it's usually about trying to tell your story visually, meaning that you ideally want as little dialogue as possible."
—Michael Arndt, screenwriter

To help shape the story, the Pixar crew turned to a then-unknown writer, Michael Arndt. Unkrich explains, "We discovered Mike Arndt when I was starting to develop an original feature I was going to direct at Pixar, and I was looking for a writer to work with. I was reading through stacks and stacks of screenplays and found one that was really funny and clever: *Little Miss Sunshine*. We got in touch with Michael. He was in the middle of production of the film in L.A., but he flew up and met with us.

"He went above and beyond the call of duty and wrote up fifteen or twenty pages of notes for me, even though we hadn't hired him," Unkrich continues. "We realized very quickly that Mike was someone special, whom we really wanted to work with. Luckily Michael was a big fan of our films and wanted to be a part of them. It seems improbable for somebody to go from an indie comedy like *Little Miss Sunshine* to *Toy Story 3*, until you learn how much Michael respects the storytelling process and what we do at Pixar. He won the Oscar for *Little Miss Sunshine*, but he was already deep into writing on *Toy Story 3* before that happened."

Arndt loved animation and had even taken classes in it at film school, but he felt he lacked the requisite drawing ability. Living in New York, he was inspired by foreign and independent films. Feature animation, he says, "seemed like Timbuktu—I knew it existed, but

Jason Katz, Pencil/Watercolor

Jeff Pidgeon, Digital

Ken Bruce, Digital

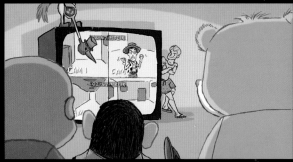
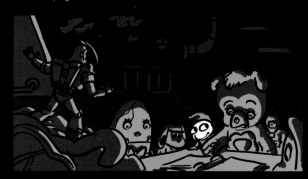

Bud Luckey, Pencil

Ken Bruce, Digital

Jeff Pidgeon, Digital

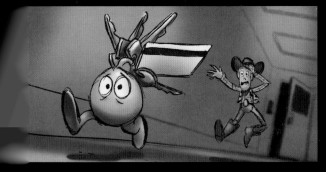
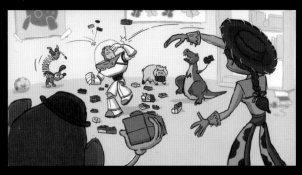

Dan Scanlon, Digital

Ken Bruce, Digital

Bud Luckey, Pencil

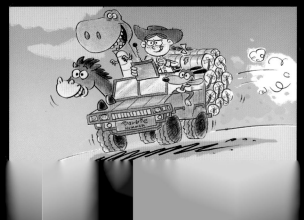
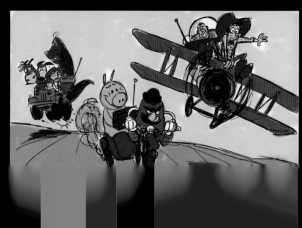

Early story concepts for Bonnie,
Story sketches, **Matthew Luhn**, Pencil/Digital, 2006

Early concepts for day care as prison, Story sketches, **Jeff Pidgeon**, Digital, 2006

I would never go there." Like the Pixar artists—and many other animators—Arndt admired the work of the Ghibli Studio. In 2000 he found the inspiration "to finally sit down and write *Little Miss Sunshine*—after years of procrastination" when he attended a screening of Isao Takahata's bittersweet suburban comedy, *My Neighbors, The Yamadas* at the Museum of Modern Art.

Arndt was also an admirer of Pixar's work. "I saw and loved each of Pixar's films as they came out, but the idea that I could ever work there never occurred to me. They seemed to be doing fine without me," he says. "There were two things I really admired about Pixar's films. First, the completeness of the stories—it's rare to see a film in which every detail of the script has been thought out completely, and Pixar's films always have that pleasurable sense of density and thoroughness. Second, you can feel a palpable joy in the process of filmmaking in every Pixar film. You just know you're watching something made by people who absolutely love what they do."

Creating and refining the story for an animated feature differs substantially from the story process in live-action filmmaking. In the latter, a writer or group of writers creates a script from which the director works. In animation, script pages serve as a jumping-off point for the story crew, who may adapt or alter the words as they storyboard the film, creating visuals. A live-action director will have the cast perform multiple takes of a scene until everyone is satisfied with the interpretation. In animation, however, most of that experimentation takes place during the storyboarding, before the animation begins. The story artists will suggest expressions, poses, gestures, and body language, which animators will later refine. The storyboard panels will also suggest possible camera angles and movements, which the director, camera crew, and editors will consider.

"One of the hardest parts of working on *Toy Story 3* was that the script and the story were so good to start with; it got to the point where we were saying, 'Can we make this any better?'"
—Christian Roman, story artist

Story sketch, **Jeff Pidgeon**, Digital, 2006

"We're the lab: we're where Lee experiments with the movie," says story artist James Robertson. "He'll give us two quantities, we'll add them together, and sometimes they'll work great. Other times they'll blow up in our faces. But it's okay to make mistakes—it's a fundamental part of our job."

"Storyboarding is a service industry," agrees fellow story artist Matthew Luhn. "We're laying out the blueprint for the rest of the film. So we want to focus on making sure the story is working, the characters are working, the world is working, and, as much as we can, the cinematography is good."

"In animation, the processes of writing, production, and editing all overlap and inform each other, so there's a genuine dialogue going on that involves the writer, the director, and the editor. It's a lot more collaborative," Arndt explains. "In practical terms, it means that live-action filmmaking (from a writer's perspective) is a terrifying, no-second-chances train wreck in which your best intentions (your script) collide head-on with reality (the shoot). The process of editing is like some dismal, painstaking salvage operation in which you pick through the wreckage, trying to find something you recognize. Animation, at least at Pixar, is infinitely more forgiving. Basically, you're allowed to make the

film—in rough form, or 'reels'—six or seven times, and you can literally redraw each frame of the film to suit your tastes.

"The key at Pixar, though, is the quality of the feedback," he adds. "Once your reels are screened, you get to sit in a room with John Lasseter, Andrew Stanton, Brad Bird, Pete Docter, and the rest of the 'Brain Trust' geniuses [the directors and top story artists at Pixar who periodically review the films in production], and listen to them suggest how to make your script better. For a writer, that is a dangerously addictive experience."

The story process can easily become contentious, especially when a writer from the live-action world, who is not accustomed to seeing his words changed, encounters the more collaborative animation process. The ability to "play well with others" is an essential quality for the members of the story crew, as the artists constantly try to improve each other's work. The *Toy Story 3* story crew is a close-knit group whose members cheerfully comment on each other's ideas.

"Pitching a storyboard is like going up in front of everybody in your underwear and delivering your best jokes," says Luhn. "If they laugh, it's great. If they don't, you get a little embarrassed, and then you go back and try to come up with more ideas."

Early Bonnie concept sketch, **Teddy Newton**, Pencil, 2006

"But you know they're going to get up in their underwear right after you," continues Dan Scanlon. "It's a lot like karaoke, where the audience is strangely supportive of everyone, because they know they're next."

"During pitches, you feel most successful when it sparks a conversation among these guys," adds Erik Benson. "You pitch your scene, and everybody feels excited and chimes in, 'This would be cool!'"

"'Plays well with others'—that's a big part of it," Luhn finishes. "You're not making your own film. You're helping this captain of the ship create his film. You're one of the crew."

Arndt clearly enjoyed the give-and-take of the story process, although he spent relatively little time with the artists. "It was really Lee who worked hands-on with the story crew," he explains. "I would feed my first-draft pages to Lee and refine them until he was happy (or, at least, not unhappy). Then he would feed those pages to the story crew. Because they'd already been refined, they usually didn't change too much. When they did change, it was usually because my ideas were too long winded or inadequate or just not working. So my response to the changes the story crew made was usually embarrassment or guilt, rather than contentiousness."

For an example of their successful collaboration, he points to the sequence in which Bonnie is playing with Woody along with her own toys when he's inadvertently been taken to her house. "I wrote many different versions of that scene, but much of what ended up in the film came from the story guys," Arndt says. "The problem with my scenes was that they made too much sense—I kept trying to have Bonnie tell a clear beginning-middle-and-end story while she played with her toys. Lee realized—and he was right—that the charm of kids' play is how they string together non sequiturs."

"I rely on Mike utterly to help provide the emotional and logical structure for the film," adds Unkrich. "But when it came to Bonnie's playtime, he was trying to graft a structure onto the story she was telling. Really, though, the charm of watching a three- or four-year-old play is that there is no structure whatsoever."

"While this all may sound like I knew what I was doing when I wrote the script, I actually didn't know any of this stuff as the process began. You figure it out along the way," Arndt continues. "I began *Toy Story 3* based on Andrew Stanton's treatment, and the final hand-off between Andy and Bonnie was the last scene of the story from the start. But it took a long time and a lot of conversations to figure out what Woody's arc was and how Lotso, the kingpin bear at Sunnyside Daycare, reflected it. Writing is just a long, painful process of stumbling around in the dark, and I was very lucky to have Lee and Jason Katz and the rest of the story team there to steer me out of the many, many blind alleys I walked into."

John Lasseter sums up the respect the artists feel for Arndt: "The level of intelligence Michael brought to the table is fantastic. We believe our audiences are very, very smart. We aim for the highest common denominator in our movies, and we know the audience will be there. He's so knowledgeable when it comes to plot, story craft, the three acts. It was still hard work—creating something from scratch is never easy. But it was great to have someone that strong and collaborative. Michael took to the way that we work at Pixar like a duck to water."

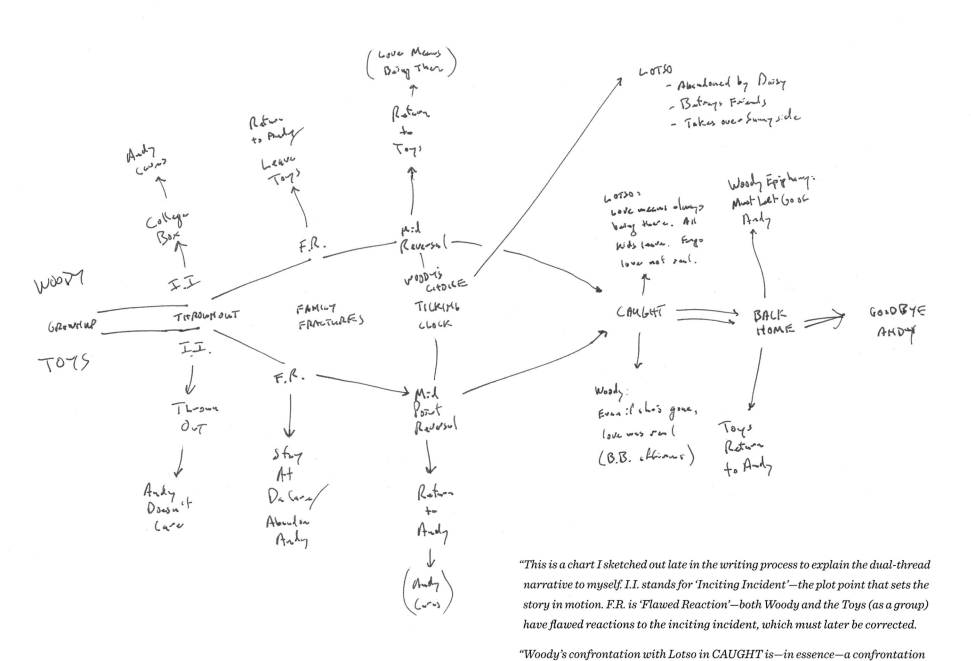

Michael Arndt diagramed the emotional beats and character arcs of the story for *Toy Story 3*, providing a blueprint for the action in the final film.
Michael Arndt, Pen, 2007

"This is a chart I sketched out late in the writing process to explain the dual-thread narrative to myself. I.I. stands for 'Inciting Incident'—the plot point that sets the story in motion. F.R. is 'Flawed Reaction'—both Woody and the Toys (as a group) have flawed reactions to the inciting incident, which must later be corrected.

"Woody's confrontation with Lotso in CAUGHT is—in essence—a confrontation with his own flawed worldview. For most in the story, Woody and Lotso share the idea that loving someone means literally always being there for them. By confronting Lotso (and later witnessing Mom say goodbye to Andy), Woody realizes he can love Andy and still let him go to college on his own."

—*Michael Arndt, screenwriter*

NEW FRIENDS AND OLD

"It's exciting and fun to play with these characters that we know and love already, but it's also exciting as an animator to have a new problem you can solve; you can bring a whole new set of ideas to a character."
—Dave DeVan, animator

Chatter Telephone, **Nate Wragg**, Pen/Digital, 2007

Chatter Telephone render, **Lou Hamou-Ihadj**, **Michael Honsel**, and **Nancy Tsang** (model), **Audrey Bagley** (shading and paint), Digital, 2009

In addition to featuring Woody, Buzz, Hamm, Jessie, and the rest of the cast from the earlier movies, *Toy Story 3* includes a number of new toy characters. Some of them have no "ancestors" in the previous films, meaning former incarnations in the same line of toys. Some are toys that actually exist in the real world, and some were created to resemble the familiar characters. One of Bonnie's toys, a Triceratops named Trixie, was designed to look like Rex, Andy's neurotic Tyrannosaurus. "The concept was, 'Let's design another dinosaur from the same toy line as Rex,'" says character designer Daniel Arriaga. "So we looked at Rex's design cues, his general shapes, the feel of the character, and applied those shapes to another character."

Designing a new toy is both more challenging and more enjoyable than adapting the design of one that already exists. But each character presents a unique set of challenges, as Arriaga explains: "Designing a new toy is always more fun, because I get to go crazy and put it all out there. When you're designing something that already exists, like the Fisher-Price telephone, it's finding ways to make it work in 3D animation that makes it somewhat challenging. The mouth on the phone is a sticker, and we weren't sure how it would look if it were a flat graphic of an actual mouth. How would that animate if it's on a sticker, versus a 3D mouth that opens and closes, like Woody's or Buzz's mouth?

So finding those kinds of things about existing toys and making them work in 3D animation is the challenge. But when you're designing from scratch, all that's up to you. You create the rules, you design the toy, and it's something totally original, which is totally fun."

"When Lee sees Daniel's designs at the art reviews, he'll say, 'I think this could be made of felt' or 'I'm seeing this as a shiny blue chrome,'" Belinda Van Valkenburg, shading director, comments. "So I take notes, and work with other artists to make up a painting, and put a shader packet on the toy. Lee and John wanted to stay true to the real toys we're using. For the Fisher-Price phone, they ended up not moving the mouth at all, but having him speak through the handset. That's how they solved that sticker problem."

One member of Lotso's gang at Sunnyside Daycare is a translucent rubber octopus, a toy that would have been impossible to animate and shade in 1995. Lasseter says proudly, "The artists at Pixar are so good at creating the character models and rigging the characters, we're casting new characters that utilize new technology and new ways of working. We're able to create toy characters we wouldn't have been able to do before, like Stretch the Octopus. She's one of those really stretchy toys:

we couldn't do that on the earlier movies and make it look so good. She's translucent, with glitter embedded in the rubber."

Guido Quaroni, supervising technical director, agrees. "She's an interesting character with a very stretchy skin and complex articulation controls for animation that we've never done before. The main characters created in *Toy Story* and the ones added in *Toy Story 2*, like Jessie and Bullseye, were so strong and loved by our audience that we immediately realized we wanted to bring them back together in *Toy Story 3*. It was a good feeling to bring characters back to life but it was also a challenge. We wanted to completely rebuild them, taking advantage of today's technologies while remaining true to each character as seen in the previous two movies."

At most studios making drawn animated features, a single animator is designated the lead or supervising animator for each character. That artist animates the key scenes and oversees the other artists' work to ensure that the character stays consistent in its appearance and acting. At Pixar, animators are usually given all the characters in a shot and choreograph their interaction. Neither method is superior: they

Color line-up of Lotso's gang, **Dice Tsutsumi**, Digital, 2008

simply represent different approaches to the formidable task of bringing an animated cast to life. But the sheer number of characters in *Toy Story 3* required the film-makers to assign the work differently.

"In the old days, you would give a shot to a single animator, and he would animate all the characters in that shot and move on," explains animator Rob Russ. "On this film we're going to have three or four animators working on a shot at any one time. You've got Lotso's gang. You've got Andy's toys. You've got Bonnie's toys. You've got the background kids. That's going to require a lot of sharing. It's going to be really important to make sure you're talking about what you're doing and showing your work to your peers. If you're working on scenes that hook up with another animator's, you need to talk to each other about what you're doing. You

share your work with them, and they share their work with you, so you can ensure that things flow together.

"As far as the performance of the character across an entire scene goes, Lee directs that. He's thinking about the arcs of the characters over the course of the entire film," Russ continues. "Lee determines whether the characters are at the right emotional point in any specific shot."

Animator Mike Venturini points out that the years between the second and third *Toy Story* films and the growth of the Pixar Animation Studios have brought about an additional change. "At the time the first two films were being made, the cast was a mixture of toys that were invented for the film and toys that already existed," he says. "A lot of the invented toys have become toys that exist. We have animators who were kids when

the films came out; they're animating toys that have always existed for them, not toys we made up for the film. That's a different mindset."

For the new characters to share the screen effectively, they have to be just as believable as the toys that audiences have come to know over the years, and they have to exhibit personalities that are as complex and nuanced. The artists have spent years developing Buzz and Woody. Pairing them with a newly designed character is a daunting assignment for an animator, comparable to expecting a novice actor to appear with a cast of veteran Shakespearean actors.

Bobby Podesta, supervising animator, explains, "As an animator, you want to build up a certain depth of information that may never be fully explained in the film but will feed into what the audience sees. When

Bob Pauley, Pencil/Digital, 2007

Daniel Arriaga, Pencil, 2008

the characters move a certain way, it just feels right. You don't have to go into the depths of explanation, but someone has done the research, like an actor. We want to make the characters have a backstory, so they seem like they're coming from someplace true, so they're believable.

"Our goal for any of the new toys—the peas in a pod, the hedgehog, the unicorn—is to establish who they are as characters, then let the characters drive how they move or act or whatever they'll do," Podesta continues. "A lot of times, animators will do a test scene for a new character, which is one of the hardest things to do, because it's a scene out of context. When I was teaching, I would make the students answer questions: 'You have a character in a room—where were they five minutes ago? Where are they going to be five minutes from now? How old are they? What do they like? What do they dislike?' You have to build a world around your character. Unless we actually build a certain amount of that world, which you'll never see, the performance won't feel authentic. It'll feel only an inch deep, and you really want something that's deeper than that in order to reach an audience."

In addition to being challenging to design, rig, and animate, the new characters were also challenging to write, and none more so than Lots-o-Huggin' Bear. While crews labored to create a believable plush teddy bear on the screen, Arndt and the story crew worked to find his personality. He couldn't be a one-note villain, twirling the teddy bear equivalent of a handlebar moustache. Instead, Lotso has to appear benign initially, and then reveal his cruel heart at a key moment in the story.

"From the start, I loved the idea of a toy gone bad—a toy who enjoys being played with by kids, but who has a cynical, hard-hearted view of the toy-child relationship," Arndt says. "But it wasn't enough to just have him be a bad guy; we needed to know why he went bad. That's the difference between a real antagonist, with a strong, understandable worldview, and a cartoon villain. The crucial thing about Lotso is that, when the story begins, he and Woody share the view that love means 'always being there.' When Lotso found that he had been replaced by Daisy—that she was no longer 'there for him'—he decided her love had been a sham, that it had never existed."

"Lotso dealt with the pain of that broken love by casting off the notion that there isn't any love whatsoever between children and their toys. He describes it as a situation where toys use kids and kids use toys: there's no love in the equation," agrees Unkrich. "That's the polar opposite of how Woody feels. We wanted Woody to confront a character who'd made some bad choices—choices that Woody himself might also have made had he been in the same situation."

"By this logic, Lotso actually wins the argument with Woody in their showdown at the dumpster," Arndt continues. "Lotso asks Woody, 'If your kid loves you so much, why is he leaving?' And Woody has no answer. In Lotso's view, toys are inherently tragic figures, doomed to be abandoned by those they love; love is for suckers, since it never lasts."

In recent years, many animated features have suffered from having superficial, cliché villains. The hero defeats one of these sneering bad guys and gets

Bob Pauley, Pencil, 2007

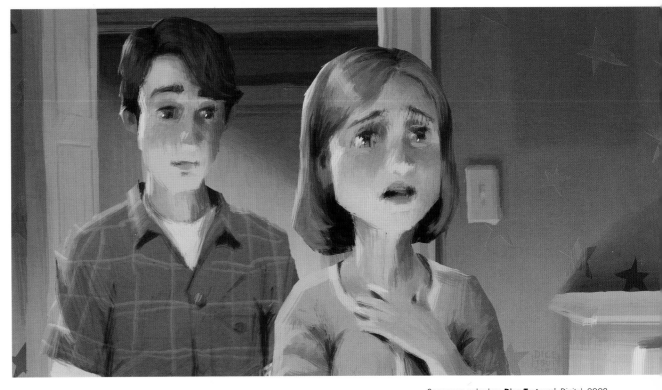

Sequence color key, **Dice Tsutsumi**, Digital, 2008

Daniel Arriaga, Digital, 2007

nothing to show for his trouble beyond a scar or two. When asked about the complex villains in *Princess Mononoke*, Hayao Miyazaki replied, "If you portray someone who's evil, then you off him, what's the point? It's easy to create a villain who's a maniacal real estate developer, then kill him and have a happy ending. But what if a really good person becomes a real estate developer?" In Lotso, Arndt and the Pixar crew crafted a character who is complicated, conflicted, and understandable, and who teaches Woody a vital lesson.

"It's only at the *very end* of the story, when Woody hears Andy himself say that his mom will always be with him—figuratively speaking—even when he's away from home, that Woody's worldview changes," Arndt adds. "The reality is that we all go through our lives meeting, falling in love with, caring about, and then having to part from many, many different people—childhood friends, high school sweethearts, teachers, work colleagues, etc. In our darker moments, we may wonder about the value of those relationships, since they were transitory and ended up not lasting. Were they 'real'? If so, why didn't they last?

"What Woody realizes in the end is that we can love someone (like Andy) and let them go, and that our physical separation doesn't diminish the realness or the beauty of that relationship," he concludes. "Those people will always be a part of us, just as we will always be a part of that other person. Indeed, the exquisitely melancholy truth is that the act of letting someone go (as Mom is doing with Andy) is often the most loving thing one person can do for another. This is what Woody learns over the course of the story."

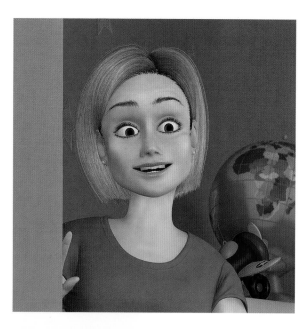

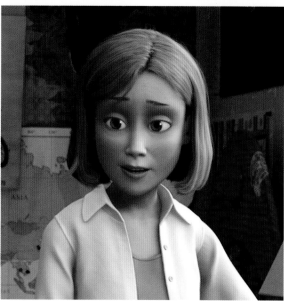

Progression of Andy's mom's character model through the three films, illustrating the artists' increasing sophistication at rendering believable human characters. Digital, 1995/1999/2009

NEW TECHNOLOGY— BUT A FAMILIAR LOOK

"On Toy Story 3, *I wanted to take advantage of what we could do now. I wanted the lighting to be as sophisticated and as beautiful as what we've done on the other films. I wanted the character animation to be at a whole other level, especially the humans. But it was also very, very important that it still feel like a* Toy Story *movie."*
—Lee Unkrich, director

Aside from the all-important questions of story, the greatest puzzle the Pixar artists faced on *Toy Story 3* was how to preserve the look and feel of the earlier films while making improvements and using the potential of the new computers and software. Every department in the studio wrestled with those questions. In the eleven years since *Toy Story 2* was made, computers have become far faster and the software they run is much more sophisticated. The early machines used for *Toy Story* look crude and even quaint by today's standards.

Advancements in both hardware and software have finally made the technology genuinely user friendly. The yawning divide between artists and technicians that produced so many unsatisfying CG films in the early days of computer animation is rapidly eroding. Quaroni says, "In the area of shading and lighting, we tend to need fewer technical people and more people who have an artistic sensibility. In the past, how a color was made on a screen or how a pattern was generated depended entirely on programming; it was about writing software. Now we see painters doing most of that work: people who understand how a computer works but are not technicians."

As the special effects in recent live-action block-busters have proved, it's now possible to create

computer animation that is virtually indistinguishable from live action. If the Pixar artists had wanted to, they could have made *Toy Story 3* photorealistic. But they didn't want to.

Lasseter explains, "Everybody agreed, 'We can't make it look like we're doing *Toy Story: The Live Action Film*.' There was a very conscious effort to make the world feel like the *Toy Story* world. If you compare *Toy Story* and *Toy Story 2*, there's a significant difference in the quality of lighting and things like that, but it still feels like the same world."

The Pixar artists have spent the last several years honing their ability to handle human characters, gradually refining their work to make it more subtle and credible. "With *Geri's Game*, *The Incredibles*, *Ratatouille*, and *Up*, we've developed a knowledge of how to do the muscles and skin and hair and facial features of humans to the point where they're believable," Lasseter says. "We decided to use that knowledge to make the human characters still feel like they're basically the same designs, or of the same world as the earlier films, but they're better. We were really on the ragged edge of technology trying to do the humans in *Toy Story*. That's why we stylized them so much. The human characters in *Toy Story 3* are really much more appealing.

"In *Up*, the subtlety of the acting is really remarkable," he continues. "There's an incredible simplicity to Russell's design, yet there was so much depth to the acting, especially when he's talking to Carl about sitting with his father on the curb outside the ice cream store and playing a game. He looks down and says, 'I like that curb.' There's an incredible subtlety there, and it's extremely challenging to make something so simple yet give it so much depth. That's not just the technology—it's the skill of the artists at Pixar; they've become so accomplished. And we're definitely using that skill in *Toy Story 3*."

"We can make something that looks perfectly realistic. We can fool you—but we don't want to," Podesta agrees. "We want you to believe in the world we're creating. We want you to believe in everything from the look and the story to the acting and the animation, so that a few minutes in, you've completely forgotten you're sitting in a box with two hundred other people watching light on a wall."

"Believability, not realism" is a phrase people working on the film repeated, like a mantra. But it was an important principle to remember, when realism was so easy to achieve. The artists and technicians had to learn to pull back and preserve the style of the earlier films.

TOY STORY'S VISUAL LEGACY

"For Toy Story 3, *I drew the most inspiration from* Toy Story. *Ralph Eggleston is the aesthetic of* Toy Story. *Those sweet curves, those shapes add up to something more. If you were to grab the chest or the bed by itself and look at it, you'd think, 'Oh, that's a weird, abstract shape.' But when you put them all together they just flow together beautifully."*
—Robert Kondo, sets art director

Although he didn't realize it at the time, art director Ralph Eggleston set the visual style for the entire *Toy Story* trilogy with his color script and design work for the first movie.

He remembers the production of *Toy Story* as an exciting but frenetic period, when the artists had to hit the ground running. "I had gotten a call from Andrew Stanton asking if I'd be interested in working on this project. They'd gone down to Disney to pitch it as a

feature," he recalls. "I showed them my portfolio at some lunch place in Burbank; John looked at it and said, 'You're hired. Can you drive us to the airport?' They hadn't even gotten the green light yet."

For a few weeks, Eggleston and the other artists talked about what they wanted the film to be. At times, they would free-associate terms like "saturated color," "pastel color," and "kid's room," discussing how the words might translate into visuals. They talked over ideas about color and shape and simplicity, and how they could believably depict a child's world or a toy's point of view. "After a few weeks, I sat in my office and did the color script for the film," Eggleston says. "I did the whole thing, probably thirty-three or thirty-five panels, 3 inches high by 30 inches wide, in about two and a half weeks."

Eggleston's vivid pastel drawings meshed with Lasseter's preliminary artwork. "Once I'd talked about a sequence with the director and had tried to understand the characters as best I could, I would find a piece of classical music that would inspire me," he explains. "I'd stay up all night and jam. Sometimes I'd do thirty, forty, fifty pastels in a night, going on sheer gut emotion. For me, the color script on *Toy Story* was really about focusing on those character issues: if you start from character, everything else will follow."

Eggleston drew stylized but believable settings that suggested the moods Lasseter and his crew wanted to express at each point in the story. To help establish Andy as a warm, sympathetic character, his house and especially his room evoked what home should feel like: warm light, calming colors, and curving shapes that seemed to welcome the viewer's eye. It wasn't realistic and it wasn't supposed to be.

The best design work for animated films has always been stylized. Director Chuck Jones pointed out that the French furniture Maurice Noble created for the

Toy Story Color Script

Toy Story 2 Color Script

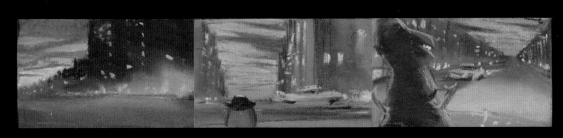

Selection of color scripts created for the feature version of *Toy Story 2*,
Bill Cone, Pastel, 1998

Color scripts, *Toy Story*, **Ralph Eggleston**, Pastel, 1993

Pepé Le Pew shorts was impossibly exaggerated, with swayback curves and spindly legs. But on the screen, it conveyed a caricatured sense of Paris. Similarly, a child who actually lived in Andy's room might find the bed oddly proportioned and the knobs on the bedposts outsized. But to filmgoers, it looks comfortable, cozy, and familiar.

Toy Story 3 had to evoke the same feelings of warmth and comfort as the first film did. "I embrace what John and everybody else had done for *Toy Story* and *Toy Story 2*, because both films are fantastic," says lighting art director Dice Tsutsumi. "As I studied the earlier movies, I found that so many elements of the art direction had a lot of thinking behind them. Those visuals aren't the result of intuitive or arbitrary choices: the artists were thinking about how to best support the story."

Although the *Toy Story 3* artists looked to Eggleston's work as a touchstone, when he completed the initial color script for *Toy Story*, he wasn't entirely happy with it. "I still had issues with it," he laughs. "When John looked at it, I was scared. I thought, 'Oh my God, I'm so fired. I'm going to be moving back to L.A.' John walked in, and he didn't say anything. Then he came over and gave me a big hug."

Eggleston compares his approach to the *Toy Story* color script to Method acting, which requires the performer to delve deeply into the character's motivations. "It's Method painting," he says, half in jest. "I would have to get into the character or mood of each scene; I'd just get obsessed about it. I can't think of one sequence at a time. I have to think of the whole thing."

He grows more serious when he emphasizes the need to understand the characters and implement the director's vision in his work. A color script needs to be both more and less than fine drawings. "If you get caught up in trying to make a pretty piece of art, you're going

to waste a lot of time," Eggleston concludes. "We've filled rooms with artwork, and the director will come in and not look at any of it, because it's not important. What's the story point? What are we trying to do here?"

"In the color script, you try to interpret the meaning and mood of the movie, and you express it through color and light on a sequence-by-sequence basis," agrees Bill Cone, co-production designer on *Toy Story 2*. "It's writing a symphony where the dynamics of the plot are reflected in the dynamics of light and color. The expression of light and color in storytelling is a bottomless well of inquiry. You won't run out of ways to express mood and emotion through those qualities."

Cone, who had been production designer on *A Bug's Life*, came to *Toy Story 2* when it changed from a direct-to-video project to a theatrical feature. Jim Pearson, the art director, recalls, "We were scheduled to release the video a year before *A Bug's Life*, so it was supposed to be

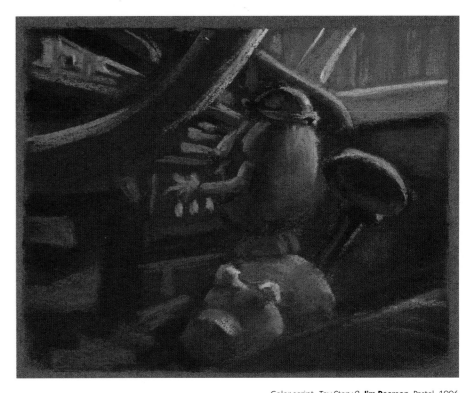

Color script, *Toy Story 2*, **Jim Pearson**, Pastel, 1996

Color script, *Toy Story 2*, **Jim Pearson**, Pastel, 1996

The original Jim Pearson color scripts for *Toy Story 2* were created for the DVD release. Once the film shifted to a feature film, Bill Cone took over to further develop the script, this time more for lighting than story. Due to this scenario, neither script is complete.

a really quick thing. John, Joe Ranft, Andrew Stanton, Lee Unkrich, Pete Docter, and the story crew basically took a week off and rewrote the story for the feature. This was January 1999; the film was coming out in November! So we went directly into this massive crunch mode for the rest of the year: Bill and I basically split the duties similar to the way John and Ash and Lee split the direction. There was so much to do in so little time."

Cone had done design work on *Toy Story*, but his first color script and sequence pastels were for *A Bug's Life*. His inspiration for his work on *Toy Story 2* came from Eggleston's work on the first film.

"Ralph had the color script on his office wall. I was sharing an office next door," Cone recalls. "I'd go by

his office and just look at all those beautiful pastels. I wanted to use pastels, because Ralph's looked so great, but I couldn't get them going. I ended up painting the color script in gouache and acrylic. I would do little tiny thumbnails of very simple shapes that sort of represented the action, just to explore mood and time of day.

"*Toy Story 2* got a very late start in terms of production: they were lighting shots before there was a color script for the movie," Cone adds. "Sharon Callahan was doing the lighting, so I sat down with her, and we talked our way through what was going on, so I could catch up and start doing the color scripts. We figured that Andy's room was like home: you knew what it was supposed to feel and look like. I felt that the outside

world was dangerous and unknown for the toys, so I tried to express those qualities."

Cone also talks about working in frantic bursts of activity once he'd assimilated the material. "I'd absorb a lot of ideas, and then I'd just start going," he explains. "You have all this stuff you've stored up; you've built up this big head of steam from all the stimulation and research. You assemble the ingredients in your heart and mind, and then they just have to come out."

During production of *A Bug's Life*, Cone became interested in landscape painting, which led him to develop ideas about natural light that he incorporated into his work on that film, and especially into *Toy Story 2*. "I would be driving home," he says, "and see

Color script, *Toy Story 2*, **Bill Cone**, Pastel, 1998

Color script, *Toy Story 2*, **Bill Cone**, Pastel, 1998

some really unusual cloud pattern in the dusk sky, and lock onto it: 'I know where to put that.' If you look at the dusk sky in the airport scenes, you'll see a certain range of color and cloud patterns that come from Edward Hopper's twilight paintings and the sky I'd see driving home from work."

Like Cone and Eggleston, Dice Tsutsumi believes that the use of color and light in a film should never call attention to itself. "The audience should be immersed in the story and the characters. We're just a supporting element," he explains.

"Color scripting is not about how well you can paint. You can give the images to the talented lighters at Pixar and they can make the final renders amazingly beautiful," he concludes. "Your job is not to make beautiful pictures. It's about how you can support the story with these images and lighting concepts."

Tsutsumi's philosophy of supporting the story rather than showcasing his own skills is shared by all the *Toy Story 3* artists. They recognized the challenges before them and set to work to give audiences a film that would be both new and familiar. Like the first two films, *Toy Story 3* would open with a playtime scene in Andy's room. Viewers would recognize the setting and characters instantly, but they also had to recognize that they were watching a fresh adventure.

The Pixar artists had to blend a new story, technical innovations, and well-loved characters into a seamless, satisfying entity, and it all begins with a return to the good times in Andy's room.

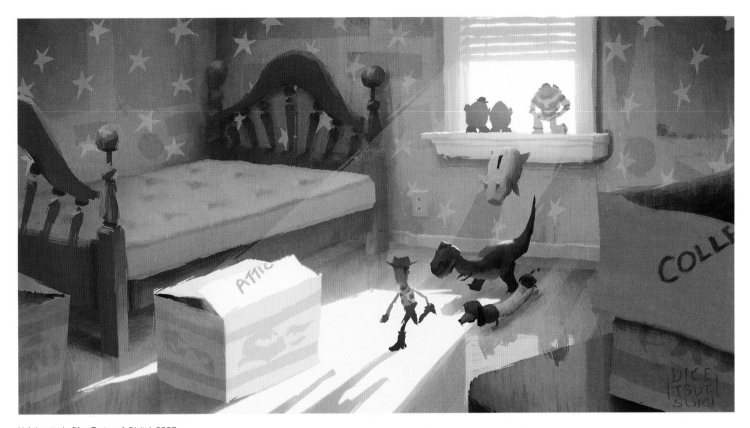

Lighting study, **Dice Tsutsumi**, Digital, 2007

"We make these movies to entertain ourselves, and we hope that the rest of the world connects with them as much as we do. We want the films to be funny, emotional, and honest."
—Jason Katz, head of story

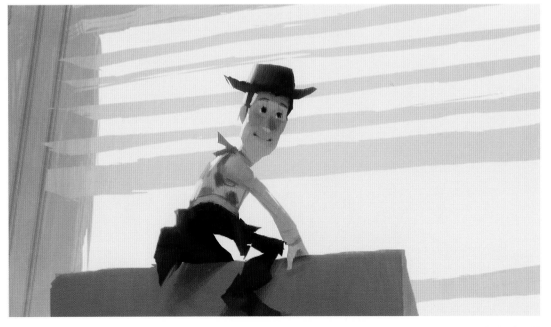

Sequence color key, **Dice Tsutsumi**, Digital, 2008

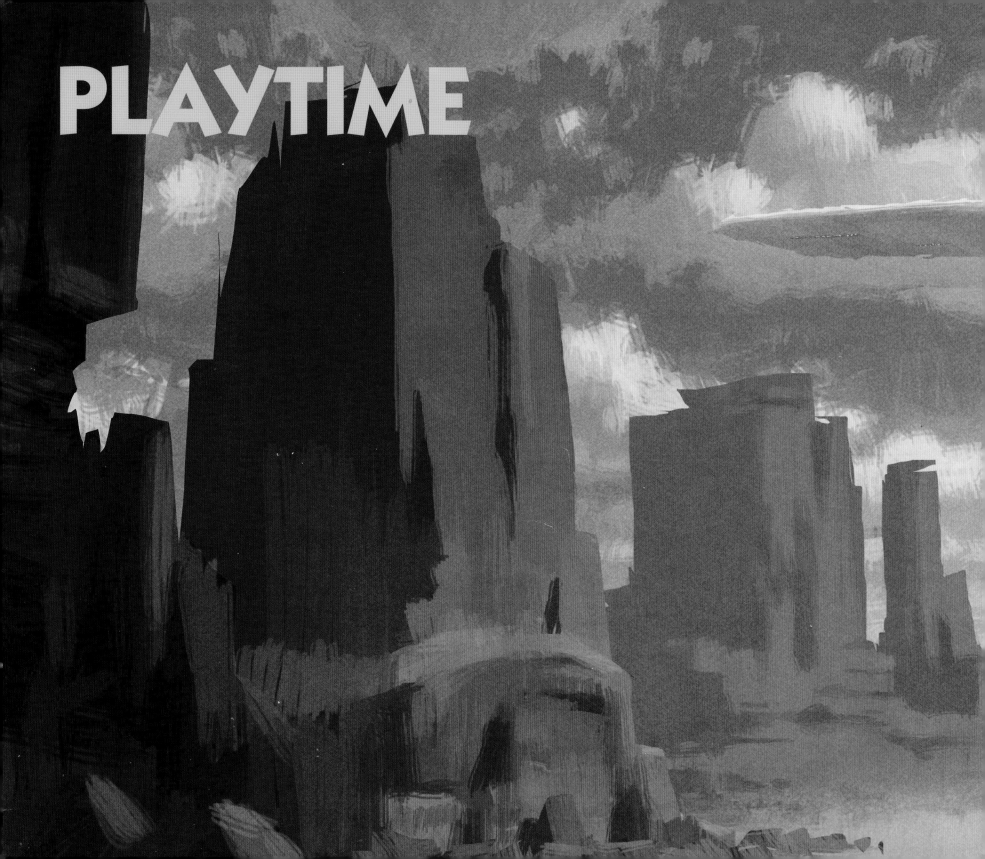

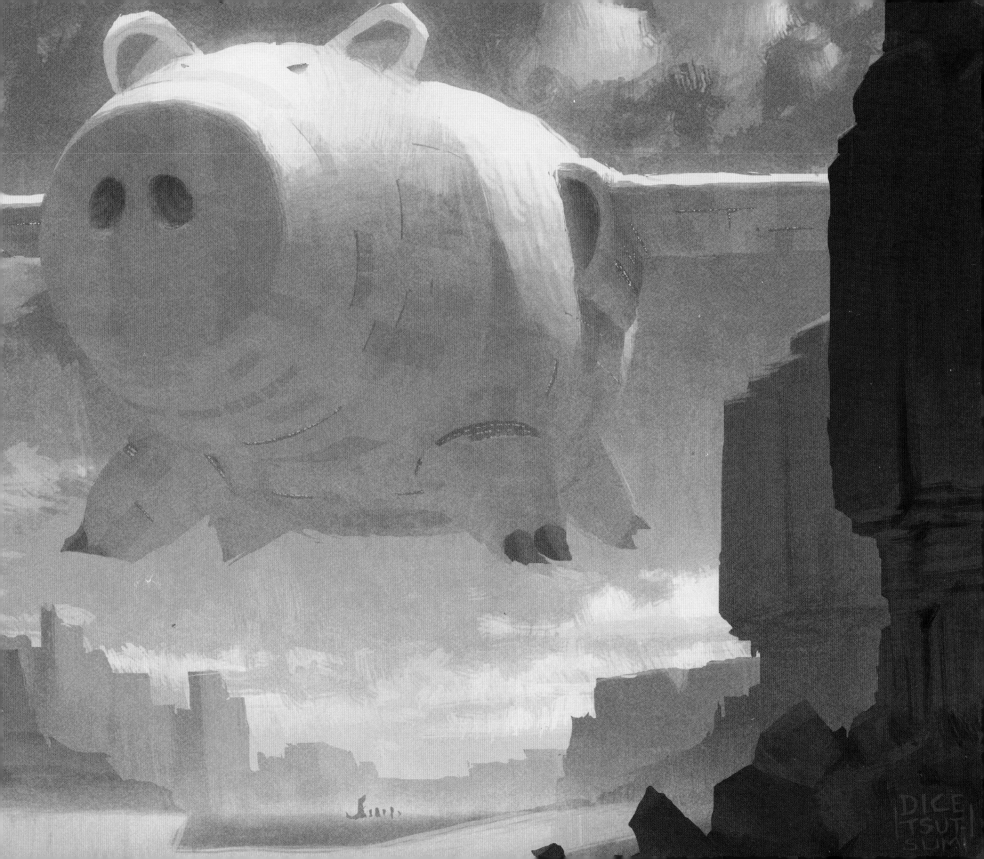

> "Central to Andy is his imagination. That's his own world, playing with those toys. They come alive when he leaves the room, but they're already alive to him."
> —John Morris, voice of Andy

WESTERN OPENING

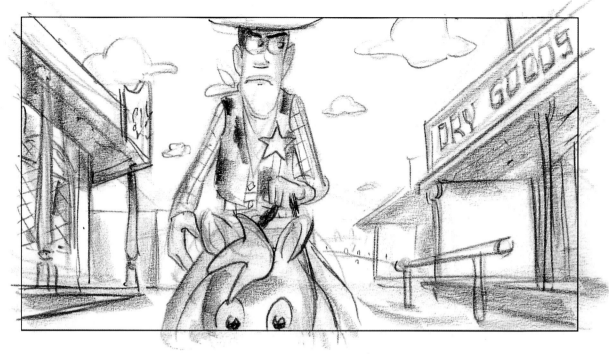

Above: Storyboard, **Bud Luckey**, Pencil, 2006
Previous spread: **Dice Tsutsumi**, Digital, 2007

Andy is the center of the toys' world: his attention and affection give their lives meaning. They are "Andy's Toys," not just a random collection of playthings. For Woody, the word "Andy" written in marker on the bottom of his boot symbolizes an indelible bond. The toys' devotion to Andy reflects John Lasseter's philosophy of animating inanimate objects: "Objects are manufactured to do a job, and if that object were alive it would want to do what it was manufactured to do more than anything else in the world. Toys are manufactured to be played with by a child, to make a child happy. Anything that prevents them from doing that causes them anxiety and worry."

Each *Toy Story* movie opens with the toys being played with by Andy. The first film begins with a Western adventure in which Sheriff Woody rescues Bo Peep and her sheep from the clutches of One-Eyed Bart (Mr. Potato Head). This brief sequence establishes Woody as Andy's favorite toy, and it also suggests Woody's limits as a toy: he speaks only when Andy pulls his pullstring, which marks him as an old-fashioned plaything—a shortcoming that will figure in his rivalry with Buzz.

Toy Story 2 begins with a clip from a fictional Buzz Lightyear video game that introduces the evil emperor Zurg. Making Rex the gamer—who loses for the umpteenth time—reestablishes the familiar characters from Andy's room while scoring a big laugh. In an interview in 1998, *Toy Story 2* codirector Lee Unkrich commented, "Rex has become a video game addict and he's completely obsessed with a Buzz Lightyear game. He's become such an expert at it that he knows Buzz's universe better than Buzz himself. In addition to his role in the game, Zurg shows up later as the Zurg toy that was made with the Buzz Lightyear toy. Like Buzz in the first movie, Zurg doesn't think for a moment that he's a toy; all he knows is that he must go out and destroy Buzz Lightyear. It's a funny idea that carries us through a lot of the movie."

For the opening of *Toy Story 3*, director Lee Unkrich and his crew pulled out all the stops in a baroque adventure-fantasy that spoofs everything from spaghetti Westerns to contemporary action films: Sergio Leone meets *Men in Black*. When the opening ends, the audience sees young Andy playing with the toys: the fantasy sequence was a visualization of what the toys experience while being played with. The camera slowly pulls out to reveal that the image of young Andy is actually on a home video, linking the sequence to the present, which is in fact a decade later. Things have changed in Andy's room since the last film—and not for the better, as far as the toys are concerned.

"It was important to open the film in a big, exciting way. I knew it was going to be a bit of a downer when we revealed that Andy has grown up and the toys are grappling with that, and I didn't want to open on a downer," Unkrich says. "Since we opened *Toy Story 2* in Buzz's world, we thought it would be fun to open *Toy Story 3* in Woody's world.

"Our first stab was a kind of gunslinger scene: a dusty, Old West town with tumbleweeds blowing through the streets; Woody, the lone gunslinger, came riding into

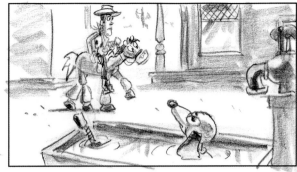

Storyboards, **Bud Luckey**, Pencil, 2006

town," he explains. "It was all shot like a Sergio Leone film. As Woody rode into town, Buzz came blasting down from the sky, and they ended up at opposite ends of the main street in a gunfight."

The *High Noon*–style gunfight then suddenly transmogrified into a rock concert. The Western buildings fell over, and the viewers found themselves in the middle of a Hannah Montana–esque performance. The rock setting revealed that Molly was playing with the toys: Andy's sister was no longer a little girl and had adopted his toys into her world. The fantasy grew increasingly elaborate and exciting, but it had a downbeat ending that proved unsatisfying. The filmmakers ultimately abandoned the idea, although they kept the Western setting.

"For a long time, the dismount from the fantasy was the reveal that the toys were practicing, trying to keep their skills up as playthings," Unkrich explains. "The

toys were no longer played with, and this game was their pathetic attempt to keep things going. We were going down that path for a long time, but it never sat quite right. It broke a fundamental tenet of the *Toy Story* universe: toys don't play by themselves; they're played with by a child. They're not in control of the play. It made no sense that the toys would be playing: that's not what they do. They're played with by Andy.

"About the same time, we were trying to strengthen the ending of the movie, where Andy turns the toys over to Bonnie and has one last playtime," Unkrich continues. "The more we looked at ways to strengthen that scene, the more we realized we needed to see young Andy playing with the toys someplace earlier in the film. We couldn't just have Woody and the others pine for the old days without actually seeing the old days. Audiences had seen playtime in the first two films, but this movie needed to be self-contained, so that

if somebody saw only *Toy Story 3*, it would still be emotionally satisfying."

The difference between the toys' memories of their playtime with Andy and the bleaker world they now inhabit is underscored by a reprise of Randy Newman's "You've Got a Friend in Me." In *Toy Story*, the song affirmed the special bond Woody and Andy shared; in the second film, it became a Las Vegas–style showstopper for Wheezy the Penguin, as sung by Robert Goulet. In *Toy Story 3*, it serves as a threnody for playtime lost.

Reflecting on the trilogy's signature tune, Randy Newman recalls, "All I did with that song was reinforce what they told me was the central idea of the movie: it's about the value of friendship and the particular, special nature of Andy's and Woody's relationship. And part of the relationship, which we introduced with Jessie in *Toy Story 2*, is that at some point, it ends.

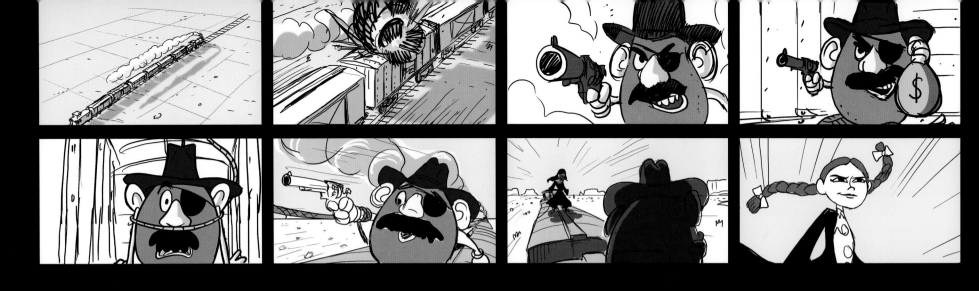

"A song for an animated film is going to be concentrated—that's the nature of the job," Newman continues. "A song lyric is not going to be four minutes long. You've got to say what you have to say: for each song, I get a bunch of adjectives from the Pixar artists about what they want to say, and then I try and say it."

"When the guys went off and wrote the treatment, they knew they wanted to start the film off with something exciting, similar to what we'd done in the other two movies," says head of story Jason Katz. "But we also recognized that it's been a long time since people have seen these characters. So we wanted to start the movie by reminding them that it's a lot of fun to see these guys again.

"Lee said it should feel like the audience has walked in on the final reel of an action picture, and they have to catch up," Katz continues. "So we start off in what feels like the Old West, including a traditional train rescue. Then you have Buzz flying and carrying the train. This is followed by a pink Corvette, a dinosaur bursting out of the ground, a force-field dog, a giant pig

ship. You're mixing things up the way a kid would. You start somewhat traditionally, then you layer in the weird non sequiturs until at the end you've got a nuclear bomb of monkeys."

The artists enjoyed the visual possibilities the fantasy adventure offered. Jeremy Lasky, director of photography, camera, says, "For the opening sequence, we talked about widescreen—*The Good, the Bad and the Ugly*—just really over the top. I remember when I was a little kid pretending stuff, I imagined it as so different from what it really was. I want it to be over the top: lens flare, anamorphic lenses everywhere, crazy."

Lighting art director Dice Tsutsumi notes that, like the Western films evoked at the beginning of the scene, "that sequence needs to be somewhat stylized: that's the glorious time they used to have with Andy. It's real, but it's also idealized. So we want to make sure that sequence comes across as colorful and fantastic—just total dream-come-true visuals, because that's the feeling the toys had when Andy played with them.

"When we started thinking about that sequence, we had a very desaturated, dusty, classic spaghetti Western look. I looked at *Once Upon a Time in the West* and other movies," he continues. "Then we realized that although it needs to look like a Western, we also need to make sure it's what Andy was imagining, playing with these toys. We felt it was more appropriate to introduce high-key colors and less photorealism for an illusion-like world."

An old-fashioned train features prominently in the fantasy. Like Walt Disney and his animators Ollie Johnston and Ward Kimball, John Lasseter is a devotee of antique trains. "The train is a beautiful model that Mike Krummhoefener built. John's a total train guy: we knew he was going to be focused on the train," says sets art director Robert Kondo. "The train is a little bit stylized: it's got toy proportions, but the shading is fairly real looking. That's where we were going with the design of the opening set—really graphic shapes but a fairly realistic treatment beyond that."

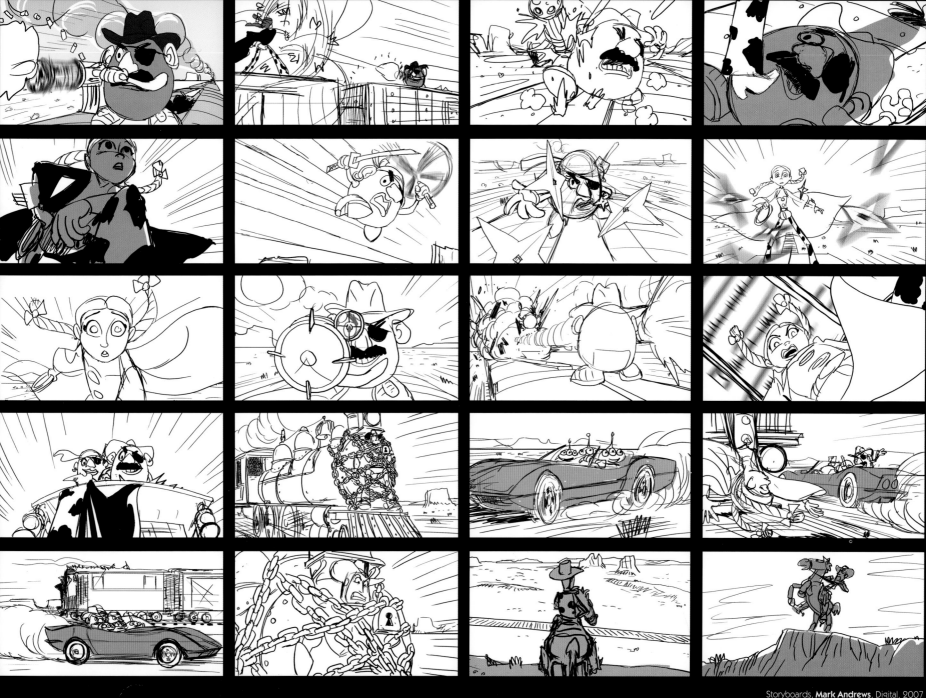

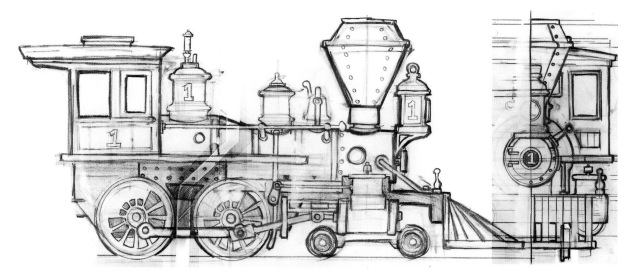

Locomotive model packet, **Dan Holland**, Pencil, 2009

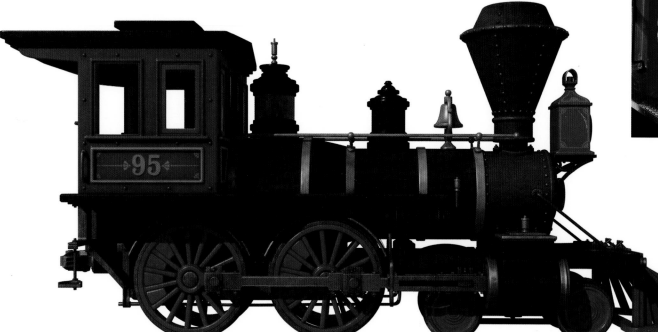

John Lasseter and Ollie Johnston on the
Marie E. Steam train at Disneyland, May 10th, 2005

Western opening train render, **Craig Foster** (graphics), **Mike Krummhoefener** (model and shading),
Chris Bernardi, **Tracy Church**, and **Rui Tong** (shading), **Chris Bernardi** (paint), Digital, 2009

Kristian Norelius, Pencil/Digital, 2009

Kristian Norelius, Pencil, 2009

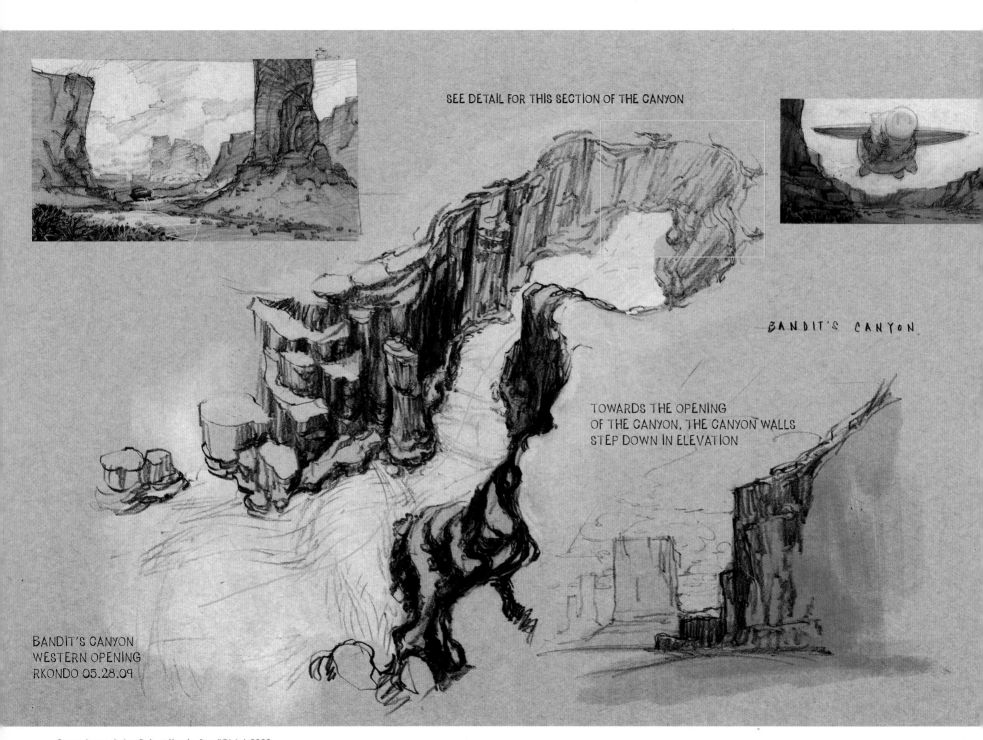

SEE DETAIL FOR THIS SECTION OF THE CANYON

BANDIT'S CANYON

TOWARDS THE OPENING
OF THE CANYON, THE CANYON WALLS
STEP DOWN IN ELEVATION

BANDIT'S CANYON
WESTERN OPENING
RKONDO 05.28.09

Canyon layout design, **Robert Kondo**, Pencil/Digital, 2009

 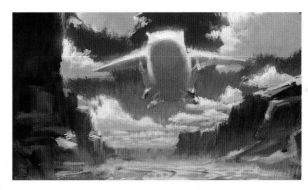

Sequence color keys, **Robert Kondo**, Digital, 2009

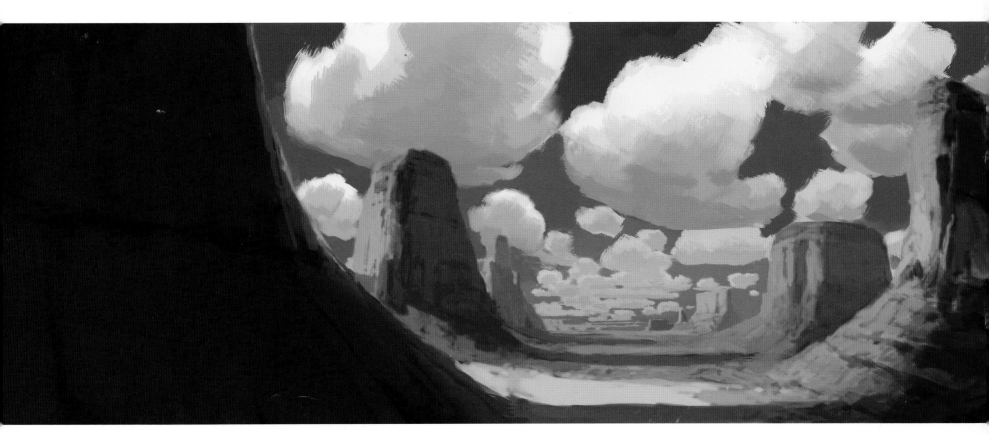

Western opening environmental study, **Ernesto Nemesio**, Digital, 2009

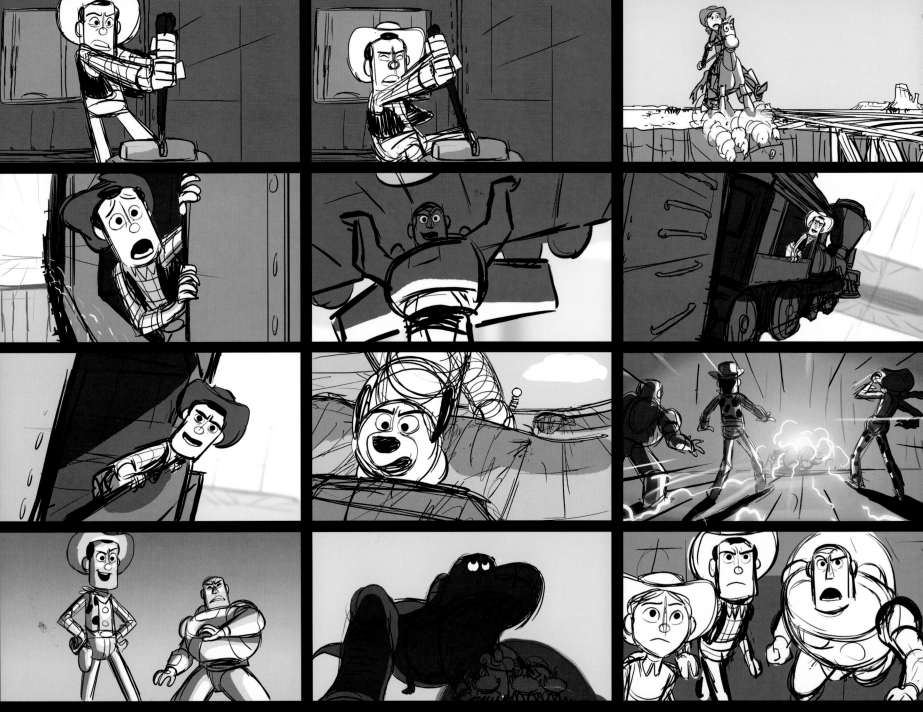

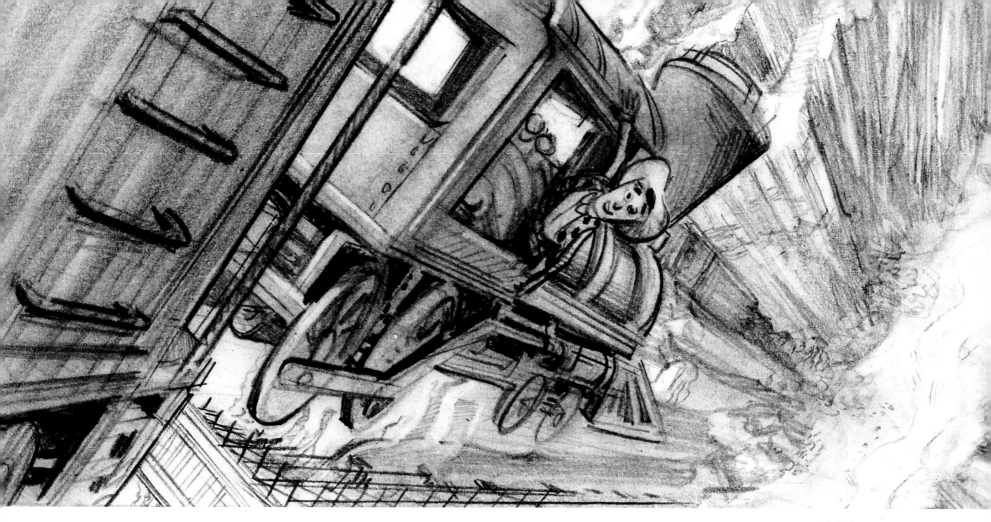

Kristian Norelius, Pencil, 2009

"This sequence was a dream job—it's dramatic, it's got players we know and love, but we're not constrained by the rules that apply in the rest of the film. It's like you've entered a movie in the middle of this big, action-packed scene, so it has that kind of drama and tension and movement. Then you've got the incongruity of a giant pig spaceship, a train, and a pink Corvette in the middle of the desert. It's the realization of a kid's playtime: kids play with all sorts of different toys together."

—Bob Pauley, production designer

HAMM SHIP

K. NORELIUS - 2009

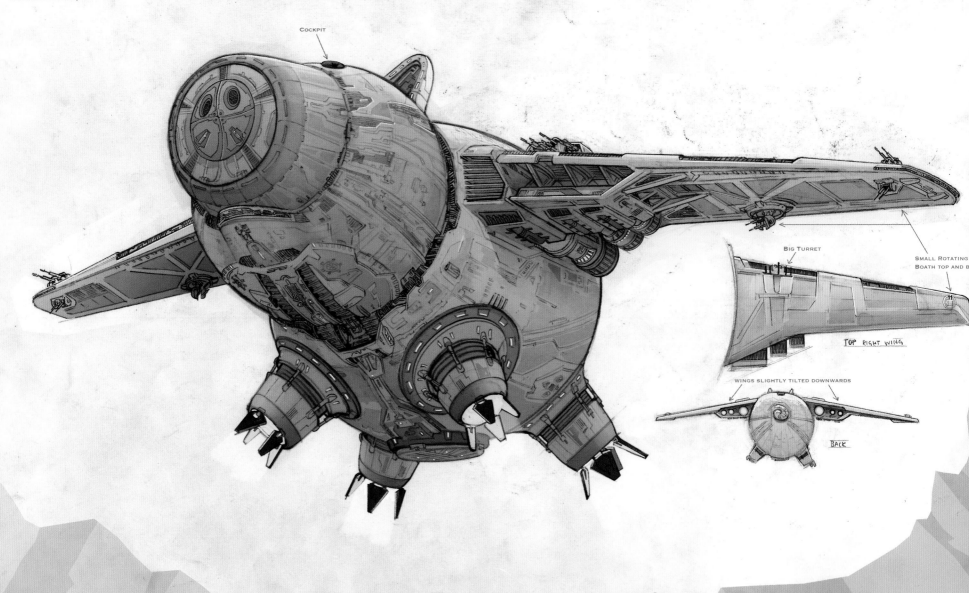

COCKPIT

BIG TURRET

SMALL ROTATING T
BOATH TOP AND BO

TOP RIGHT WING

WINGS SLIGHTLY TILTED DOWNWARDS

BACK

Model packet, **Kristian Norelius**, Pencil/Digital, 2009

HAMM-SHIP:
CONTROL BRIDGE EXTERIOR

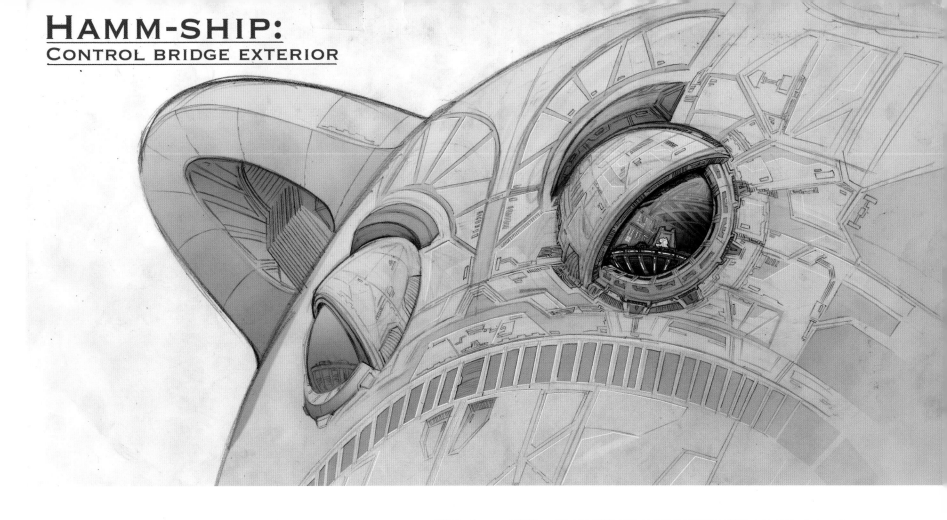

HAMM SHIP'S
MAIN CANNON / K. NORELIUS - 06-02-2009

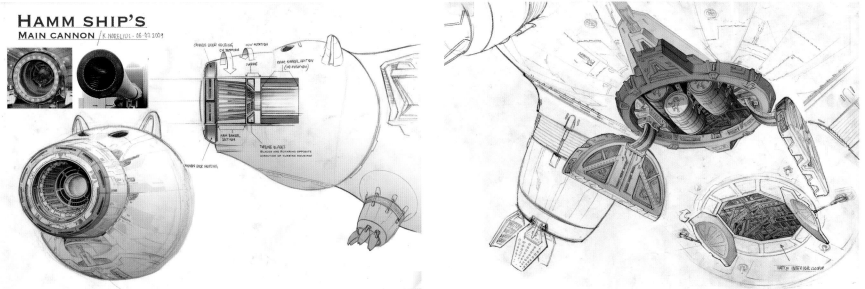

Model packet, **Kristian Norelius**, Pencil/Digital, 2009

GOLDEN AGE

After the initial laughs, the opening sequence strikes a melancholy note: a montage of home videos shows Andy growing up—and getting too old for his childhood playthings. "Originally, the video sequence wasn't there," Katz explains. "We had this exciting opening that went right into a sequence of Andy grown up. The only nod to the past was the moment Woody lifted up the photo of Andy at his high school graduation revealing a photo of a young Andy, surrounded by his toys. Seeing the boy we knew from the previous two films packed an emotional punch. Ultimately, we wanted to build on that emotion."

As Katz notes, the video montage provides a visual and emotional transition from the flamboyant color and action of the Western adventure to the sadder world the toys know today. Ten years have passed since *Toy Story 2*, and playtime with Andy has become a thing of the past. "We wanted to be realistic about the fact that time had gone by," says Unkrich. "We didn't want these characters to be deluded about what was in store for them. We knew it couldn't be a big surprise to them that Andy was going to college."

Sequence color key, **Dice Tsutsumi**, Digital, 2009

"We lit the montage like the *Toy Story* world, where the shadows are bright purple and the sunlight comes through the window, bounces off the wooden floor, and warms the entire room," adds Tsutsumi. "That's one of the signature styles of *Toy Story* that John really pushed. The third sequence is seven years later and Andy has grown up. We lit those scenes slightly differently from the scenes in his childhood to make sure the audience can feel the change. It's nice to play with bringing the audience back to the *Toy Story* world, yet remind them seven-plus years have passed; it's a different world."

More than anything else, Woody fears that someday Andy will outgrow him. Unkrich explains that the main story line of *Toy Story 3* begins with Andy deciding what to take with him to college, what to leave behind, and what to throw away. "In *Toy Story 2*, the Prospector mocks Woody, 'Do you think Andy's gonna take you to college?' Yet Woody's hoping he will," Unkrich says. "When Andy puts him in the box to go to college, Woody's very happy, although he's not happy that his friends aren't coming. After he's separated from Andy, he spends the first half of the film trying to get back so that he can go to college with him. I don't know what

Woody thinks is going to happen when he gets there, but he's not ready to let go of Andy.

"These toys have not only been with Andy a long time, they've spent a long time not getting played with," he continues. "We have lots of scenes on the cutting room floor of the toys trying to occupy themselves when Andy no longer plays with them. We had some great ideas: Hamm had learned all these languages, because he spent all this time online doing correspondence courses. Slinky had done puzzles so many times that Woody would time him doing one in ten seconds. We had a lot of funny stuff, but we realized that in trying to communicate the boredom and stasis of their lives, we were making the film boring and static."

All that survives from those scenes is Hamm's comment, "Let's see what we're going for on eBay."

The opening scenes establish that not only has time passed, but the emotional climate in Andy's room has also shifted. *Toy Story 2* ended so neatly that the first thing the filmmakers had to do was convince the audience that problems still existed.

Kim White, director of photography, lighting, notes that the lighting artists set out to suggest the emotionally troubled situation in Andy's room. "In order to emphasize the sad situation that the toys found themselves in, we lit Andy's room with indirect, desaturated light," she explains. "In the first two films, there was usually strong sunlight streaming into the room casting a patch of light onto the floor. We also used a lot of saturated, warm sunlight and cool fills. Lighting Andy's room without direct sunlight and saturated contrasting colors emphasized the downbeat feeling of that sequence. We also lit the preceding sequence—the home movies of young Andy playing with the toys—in the classic *Toy Story* style with lots of sunlight coming in through the windows, and we bumped up the saturation even further to push the nostalgic feel and to establish a greater contrast in grown-up Andy's room. Cutting from the supersaturated, directly lit sequence to the desaturated, indirectly lit one will enable the audience to feel how sad the situation is for the toys."

"If you look at *Toy Story 2*, it feels like all the emotional conflicts are resolved at the end of the film," Unkrich explains. "Woody's made his peace with the fact that Andy's going to grow up someday. He knows that's going to happen, but at least he's got Buzz and his other friends around him. It feels very tidy and warm and satisfying. However, it's one thing to make peace with the idea of something that's going to happen someday; it's another to find yourself at that day. We can all imagine how we might react to our kids growing up and going off to college or our parents passing away. But when we're really confronted with it, we often don't react in the way we'd like to think we would. That's where we decided to stick Woody."

Sequence color key, **Dice Tsutsumi**, Digital, 2009

Sequence color key, **Dice Tsutsumi**, Digital, 2009

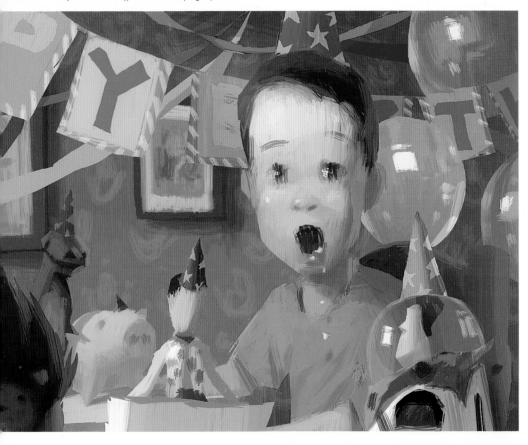

Sequence color key, **Dice Tsutsumi**, Digital, 2009

Sequence color key, **Dice Tsutsumi**, Digital, 2009

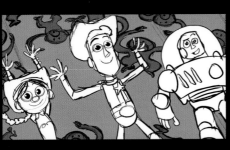
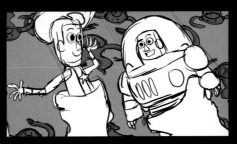

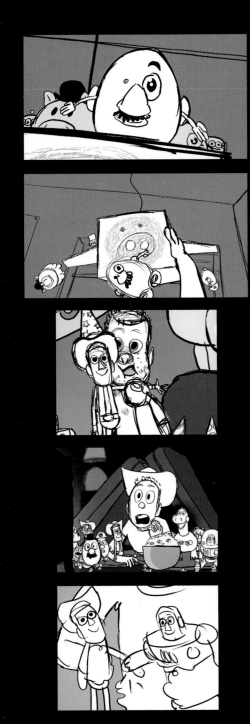
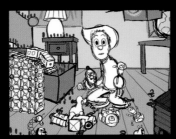
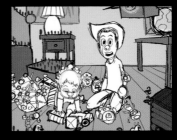

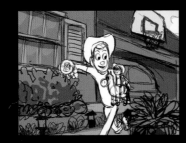

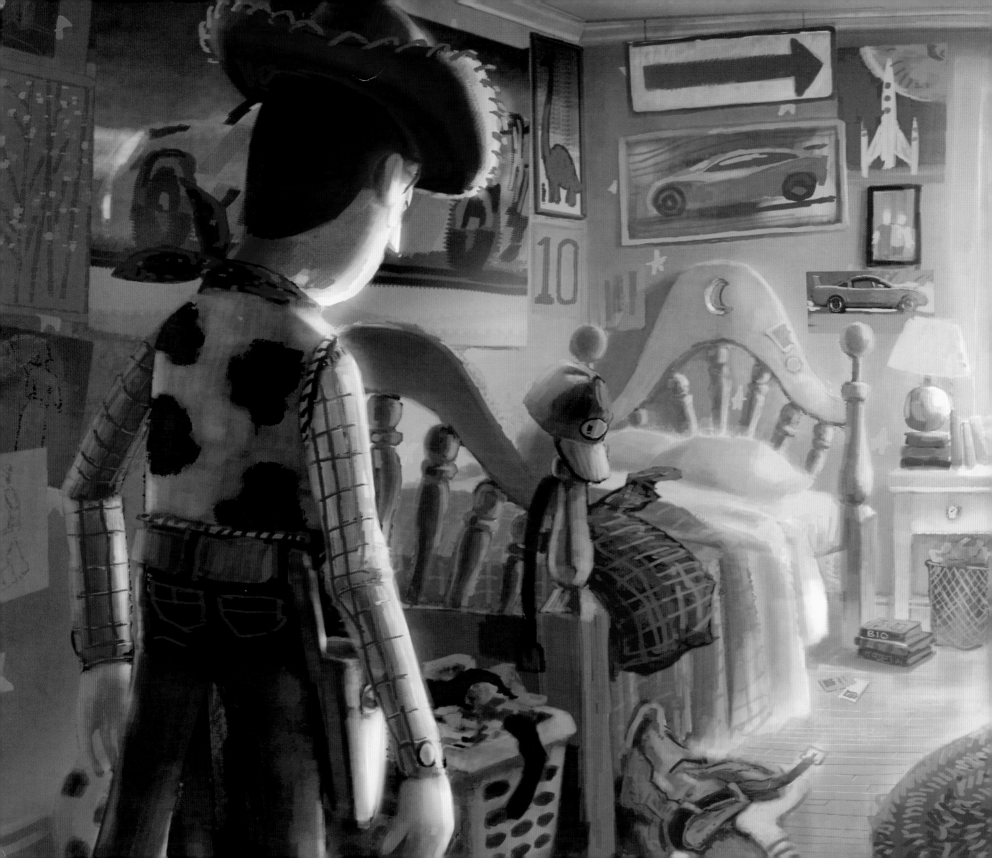

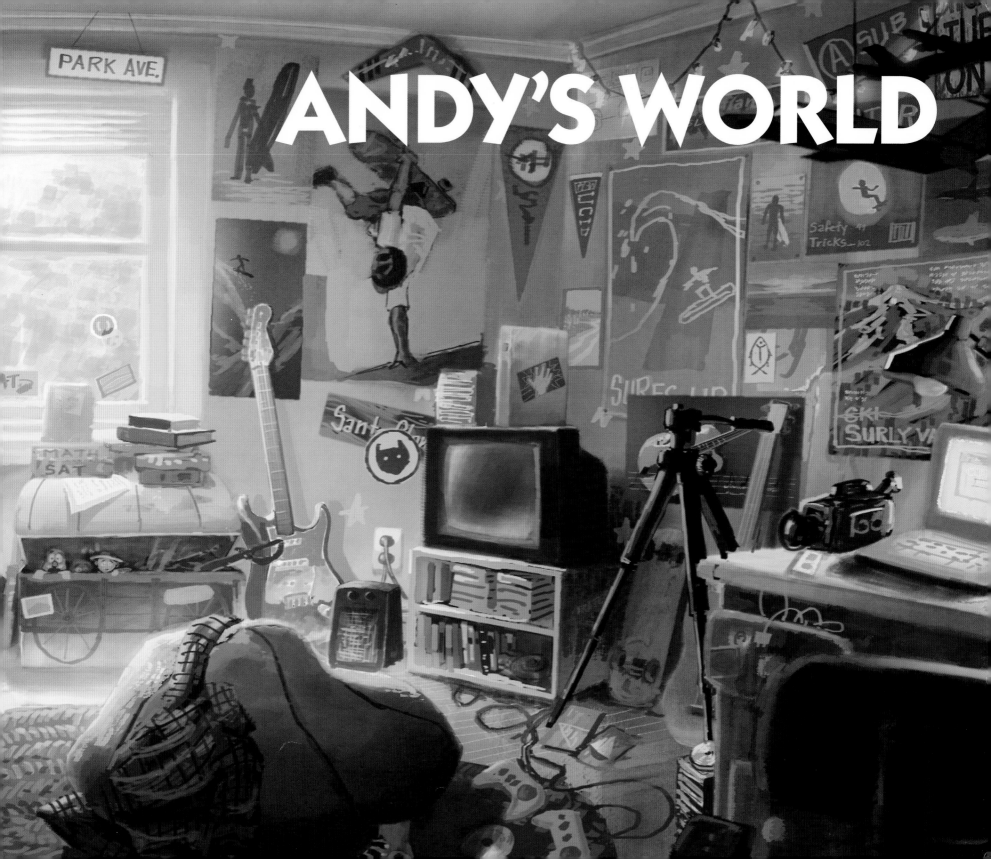

> "Andy's room was kind of everyone's fantasy childhood. We've gotten better at textures and details, but if we were successful in one area in particular, it was capturing the essence of that Midwestern, all-American, second-hand feeling in the colors and textures and basic shapes of the furniture."
> —Ralph Eggleston,
> production designer, *Toy Story*

Above: Color script, **Dice Tsutsumi**, Digital, 2007
Previous spread: **Glenn Kim**, Digital, 2007

If any image has become an emblem of the *Toy Story* movies—and of the work of the Pixar studio—it's Andy's room. The stylized furniture and sky-blue wallpaper, decked out with clouds in the first film and stars in the second, are recognized around the world.

The images of Andy's house may give the impression of a warm, loving home, but the artists knew it was badly in need of upgrades for the new film. "We discovered that if you went down the stairway in the model of Andy's house from *Toy Story 2*, it just stops and you'd fall into an abyss. It would be an extremely dangerous house to live in," chuckles production designer Bob Pauley. "Basically, we only build what we're going to see, plus a little bit more, because you want to be able to move the camera a bit."

For Andy's room in *Toy Story 3*, the artists were eager to take advantage of new technologies and faster computers in order to make everything in the room look better than it had previously. But they also knew they had to preserve the shapes and colors that made it a familiar, beloved place. Sets shading lead Chris Bernardi explains, "The challenge for us in Andy's room

was that it's such a *known* place. There were things we wanted to do with the floor, and things we wanted to do with the bed. But how do we add the detail we want without it looking like a different bed?"

Belinda Van Valkenburg, shading art director, says, "Andy's bed was iconic in shape—really pushed in a cartoony way. But the texture was just stripes of wood grain that were burling all over the place. We kept a little bit of that and then added two or three levels of detail, like aging and a little grain, so if you get close up, you don't just get these big abstract stripes."

"We did little things that we didn't do back then," agrees Bernardi. "The subtle modulations of the grain, and the way the grain accepted the wear differently— we wore off little veins in places that break up the reflection in a more sophisticated way."

The artists also had to accommodate a change that was far more profound than wear on the furniture: Andy

has grown up. The exuberant little boy of the first two films has graduated from high school and is preparing to go to college. The crayon drawings of Buzz and Woody were put away long ago. It's still Andy's room, but it reflects the changes that Andy has undergone over the last ten years.

"We tried to find out more about Andy," says Pauley. "He's an average, good kid. He was into soccer and baseball and sports. In *Toy Story*, Ralph had done these nice little drawings of Andy's, so we carry that forward. In *Toy Story 3*, in addition to the posters on his wall, he's got his own drawings from art class pinned up. On the floor, there's a sports bag. There's shoes. There's shirts. We try to show personality in the clutter. The hardest part is to artfully organize the stuff so it tells a little bit of the story but isn't distracting. With Andy, the big note was that it's the same bedroom, but he's no longer a kid."

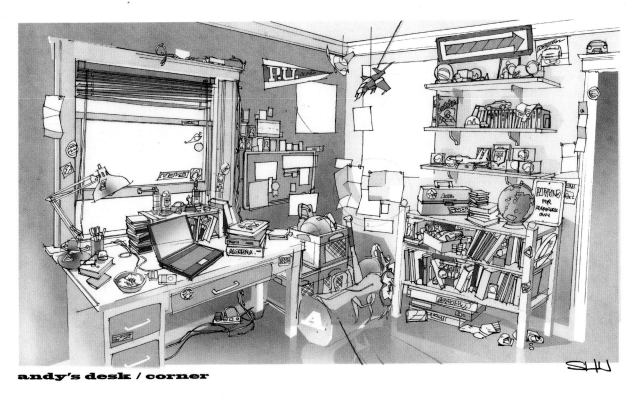

andy's desk / corner

Jay Shuster, Pen/Digital, 2007

P. J. Lasseter's room, **John Lasseter**, 2007

Old Buster character sketch, **Daniel Arriaga**, Digital, 2008

Toy Story 3 begins with Andy sorting through his things, preparing to leave for college: what to take, what to leave, what to throw away—and what to do with his toys. It's a much more subdued sequence than that of the birthday party excitement of *Toy Story* or the routine weekend chaos of *Toy Story 2*. Soon, the iconic bedroom will be taken over by Andy's sister, Molly. Andy is moving on, and there are good-byes to say before he begins life as a college student. He's not quite ready to say good-bye to Woody, so he puts the cowboy in a box of things he's taking with him—a decision that some in-house screening viewers found unlikely.

"For animators or people who just never grew up completely, the idea of taking toys off to college is not at all strange," Unkrich comments. "I think it makes perfect sense. But I've gotten notes from people saying, 'I don't believe a teenager would take a toy. That's ridiculous.' Some people just think toys are for kids, and that it's shameful for a teenager or an adult to have anything to do with toys, but many people want to surround themselves with things from their childhood."

"I worked on the sequence where Andy is leaving to go to college—packing up and feeling the room being empty; taking down stuff from the walls and revealing the stars; saying goodbye to his sister and his dog," recalls story artist Dan Scanlon. "It was very emotional, because we've all gone through something like that. It's so sad when Andy says good-bye to Buster, because Buster's so old! My dog was that age; he represented my childhood, and he wasn't there when I came back.

That moment was so emotionally charged for me to board, but it was fun. It's a good memory."

"Andy's packing is a wonderfully honest, emotional moment," agrees Jason Katz, head of story. "When we were trying to find analogies for what the toys are going through, we thought they'd feel like parents: their child was graduating and moving on, and they were feeling forgotten and neglected."

Andy doesn't intend to abandon his other toys completely: he plans to store them in the attic, where they might remain until he has children of his own. But he gets distracted and leaves them in the hall in a garbage bag. His mother thinks the bag is full of trash and leaves it at the curb, at the risk of being thrown on a looming garbage truck. That story point is based on a misunderstanding Unkrich and his future wife experienced when they moved from West Hollywood to Pasadena, CA.

Storyboard, **Dan Scanlon**, Digital, 2008

Dice Tsutsumi, Digital, 2008

"In addition to packing all our stuff, we were filling garbage bags with junk we wanted to throw away, and I was dutifully taking them out to the dumpster behind the building," he recalls. "We got all our stuff packed, loaded up the truck, and drove to Pasadena. Much later, my wife said she couldn't find the stuffed animals she'd been saving from her childhood. I asked, 'What box were they in?' She said, 'They weren't in a box. They were in a big garbage bag.' I knew immediately what had happened, and I had to figure out how to break the news to her. It didn't go well, but she still married me! At one of our early screenings, we showed the sequence where Andy's mom picks up the garbage bag and takes it down to the curb. I felt my wife turn to me in the dark and glare at me. I like to think that that moment in *Toy Story 3* immortalizes her stuffed animals, and that their deaths in the landfill were not in vain."

The clutter in Andy's room reflects his growing up, but his toys still look good. "Andy is like John Lasseter,

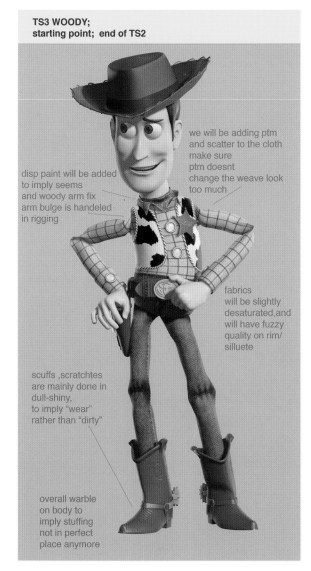

TS3 WOODY;
starting point; end of TS2

disp paint will be added to imply seems and woody arm fix arm bulge is handeled in rigging

we will be adding ptm and scatter to the cloth make sure ptm doesnt change the weave look too much

fabrics will be slightly desaturated,and will have fuzzy quality on rim/silluete

scuffs ,scratchtes are mainly done in dull-shiny, to imply "wear" rather than "dirty"

overall warble on body to imply stuffing not in perfect place anymore

Shader packet, **Belinda Van Valkenburg**, **Judy Jou**, Digital, 2008

Toy Story 2 (left) and Toy Story 3 (right) renders, showing the progression of Woody's front and back details, Digital, 1998/2009

who took care of all his toys, and still has some of them," comments Pauley. "But many of us are probably closer to Sid. I don't have anything left: I used a glue gun and a hacksaw on them."

Andy's toys actually look better than they did in the previous movies. The artists worked to improve the models, adding details, correcting flaws, and introducing new controls that allowed for more subtle movements and expressions. But it wouldn't work if the improvements and changes to these familiar characters were too noticeable. Although eleven years elapsed between films, the characters have never gone away. They've remained popular on video, as toys, on merchandise, and in the Disney theme parks. They had to remain the same Woody and Buzz and Jessie and Hamm that audiences knew and loved.

"We had to rebuild all the models but make them look exactly the same," says executive producer John Lasseter. "We went in and made the seams look like real seams in the fabric—all the tiny little details just look that much better. Bullseye really looks like a toy that was sewn, and his mane feels like it's made of felt. To most people in the audience, it's just Bullseye; they're not going to be able to tell the difference. But it upgrades the look of the film, making it that much more believable. Not realistic, but believable."

"Without changing the design or nature of the character, we increased the level of detail and richness in some of the toy materials—such as the collar and pull-string—in an effort to make it more believable," explains Pauley.

"One character that went through a ton of subtle changes was Buzz Lightyear. The old model for Buzz comprised a bunch of surfaces that intersected each other," adds animator Rob Russ, running his finger along the flange where Buzz's helmet joins his space suit. "All along here, there were crisp, hard edges. They

63

Buzz model modifications, **Bob Pauley**, Digital/Pencil, 2007

remodeled them to look like molded plastic. They would have loved to do that for the first two films, but they didn't have the tools. When people watch *Toy Story 3*, we hope they'll say, 'Buzz looks fantastic.' They won't necessarily realize that work's been done, but he'll feel more tangible and real."

In addition to looking the same, the characters had to move and act as they did in the earlier films. Although the controls of the characters are far more flexible than they were on the first two films, viewers still expect Buzz and Woody to behave the way they did in the past.

"While we didn't need to police the design of the characters from scratch, we did need to make sure we

were animating on model," Russ continues. "Previously, there were limitations on what you could do, and you were happy to get what you could out of the model. The way Buzz and Woody are rigged now, you can do almost anything with them. So you really have to pay close attention to what is and isn't on model for those characters."

The studio veterans hadn't animated the *Toy Story* characters in years, and many of the younger artists had never worked with them. Podesta recalls, "One of our best animators, Dave DeVan, who did amazing work on Woody in *Toy Story 2*, was doing a test shot, and he remarked, 'Man! It's really hard to animate him on model.' I said, 'What are you talking about? You

helped make the model! Whatever you do is on model!' He said, 'No, no, no! This is really hard!' And I thought, 'Great. If this is hard for you, we're screwed.'"

One character missing from the group is Bo Peep. "It was a tough decision, but it was very difficult for us to find a place for her in the story we're telling in *Toy Story 3*," explains Unkrich. "Bo Peep was created to get a female voice in the group of toys. In *Toy Story*, Andy shares his bedroom with Molly, and Bo Peep is a porcelain nursery lamp sitting next to her crib. She was not only a female character but also a love interest for Woody."

It had also been hard to find a place for Bo Peep in *Toy Story 2*, which is why she appears only at the beginning and end of the film. The filmmakers felt audiences wouldn't accept a porcelain lamp going off into the city and having an adventure. They even joked that she might roll herself in bubble wrap and FedEx herself to Al's apartment.

"It was really stretching believability for Bo Peep to still be a part of this world," Unkrich continues. "It made no sense for her to be in Andy's room. It made no sense for Molly to have her, because Molly's twelve now. But it also felt wrong not to have her in the movie, because she's one of the core characters. For me, the deal breaker was that I could not see a way to have Bo Peep be in the group of toys Andy hands off to Bonnie. I couldn't imagine Andy removing her from the box and having anything special to say about her: she's a lamp.

"We finally decided to make Bo Peep emblematic of how the room had changed and the sacrifices the toys had made along the way," he concludes. "We have a touching moment where Woody talks about the toys that have moved on. Rex brings up Bo Peep, and Woody has a little catch in his throat as he says that she's okay,

Tom Gately, Pencil, 2007

Peter Sohn, Digital, 2007

Peter Sohn, Charcoal, 2007

she's with all the other toys that have gone on to new owners. It's clearly a loss for him. We explain why she's not there, but we struggled with it for a long time."

Even more daunting than updating the settings and the toys were the challenges surrounding the design and animation of the human characters. When *Toy Story* and *Toy Story 2* were released, the animation of the human characters represented the state of the art and technology. But no one at Pixar was really satisfied with them. In *The Incredibles*, *Ratatouille*, and *Up*, the artists kept pushing the envelope, developing ways to animate humans that were more sophisticated and believable. But a character as stylized as Linguini or Russell wouldn't fit into the world of the *Toy Story* films.

"It's been like walking a tightrope, designing new characters that look good by today's standards," says Pete Docter, who was the supervising animator of *Toy Story*. "When I go back and look at *Toy Story*, a lot of the humans are a little scary. But that's where we were artistically and technically. *Toy Story 3*'s humans have to fit with those, so that they feel of the same world, but you don't want to do those same humans again."

"We were a bit freaked out when we decided to re-create Andy from *Toy Story 2*, because nobody was completely happy with how Andy looked then," adds Unkrich. "But we couldn't deny that we needed to see young Andy playing with the toys."

"With *Toy Story* and *Toy Story 2*, Andy was the best that we could do at the time," agrees character designer Daniel Arriaga. "Since then, humans have come a long way in 3D animation. When you're asked to put young Andy back on the screen, you kind of cringe, because you know we could now do him better. There's a fine line, tweaking it just enough to make

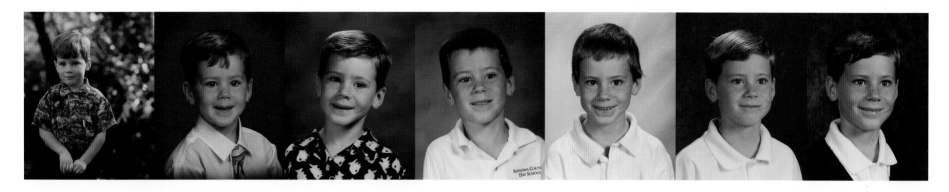

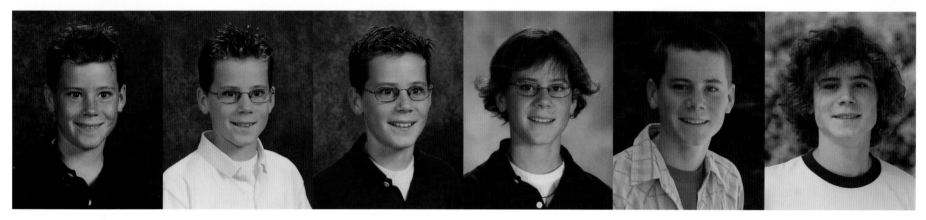

P. J. Lasseter grades K–12 age progression, Photographs, 1996–2009

it work by today's standards, but staying true to the original young Andy. Finding the older Andy was another big challenge. He had to be really appealing. But how does he relate to the young Andy? It took many, many drawings."

The designers and animators studied photographs of boys at various stages of development, learning how facial proportions shift during adolescence. They also researched changes in overall anatomy and posture.

"I've been looking at the older guys in my son's scout troop: behavior, posture, hand size, face," adds Pauley. "As humans grow, the head and the eyes don't change, but you get a lot of nose growth and the lower jaw grows down and gets larger. We needed to understand who Andy is, and how he grows. We looked at these great

charts of John Lasseter's kids growing up, lining up their faces to understand how they grew—in an effort to make the audience recognize that this is still Andy."

"There were two things driving the design of Andy. One was that he needed to be a recognizable progression of the Andy from the first two movies," Unkrich says. "The other was that, from a storytelling standpoint, I wanted the Andy of *Toy Story 3* to be right on the cusp, straddling childhood and adulthood. I didn't want him to be too grown up, with razor stubble. I wanted to find this sweet spot where he had gotten tall and had clearly grown up but still retained many boyish qualities, including a boyish charm. He needed to be kind of gangly and overgrown—he's still not comfortable in his larger, adult body."

In *Toy Story*, because of the limitations at the time, there's not much stylistic difference between the way the toys and the humans are animated. In the new film, animator Dave DeVan enjoyed the chance to "differentiate between the animation of the humans and the animation of the toys. We wanted to keep the toys simpler and have the humans more nuanced."

"Woody is a rag doll who weighs a pound or less. How he moves, how fast he drops off the bed, how much time it takes him to start and stop should be vastly different from the way Andy moves," explains supervising animator Bobby Podesta. "Andy's six-foot-something, a big kid: it's going to take him a certain amount of time to get up, to move through a doorway, to stop. Woody can be a little more springy. He can run

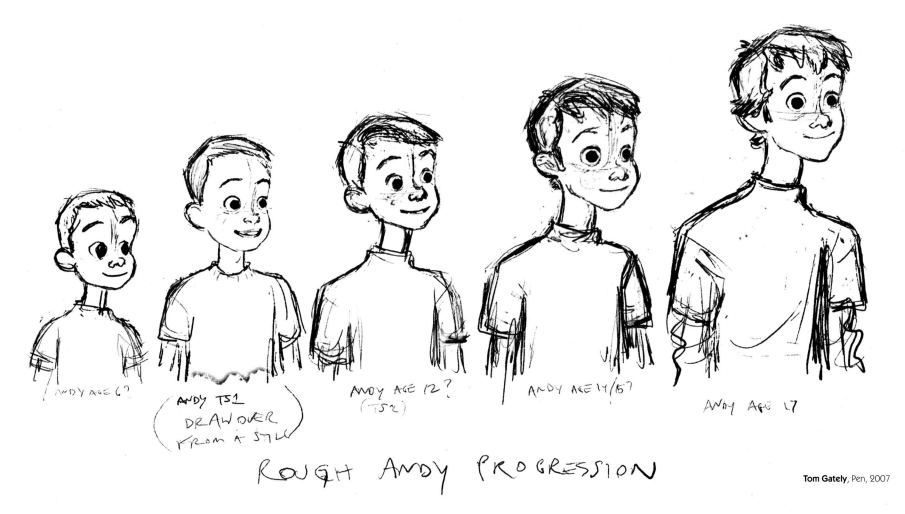

ANDY AGE 6?

ANDY TS1
DRAW OVER
FROM A STILL

ANDY AGE 12?
(TS2)

ANDY AGE 14/15?

ANDY AGE 17

ROUGH ANDY PROGRESSION

Tom Gately, Pen, 2007

across a room and flop down. You should get different feelings from the two characters.

"Animators are thieves," Podesta continues. "I'm going to look at how someone is sitting and carrying himself, or how he agrees or disagrees with me, and I'm going to steal bits and pieces of those behaviors. When I'm animating, I go back to this giant file cabinet of behaviors I've stolen from people over the years. When I need to animate a teenager, I say, 'Oh! A teenager. Got it.' I know just who to reference. My neighbor, my cousin, the dude in high school who annoyed me—they're all fair game. In terms of making Andy convincing as a teenager, some of the animators aren't

much beyond teenagers themselves, so they can pull from their own experience."

While Andy posed problems because he'd changed so much, his mother posed problems because she hadn't changed. Animator Rob Russ says, "As far as the people go, the most challenging one was Andy's mom, because she had aged the least from the previous films. With the other human characters, there was a little bit more leeway: we can reference what they looked like before, but take some liberties. You want them to feel like they've come out of that world, but they don't have to look exactly like the character you've seen previously. Andy's mom was a different story."

The artists knew they could rely on how audiences remembered the older movies looked, rather than on how they actually looked. "In the theater you're not watching the old movies and the new movie side by side. So it's really about the spirit that the audience remembers," says Pauley.

"The challenge of making a sequel is like the challenge of taking over a role in a Broadway show," concludes Podesta. "It can be intimidating when you have to put your animation next to all the great work that had been done previously."

Andy

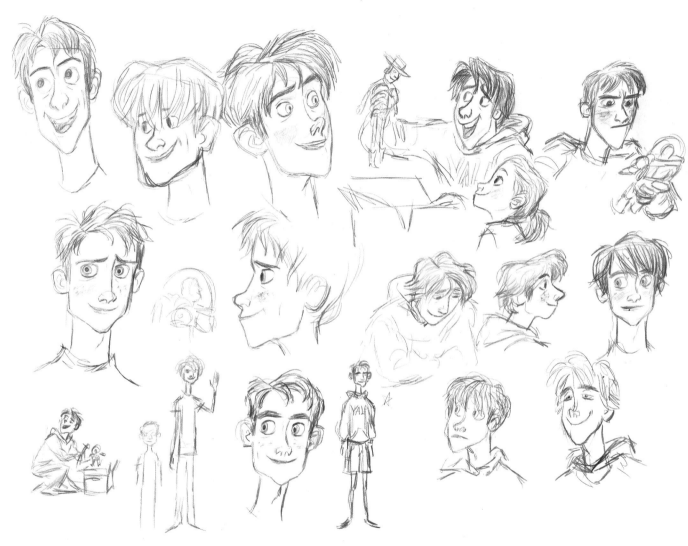

Peter Sohn, Pencil, 2007

Tom Gately, Pencil, 2007

Tom Gately, Pencil, 2007

Peter Sohn, Digital, 2007

Tom Gately (layout) and Nate Wragg (paint), 2007

Andy's Family

Tom Gately, Pencil/Digital, 2007

"We've made vast strides since *Toy Story 2* in how we can render and animate humans. We want to take advantage of new technologies, but also to be true to what had been done previously."
—Rob Russ, animator

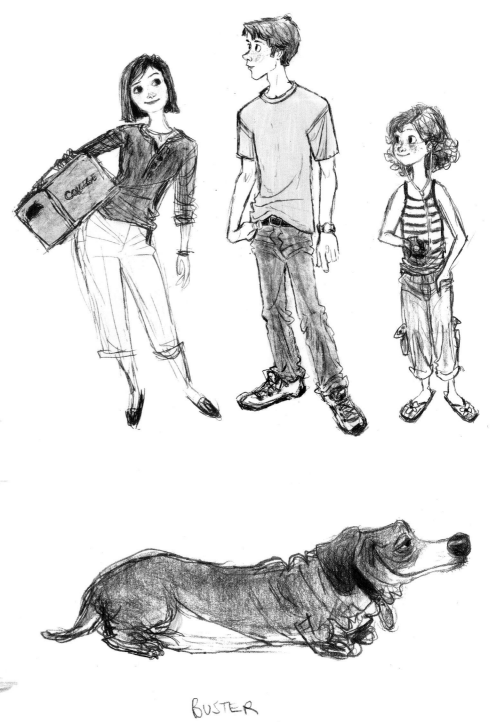

BUSTER

Andy's Room

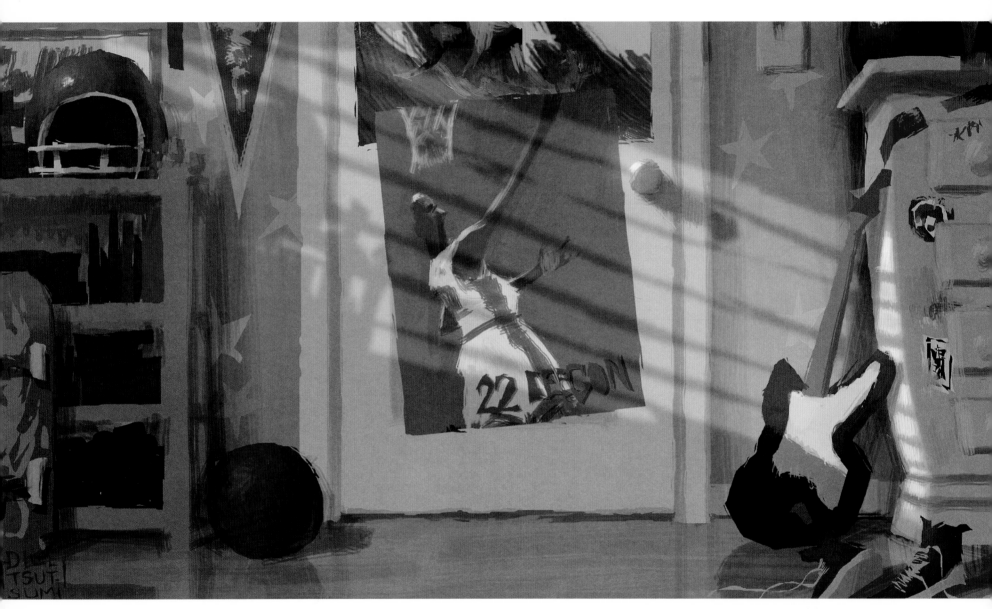

Dice Tsutsumi, Digital, 2007

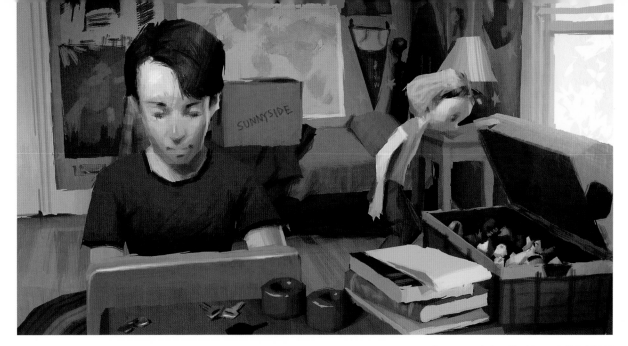

Sequence color key, **Dice Tsutsumi**, Digital, 2009

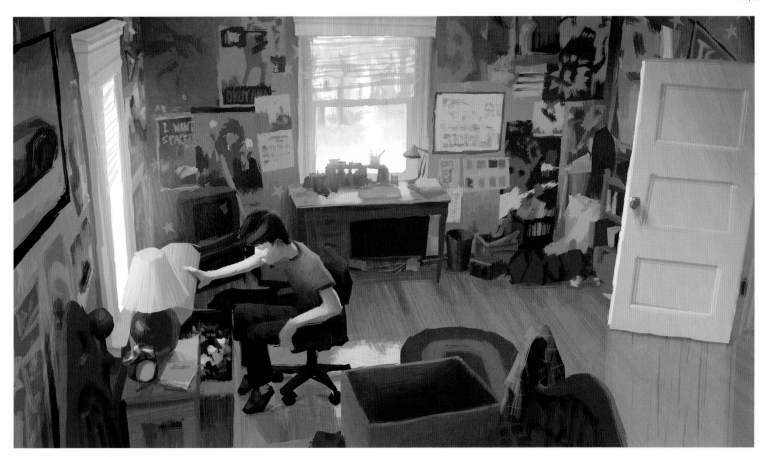

Sequence color key, **Dice Tsutsumi**, Digital, 2009

Posters and ephemera for teenage Andy's room, **Craig Foster** with **Nate Wragg** and **Mark Holmes**, Digital, 2009

Robert Kondo, Digital, 2007

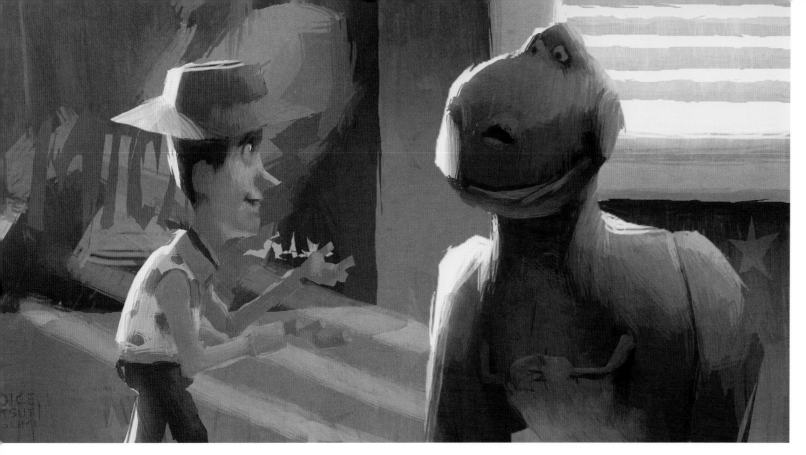

Dice Tsutsumi, Digital, 2008

"Being back with these characters really is like being with your family: we all know Woody and Buzz so well. In story meetings or in brain trust meetings, we'd often say, "Woody would never do that." We know them like they're our siblings or close friends."

—Rachel Raffael, story manager

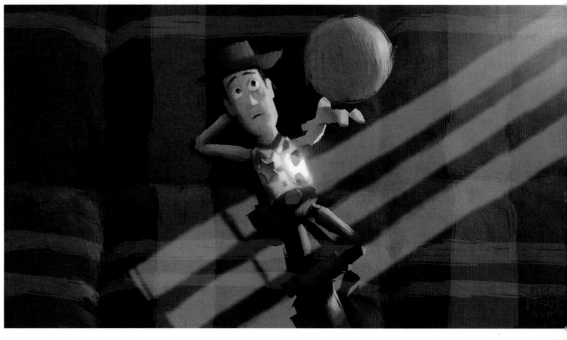

Dice Tsutsumi, Digital, 2007

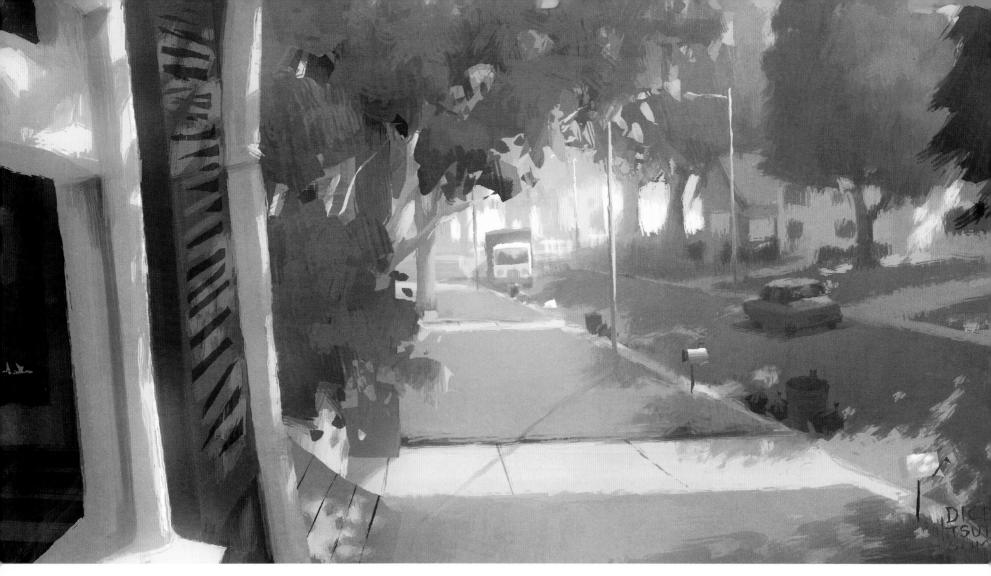

Dice Tsutsumi, Digital, 2007

"For some of the sets, artists have developed little backstories
for why a location is the way it is. In Andy's neighborhood,
each yard has a different aesthetic. One neighbor wants bushes
everywhere, but the next yard is just grass. You get the sense
of a little bit of character in the properties."

—David Eisenmann, sets supervisor

Andy's house landscaping pass, **Kristian Norelius**, Pencil, 2008

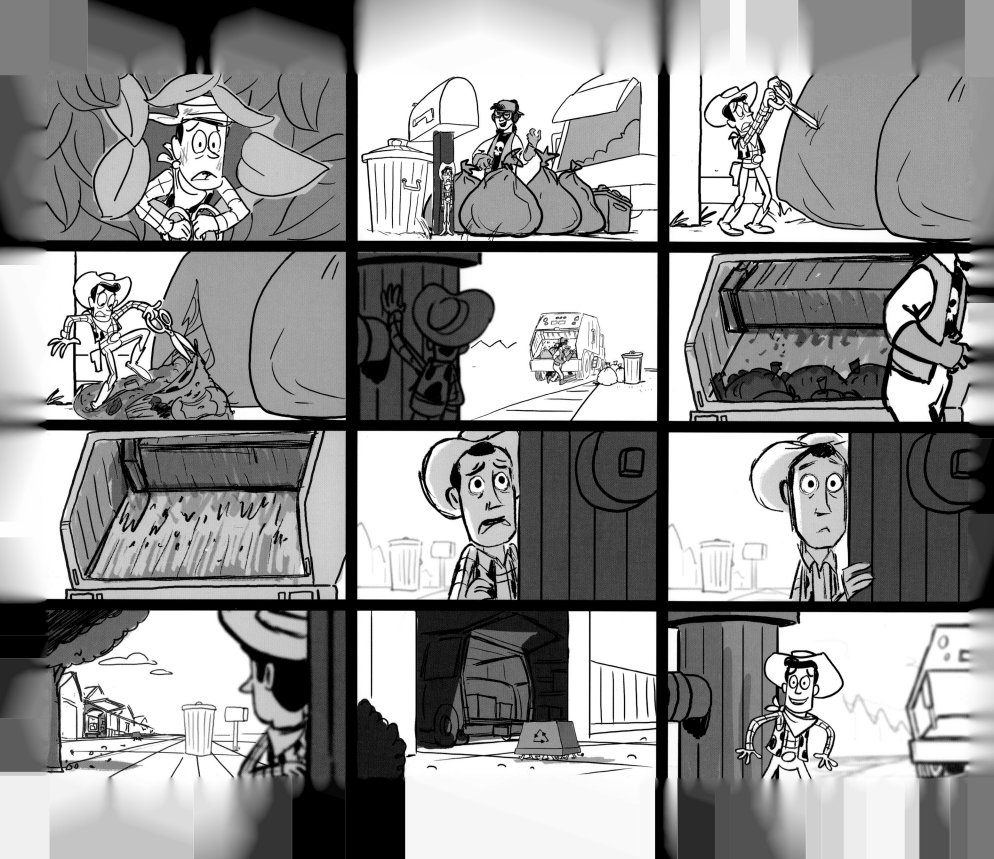

Robert Kondo, Digital, 2007

Maquettes

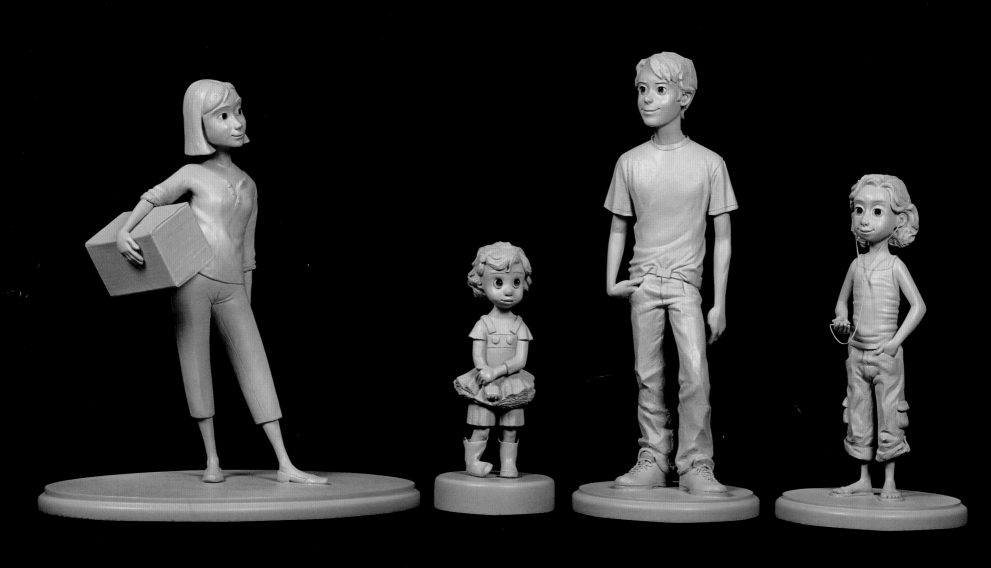

Andy's mom, Bonnie, Andy, and Molly, **Jerome Ranft**, Cast urethane, 2008

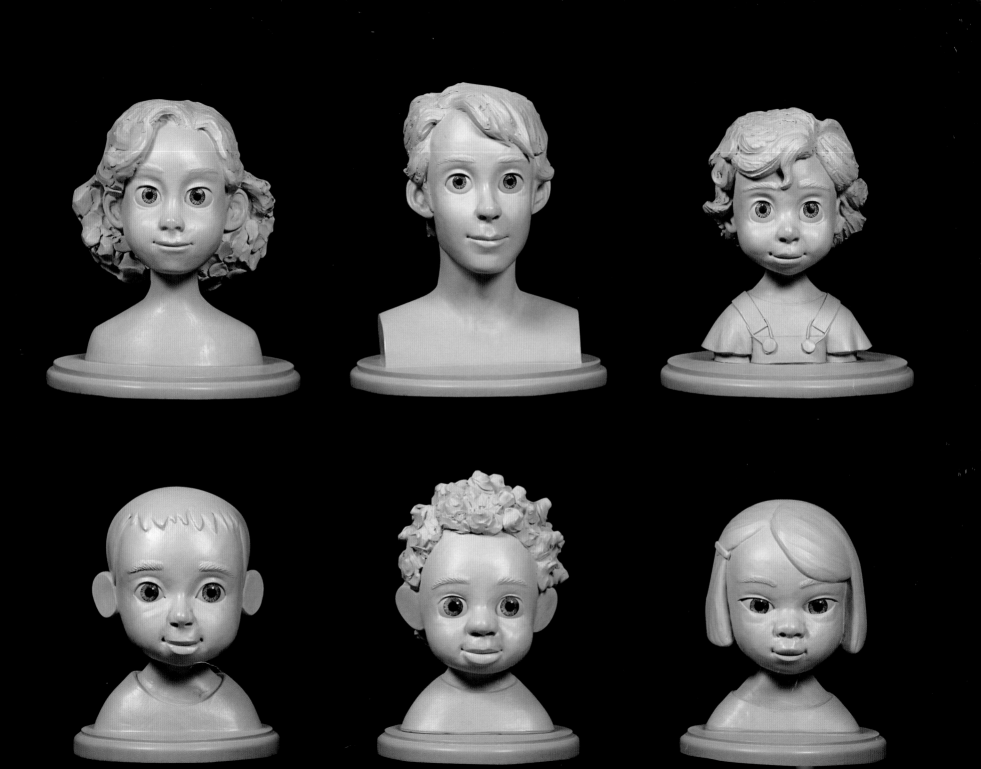

Design sketch over Lotso sculpt, **Daniel Arriaga** (sketch)
and **Jerome Ranft** (sculpt), Clay and digital, 2008

Big Baby, Trixie, and Twitch, **Jerome Ranft**, Cast urethane, 2008

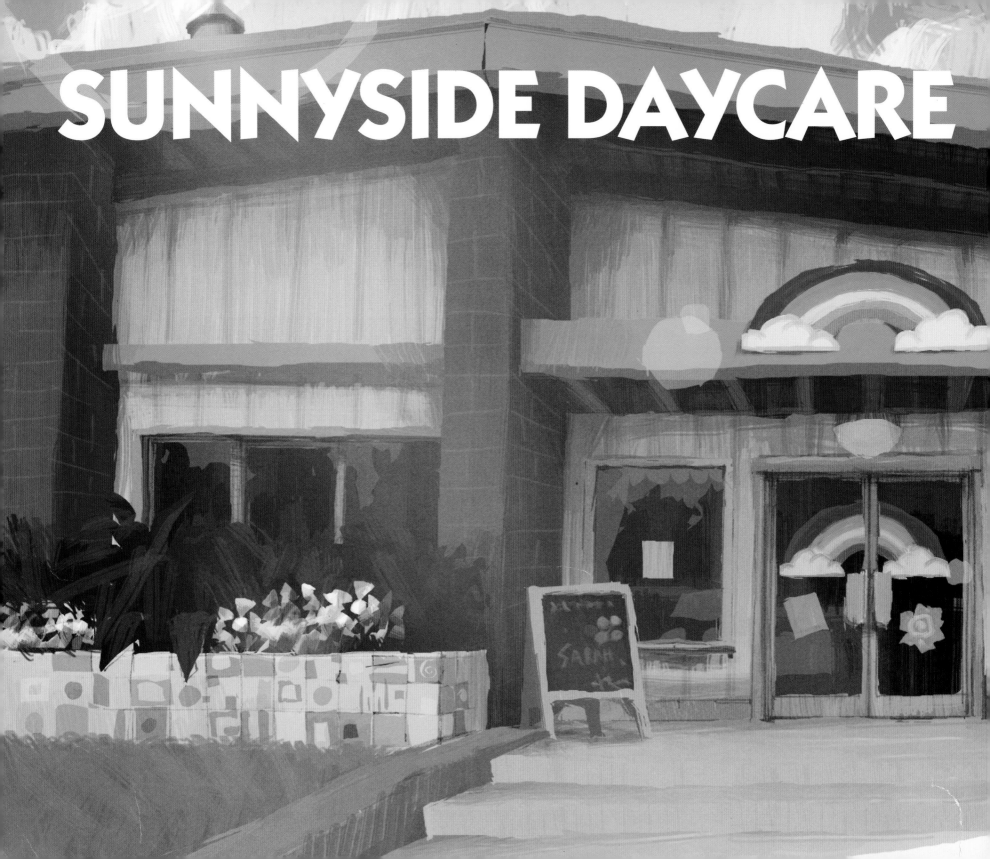

"You want Lotso to be instantly huggable, instantly lovable. Every moment he's on camera he should exude comfort and safety. Every scene he's in, you want him to steal."
—Jason Katz, head of story

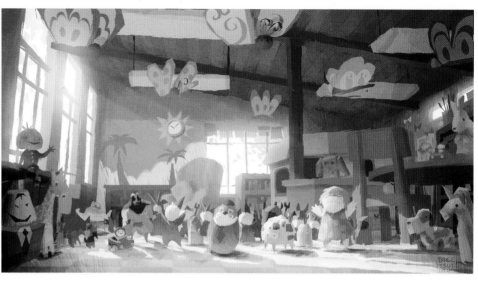

Above: **Robert Kondo** (layout), **Dice Tsutsumi** (paint), Digital, 2008
Previous spread: **Dice Tsutsumi**, Digital, 2008

For the scenes at Sunnyside Daycare, the Pixar artists had to create an environment that could appear safe and welcoming one minute, and threatening and oppressive the next. But, regardless of the mood, Sunnyside had to be a believable day care center. Before they designed Sunnyside, crews took field trips to facilities around the San Francisco Bay Area, studying buildings that had been turned into child-care centers.

"After you go to a couple of them, you start to see the rules—how the tables are organized, where the artwork's kept, the structure of the bins. There's a lot of consistency," says production designer Bob Pauley. "Being there is great, because you notice, 'Wow, that chair's tiny; those toilets are tiny.' We did a lot of research on how tall kids really are relative to adults, and what looks right on screen. After you get all the facts, you can then cheat it to make it feel right."

"A lot of us have children, so the day care scenes were pretty familiar," adds sets supervisor David Eisenmann. "They're like really overstuffed, messy offices. The organization is based on necessity and function: here's an area filled with blocks, there's a cabinet stuffed to the brim with artwork, but it's actually all organized."

After Andy's toys mistakenly conclude they've been thrown away, they decide to donate themselves to Sunnyside. There they meet Lots-o-Huggin' Bear

("Lotso"), who acts as the mayor of the day care. He shows them around and persuades the toys that Sunnyside will be the best place to spend their post-Andy years.

"For the day care to believably feel like a place the toys would choose over heading home to be with Woody, every scene has to feel like it's the safest, most welcoming place for them," explains Katz. "When they first arrive at Sunnyside, everybody's a little nervous, a little scared. Lotso's a calming presence who welcomes the toys with open arms. He's comforting and understanding—a perfect contrast to the kind of character we learn he really is."

Sunnyside is divided into two classrooms: the Butterfly Room, where the older children are, and the Caterpillar Room, which is the younger children's area. Buzz and the rest of the gang discover they've been consigned to the Caterpillar Room, which means they're the toy equivalent of cannon fodder. They're yanked, pounded, trampled, and mauled by hyper-energetic preschoolers while Lotso and his pals enjoy the comfort and creative play of the Butterfly Room.

"Dice Tsutsumi, lighting art director, gave the Butterfly Room the color scheme of a tropical island—it's a paradise," Pauley says. "The Caterpillar Room is a little more pastel and soft. The Caterpillar kids aren't mean, but they play rough. They've got chunky hands, and they throw things around. For a toy, it's like being in the middle of a battle zone."

When the toys try to escape from the Caterpillar Room, they learn that Sunnyside is more prison than playroom. Lotso calls the shots, and his decisions are enforced by a gang of large, tough toys that includes a stretchy rubber octopus, an insect-headed alien, a spark-spitting robot, and the outsized doll, Big Baby. (The idea for the latter enforcer came from the field trips, because every day care had piles of large, well-worn baby dolls.) Andy's toys are subjected to a lockdown that brings to mind old prison movies.

"We went to Alcatraz to get the sense of a prison—that was a great research trip!" Pauley continues. "In a lot of day cares, you see cubbies or a shelf with bins. We arranged them to evoke a prison. Dice desaturated the

colors and the lighting to support the transition to day care as prison. We put a lot of consideration into how the light can make things look really bright and fun by day but like a cell block at night, when the characters are at their lowest moments."

The events at Sunnyside demand very specific physical layouts. Buzz has to be able look up from the chaos of the Caterpillar Room and see the comfortable playtime that Lotso is enjoying in the Butterfly Room, which means the rooms need to have facing windows. The audience also has to follow an elaborately choreographed prison escape on the grounds of the day care.

"We knew that we were going to be filming all around certain sets, like the day care. If we build them completely, we have more freedom to shoot wherever we want," explains Robert Kondo, sets art director. "The day care, for the most part, is a working set. We

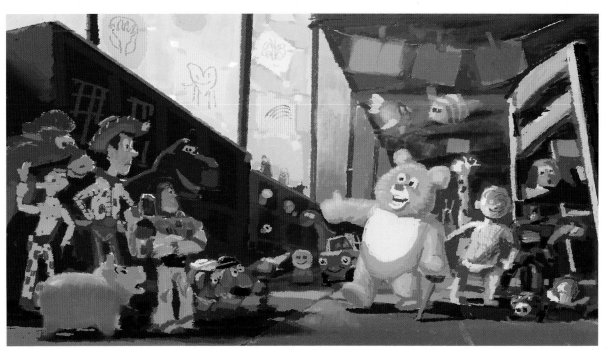

Bob Pauley (layout), **Robert Kondo** (paint), Digital, 2007

Storyboard, **Christian Roman**, Digital, 2008

have an actual floor plan and the rooms fit together. When you build a set that makes logistical sense, it's something you can feel. You can cheat here and there, but if you cheat too much, people sense it."

Lotso ranks among the most complicated characters Pixar has created. His cute appearance, pink color, and strawberry scent recall the product-based characters of the 1980s. Lotso was once the favorite toy of a little girl named Daisy, but after he was inadvertently left at a rest stop and subsequently replaced, something snapped inside him. He conceals his bitterness and malice behind a benevolent exterior that's so convincing that the revelation of his true nature is one of the film's most dramatic moments: it's like finding out that Mr. Rogers was really a mafia don.

"We have this cute, pink teddy bear, but he has an evil heart. On some level that might seem like an

obvious way to go," comments director Lee Unkrich. "But in our journey to discover Lotso's character, we enriched him to the point where he's no longer a cliché. He's not simply a cute character who's mean; he has much more richness and depth. I wanted him to be an amalgamation of all those insipid '80s product toys. We pulled elements from here and there and made him strawberry scented. I think the idea of a bad guy who's bright fuchsia pink and smells like strawberries is very funny."

"He's also enormous. Teddy bears can be quite big," adds Pauley. "We wanted Woody and Lotso to stand at eye level, but Woody's so thin that there's a nice contrast. Lotso steals the room when he comes in, but in a relaxed, grandfatherly way."

The original concept for Lotso came from the first version of *Toy Story*, when the plot was a Rip Van Winkle story starring Tinny, the mechanical musician from *Tin Toy*. After years of slumbering on a stockroom shelf, Tinny would awaken and discover that the little mom-and-pop store he'd fallen asleep in was now a big, corporate toy emporium. The huge store was a like a city, and the different aisles were like different neighborhoods.

"There was a gang of bad toys led by Lotso, bargain-bin toys that were defective or couldn't get sold for some reason and were bitter. They'd go out for nightly raids on other neighborhoods," Unkrich recalls. "Some of these ideas ended up in the Prospector storyline in *Toy Story 2*. But everyone thought the idea of a bitter teddy bear was funny, and he was named Lots-o-Huggin' Bear. He shortened his name to Lotso, because it sounded like a good tough-guy name. For *Toy Story 3*, we reinvented Lotso as a big, pink plush teddy bear."

The artists think of Lotso as an older man who commands a great deal of power but doesn't need to call attention to that fact. He speaks slowly and seems

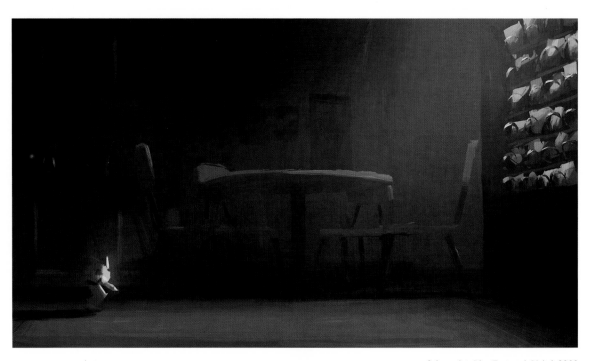

Color script, **Dice Tsutsumi**, Digital, 2008

to be listening to the other toys. For ideas about how to portray his restrained menace, the artists studied a number of live-action performances, including Burl Ives in *Cat on a Hot Tin Roof*, Orson Welles in *A Touch of Evil*, Andy Griffith in *A Face in the Crowd*, and John Huston in *Chinatown*.

"I constantly remind the animators not to go too big with him: his power comes from his self-control," Unkrich explains. "A character who's doing something not nice and is acting mean and cynical and evil is far less interesting than a character who's doing something not nice but doing it with a smile on his face. We play him over the top in terms of how warm and friendly and generous he appears, and we've injected him with a lot of Southern hospitality—kind of a New Orleans drawl."

"We had the wonderful premise of a day care being a prison, so we looked for archetypes," says Katz. "The

toughest guy in prison may be the person just quietly sitting back. He's the least physically threatening in the group. Instead, he has a bunch of tough guys fighting for him."

The Pixar artists carefully avoid showing Lotso's true nature as long as possible, teasing the audience's expectations and heightening the drama of the revelation. Buzz Lightyear discovers the seamy underbelly of Sunnyside when he follows Ken, one of Lotso's gang, into the interior of a vending machine. Inside is a hidden casino, where Lotso's henchmen gamble with Monopoly money. They catch Buzz and tie the space man to a chair. Buzz is initially relieved when Lotso comes in, certain that the kindly bear will make everything right—only to discover later that Lotso is the boss of the unsavory gang.

"From very early on, we had the idea of Buzz following Ken and discovering a secret meeting," says Unkrich.

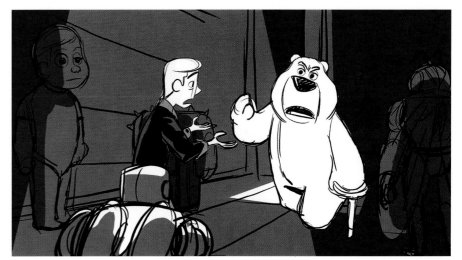

Robert Kondo, Digital, 2007

Storyboard, **James Robertson**, Digital, 2009

"Originally, it was the scene where the audience and Buzz discover Lotso is not the nice guy that he pretends to be. We took it out because it turned the tables too suddenly. It was much more interesting to milk Lotso as long as possible in terms of not quite knowing what's up with him.

"One of the fun things about the *Toy Story* world is that we can experience the human world from completely unattainable perspectives, because we're toys—we're small," Unkrich continues. "We talked for a long time about where we could stage the meeting, and I said, 'It needs to be someplace cool, like they climbed up inside a vending machine and they're in the top. But there's something cooler out there.' It had to be somewhere right in the day care. We tried a number of settings, but people finally convinced me we should use the vending machine idea, so that's where we staged it."

The design, rigging, and animation of Lotso also posed major challenges. He's the first real plush toy in the *Toy Story* world. All the other characters are toys with hard plastic, cloth, or metal exteriors that dictate their anatomy and style of movement. A plush teddy bear is essentially an oddly shaped pillow: it has no internal structure or anatomy for the animators to work with. In the previous *Toy Story* movies, plush toys were kept in the background as set dressing.

When he began working on Lotso, character designer Daniel Arriaga discovered how many decisions go into making a plush toy. "It's really amazing how much thought goes into one, from the way the seams are designed to where the tag is placed to where the eyes go in the head and where to put the patterns of the fur," he says.

"We had the Disney Store people make us some prototypes from our early designs. We wanted to see how this plush would be made if it were a real toy," he continues. "When the plush expert came in, he drew seam lines on the clay sculpt. It was interesting to see how those lines helped the construction, even though there's no skeleton. There are a lot of limitations we didn't know about. You can make anything from plush, but if you want to mass produce it, that's a different story—and Lotso is meant to be a mass-produced item."

Lotso sculpt showing plush seam lines, **Jerome Ranft**, Clay, 2008

Animators playing with their toys (*i.e.,* using prototype Lotso plushes to explore motion), Photographs, 2008

"It was great to have the stuffed prototype bear, because we could play with him as we were rigging him up," adds animator Dave DeVan. "Stuffed characters are really hard, because there's no skeleton or structure, yet everything has to be tied together. In rigging Lotso, we had to spread everything out: his arms affect his belly, and his legs affect his chest. Everything has to affect everything else, because he's all sewn together."

Lotso is not a new or well-cared-for bear. The audience gets the impression that he had been in service long before he got to Sunnyside and established himself there. Convincingly conveying the appearance of dirt and wear adds to the technical challenges.

"The thing we always fight is how perfect everything is in CG. We use dust and elements to break up lines and edges. But a little bit of dirt goes a long way," says Pauley. "In a flashback, we see Lotso as a new toy, stuffed and fresh. Later on he's lost a little of his stuffing, and he's a little weathered. In researching these things we found out that, as teddy bears wear, some of the stuffing wears thin and hangs differently."

Drawing on the knowledge gleaned during the field trips, sets shading lead Chris Bernardi explains, "At day care centers, the toys tend to be hand-me-downs. You get a great sense of how things wear from them because they're secondhand toys that have been played with heavily by a lot of children. It tells a different kind of story from a shading standpoint, of how things wear and how kids beat things up, versus how natural elements age them."

Creating a believable simulation of plush, especially worn plush, is largely the job of the lighting and shading crews. Kim White, director of photography, lighting, explains, "In Lotso's case, we're going in early while they're still finishing the shading and fur, putting lights on him and seeing if he responds to the lighting the way we expect. He's pink, so he's going to look different under different lighting conditions. Can we get the color inside the shadowed areas of his fur? We work back and forth with the shading department to get the look we want."

Shading art director Belinda Van Valkenburg adds, "We're working backwards, because Lotso's already old and worn and played with. He's faded from the sun, but where the plush connects to the fabric the color's more saturated. There's wear around the seams and around the nose—the pile's rubbed off and you can see the fabric."

She pauses and sighs, "Lotso's going to be in the rain, so his fur is going to get wet. But what does a wet teddy bear look like? I guess we're going to dump a toy in a pool and take pictures to see what it looks like."

During early screenings of *Toy Story 3*, the artists were surprised that audience members wanted Lotso to undergo a last-minute conversion and become a nice guy.

"A lot of people wanted him to be redeemed, but we didn't want that to happen. We went back into the story to figure out why people wanted him to redeem himself," Unkrich says. "In one scene, Chuckles the Clown tells the story of how he, Lotso, and Big Baby got left at a rest stop. They make a valiant journey to get back to Daisy's house, only to find that Lotso has

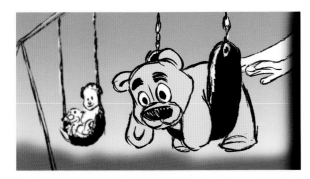

Storyboards, **Dan Scanlon**, Digital, 2007/2008

Dice Tsutsumi, Digital, 2007

been replaced with a new teddy bear. People were feeling too much sympathy for him, so we made some subtle changes. Only Lotso was replaced by his owner, but we had him lie to Big Baby, telling him, 'She's replaced all of us. She don't love you no more.' It's a terrible, selfish thing for him to do in that moment, and it overshadows any sympathy the audience might feel for him. It also lessens the audience's desire to see Lotso redeemed at the end. When that lie comes out

later in the film, it makes Big Baby turn on Lotso and throw him in the dumpster."

Unkrich feels that Lotso gets what he deserves at the end of the film, when he's strapped to the front grille of a garbage truck as a sort of ornament. (Using old stuffed toys to decorate truck grilles seems to be an East Coast practice, but Lotso's fate may cause it to spread across the United States.)

"When Lotso ends up tied to the truck, it's the perfect comeuppance," Unkrich concludes. "I never wanted to send him into the shredder, or the incinerator—that would be sadistic. But he definitely gets his just desserts on the front of that garbage truck."

"If you don't go through all the work we did to get those wrinkles and folds, when we go to animate him, Lotso won't feel like a plush toy. We can have him act soft and cuddly, but he won't physically feel soft and cuddly. He'll feel like a solid gumdrop or something."
—Bobby Podesta,
supervising animator

A group of Pixar artists visit day care centers in the San Francisco Bay Area. The artwork on the following pages shows how they used what they observed in many of the key moments in *Toy Story 3*.

Lee Unkrich, Bob Pauley, Belinda Van Valkenburg, Robert Kondo, Dice Tsutsumi, Photographs, 2009

The artists visit Alcatraz to gain an understanding of what makes a building feel like a prison, which later informed the grim after-hours setting at Sunnyside Daycare.

"If going to prison could be a good thing, that trip was. We got behind closed doors; they locked us in a dark cell for a little bit, which was kinda fun. We got to ask questions about the prisoners, the guards, the rapport. It was really helpful to go there to see what it looks and feels like firsthand. The motifs of the bars and the two rows of cell blocks facing each other were big influences on how we got that feeling into the cubbies in the day care."

—Bob Pauley, production designer

Lee Unkrich, **George Durgerian**, Photographs, 2009

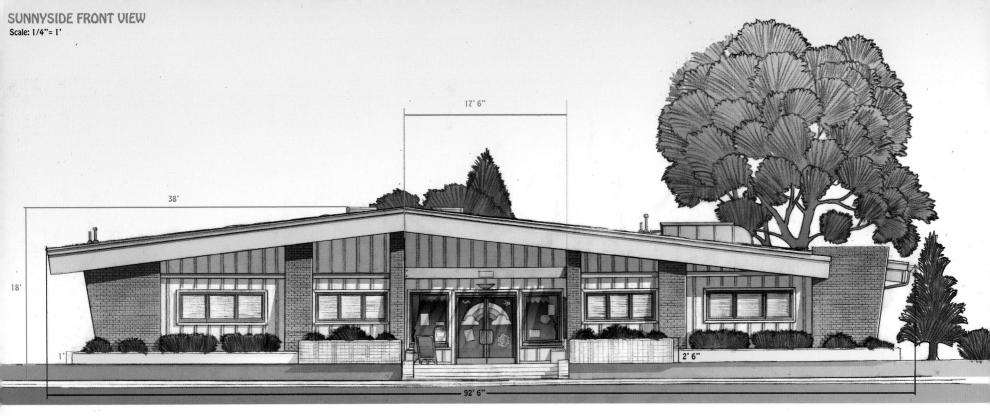

17' 6"

38'

18'

1'

2' 6"

92' 6"

Model packet, **Kristian Norelius**, Pencil/Digital, 2008

Model packet, **Kristian Norelius**, Pencil/Digital, 2008

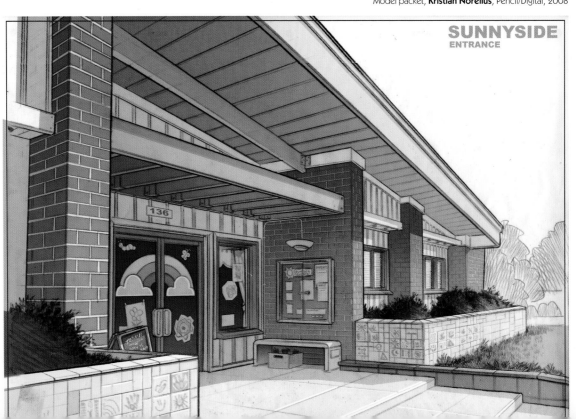

SUNNYSIDE
ENTRANCE

136

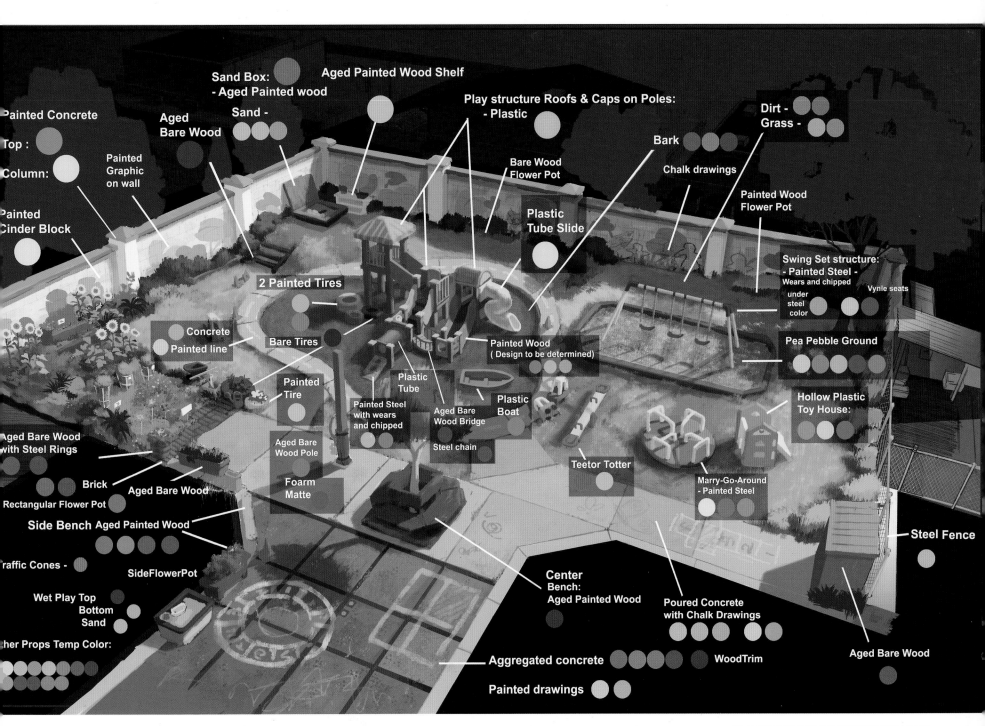

Painted Concrete

Top :

Column:

Painted
Cinder Block

Aged
Bare Wood

Painted
Graphic
on wall

Sand Box:
- Aged Painted wood

Sand -

Aged Painted Wood Shelf

Play structure Roofs & Caps on Poles:
- Plastic

Bare Wood
Flower Pot

Plastic
Tube Slide

Bark

Chalk drawings

Dirt -

Grass -

Painted Wood
Flower Pot

Swing Set structure:
- Painted Steel -
Wears and chipped
under
steel
color

Vynle seats

Pea Pebble Ground

2 Painted Tires

Concrete
Painted line

Bare Tires

Painted
Tire

Aged Bare
Wood Pole

Foarm
Matte

Painted Steel
with wears
and chipped

Plastic
Tube

Aged Bare
Wood Bridge

Painted Wood
(Design to be determined)

Plastic
Boat

Steel chain

Teetor Totter

Marry-Go-Around
- Painted Steel

Hollow Plastic
Toy House:

Aged Bare Wood
with Steel Rings

Brick

Rectangular Flower Pot

Aged Bare Wood

Side Bench Aged Painted Wood

Traffic Cones -

SideFlowerPot

Wet Play Top
Bottom
Sand

her Props Temp Color:

Center
Bench:
Aged Painted Wood

Poured Concrete
with Chalk Drawings

Steel Fence

Aged Bare Wood

Aggregated concrete

WoodTrim

Painted drawings

Daycare shader packet, **Jennifer Chang**, Digital, 2009

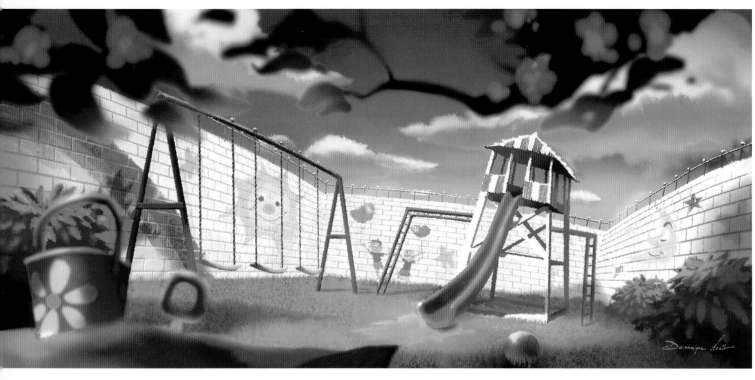

Dominique Louis, Digital, 2006

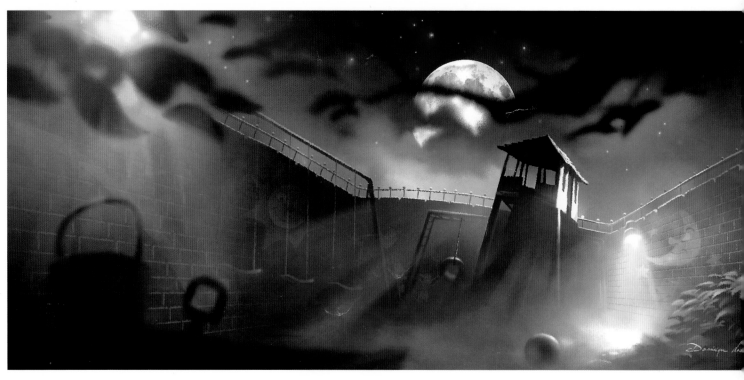

Dominique Louis, Digital, 2006

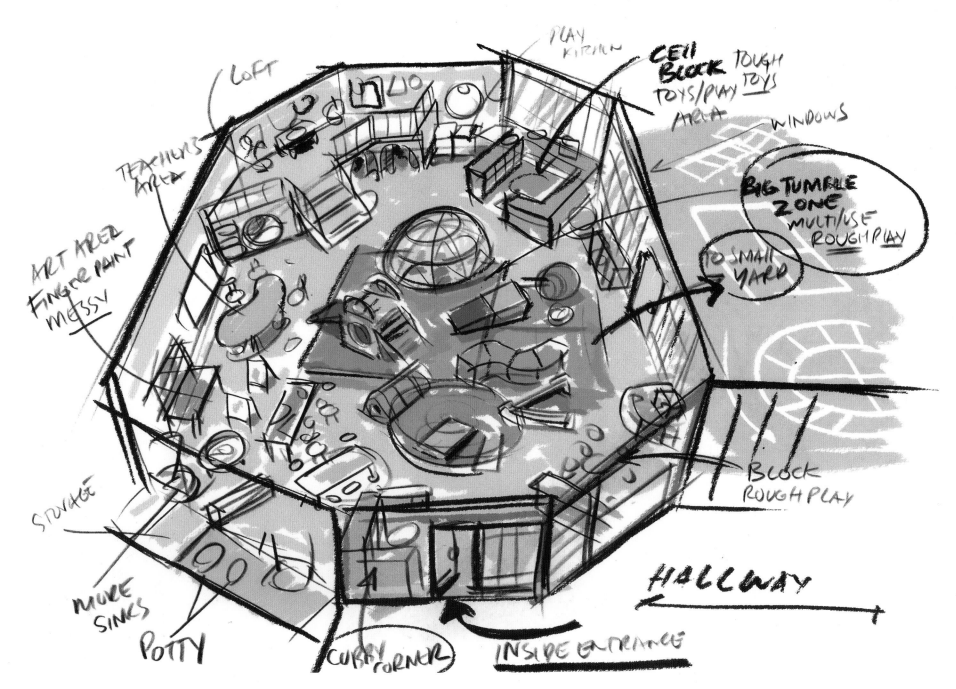

LOFT

PLAY KITCHEN

CELL BLOCK TOUGH TOYS/PLAY TOYS AREA

WINDOWS

TEACHERS AREA

BIG TUMBLE ZONE MULTI/USE ROUGH PLAY

ART AREA FINGRE PAINT MESSY

TO SMALL YARD

BLOCK ROUGH PLAY

STORAGE

HALLWAY

MORE SINKS

POTTY

CUBBY CORNER

INSIDE ENTRANCE

Daycare design sketch, **Bob Pauley**, Digital, 2007

Daycare Color Explorations

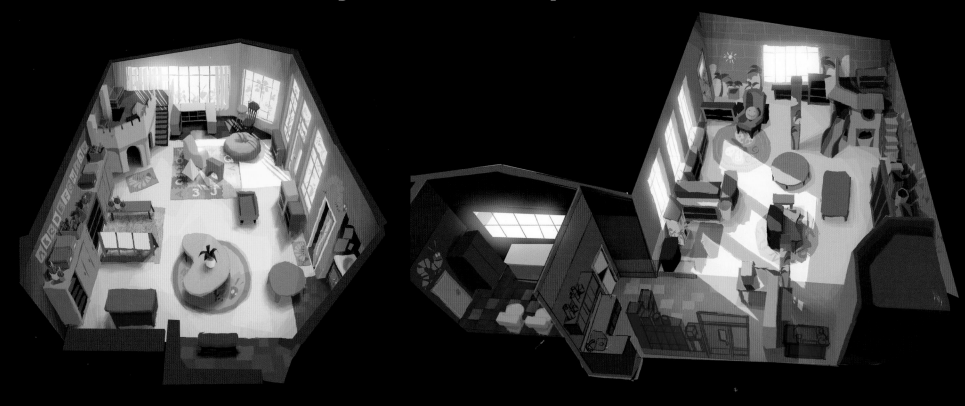

Daycare color concept, **Dice Tsutsumi**, Digital, 2008

Caterpillar Room environment, **Kristian Norelius**, Pencil/Digital, 2008

Cubbies design, **Jennifer Chang**, Pencil, 2007

Jennifer Chang (layout), **Dice Tsutsumi** (paint/digital), 2008

Caterpillar Room Ceiling Art

Caterpillar

Caterpillar diorama, **Jennifer Chang**, Digital, 2008

Caterpillar diorama, **Jennifer Chang**, Digital, 2008

Butterfly Room model packet, **Kristian Norelius**, Pencil/Digital, 2008

Dice Tsutsumi, Digital, 2008

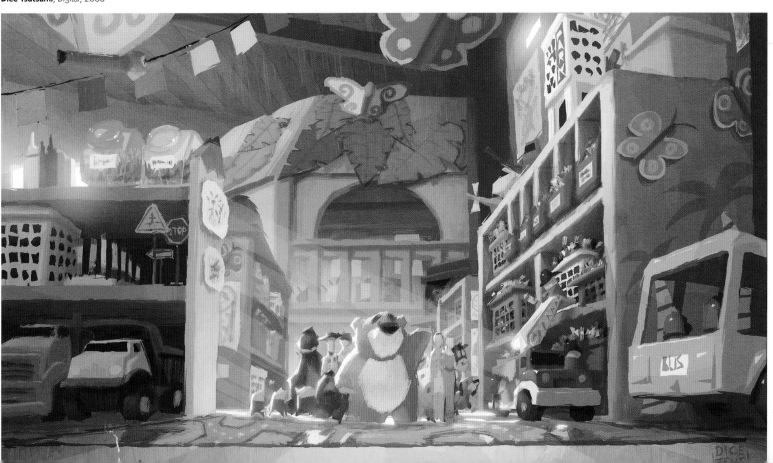

Sequence color key, **Dice Tsutsumi**, Digital, 2007

Sequence color key, **Dice Tsutsumi**, Digital, 2009

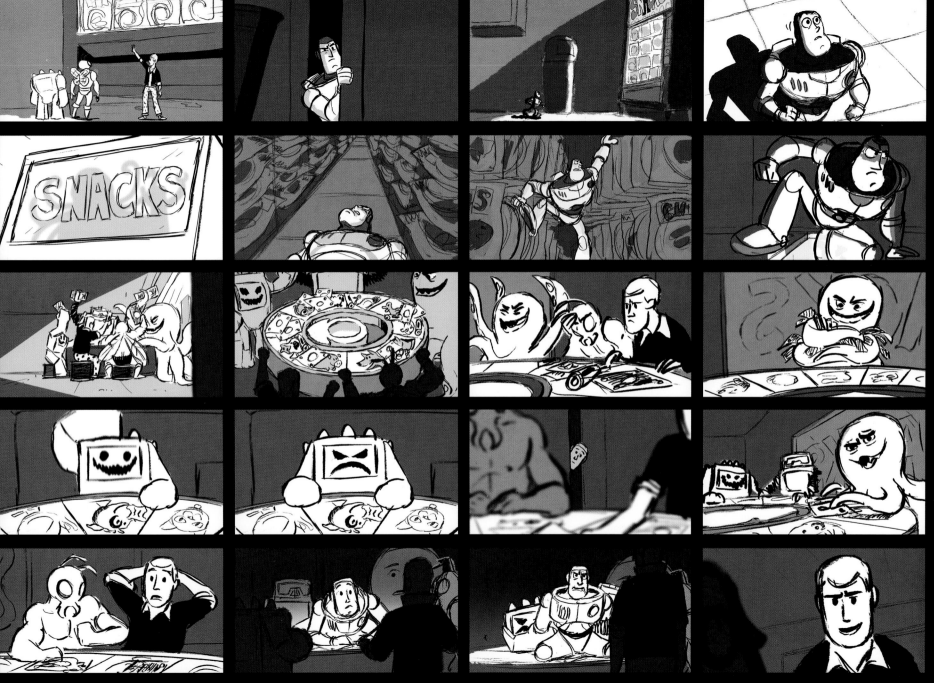

Storyboards, **John Sanford**, **Dan Scanlon**, Digital, 2007/2008

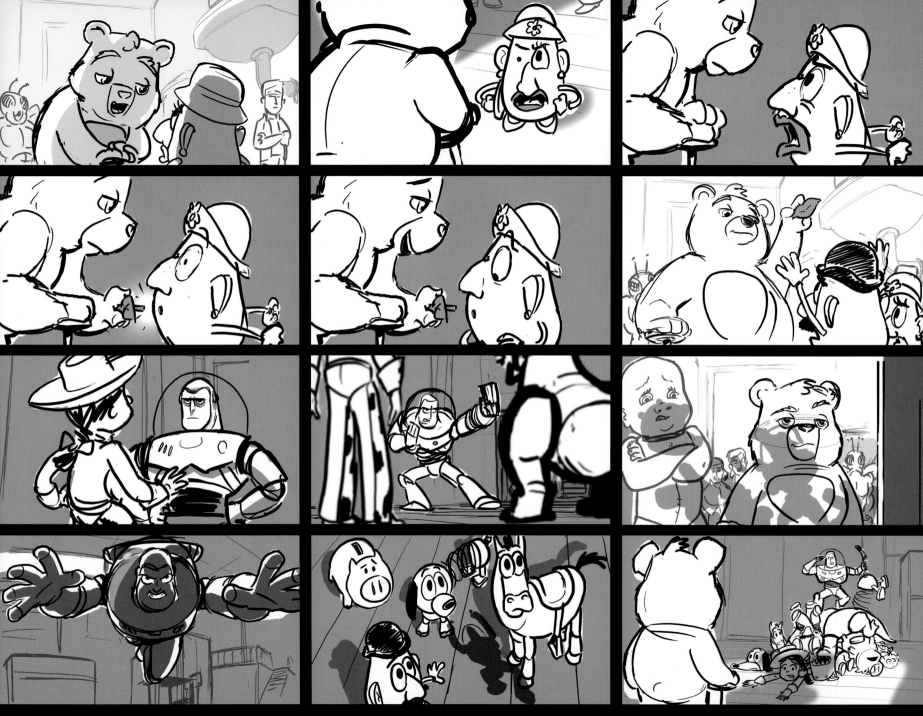

Robert Kondo, Digital, 2007

Robert Kondo, Digital, 2007

Sequence color key, **Dice Tsutsumi**, Digital, 2009

Robert Kondo, Digital, 2007

Matthew Luhn (layout), Dominique Louis (paint), Digital, 2006

Sequence color key, **Dice Tsutsumi**, Digital, 2007

Daycare Kids

Caterpillar Kids

Butterfly Kids

Caterpillar Kid

Character lineup,
Daniel Arriaga, Digital, 2008

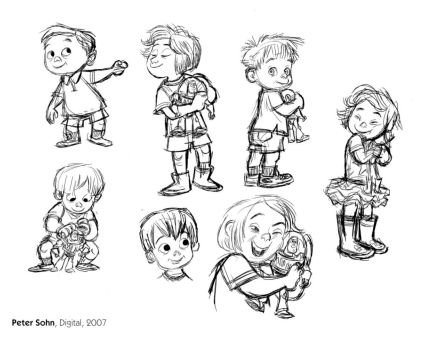

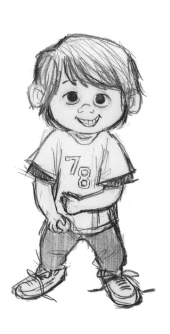

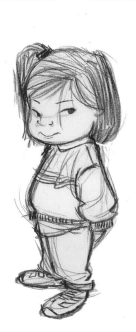

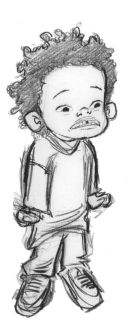

Peter Sohn, Digital, 2007

Daniel Arriaga, Pencil, 2008

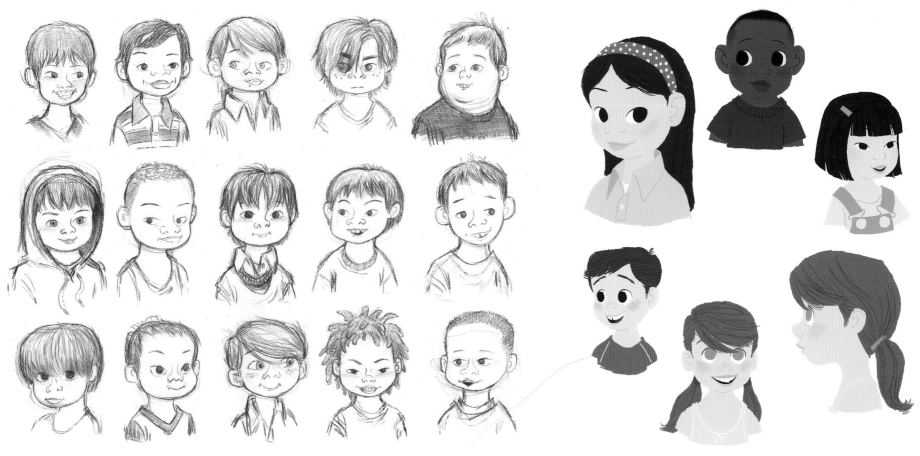

Daniel Arriaga, Pencil, 2008

Daniel Arriaga, Digital, 2008

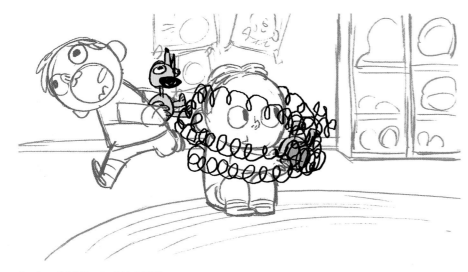

Storyboard, **Erik Benson**, Digital, 2008

Sequence color key, **Dice Tsutsumi**, Digital, 2009

Lotso

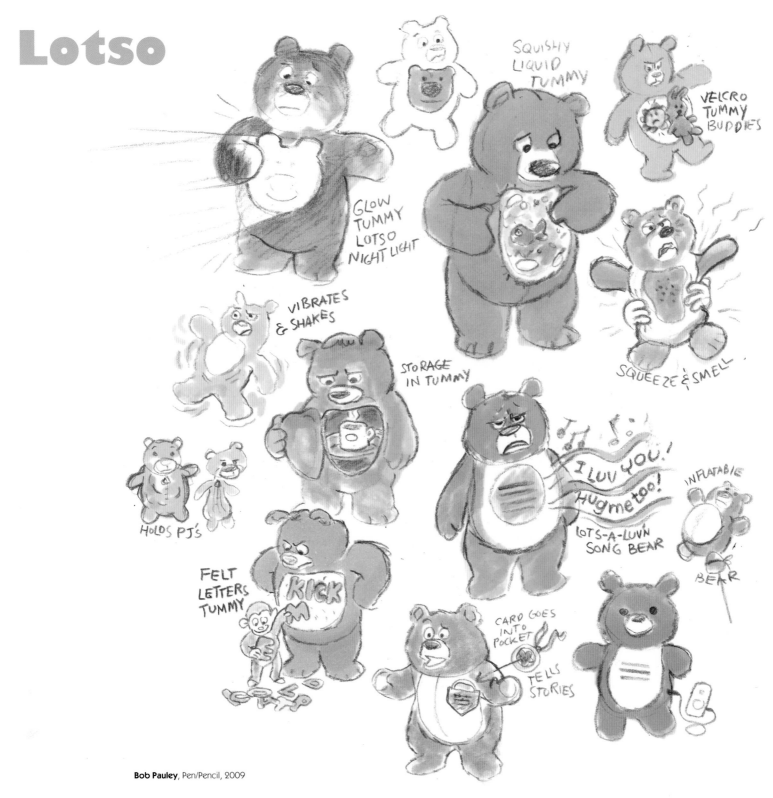

SQUISHY LIQUID TUMMY

VELCRO TUMMY BUDDIES

GLOW TUMMY LOTSO NIGHT LIGHT

VIBRATES & SHAKES

SQUEEZE & SMELL

STORAGE IN TUMMY

HOLDS PJ'S

FELT LETTERS TUMMY

KICK M

I LUV YOU! Hug me too! LOTS-A-LUV'N SONG BEAR

INFLATABLE BEAR

CARD GOES INTO POCKET TELLS STORIES

Bob Pauley, Pen/Pencil, 2009

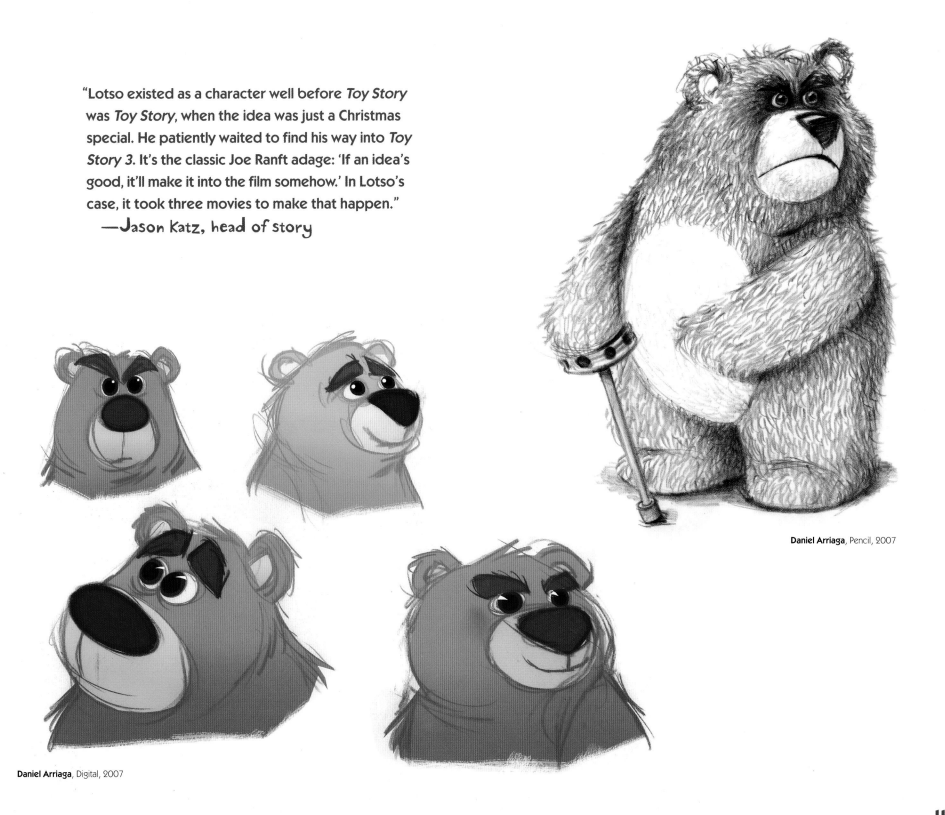

"Lotso existed as a character well before *Toy Story* was *Toy Story*, when the idea was just a Christmas special. He patiently waited to find his way into *Toy Story 3*. It's the classic Joe Ranft adage: 'If an idea's good, it'll make it into the film somehow.' In Lotso's case, it took three movies to make that happen."

—Jason Katz, head of story

Daniel Arriaga, Pencil, 2007

Daniel Arriaga, Digital, 2007

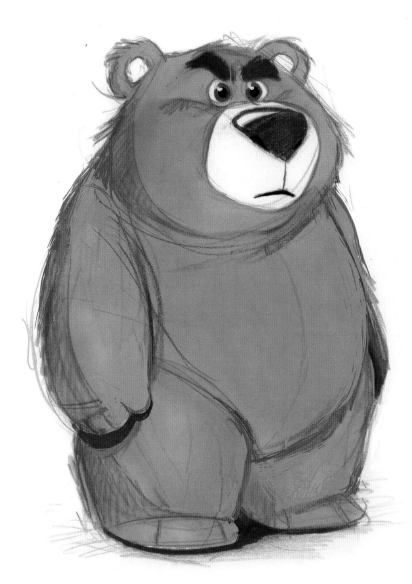

Daniel Arriaga, Pencil/Digital, 2007

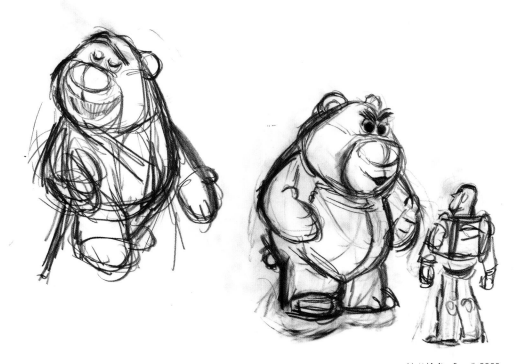

Matt Nolte, Pencil, 2008

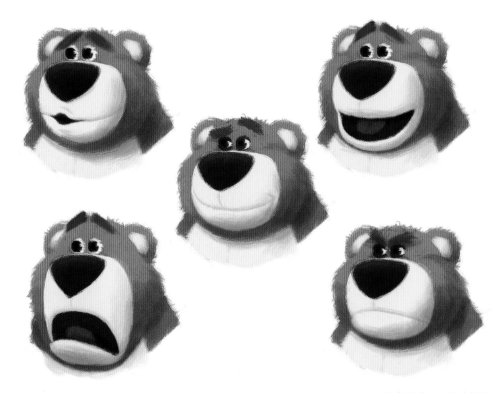

Daniel Arriaga, Digital, 2008

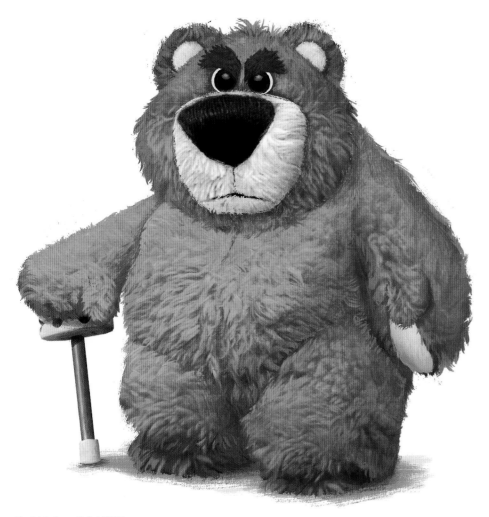

Daniel Arriaga, Digital, 2007

"He's round, he smells of strawberries. We love taking conventions and flipping them on their head. We've always believed there are different ways to bring toys alive. The green army men, you make them be exactly the way you always envisioned them; with Rex, you take the most fearsome creature ever to walk the Earth and play him as the opposite."

—John Lasseter, executive producer

James Robertson, Digital, 2008

James Robertson, Digital, 2008

Lotso's Gang

Chunk, **Daniel Arriaga**, Digital, 2008

Twitch, **Daniel Arriaga**, Digital, 2008

"When I was asked to design a bunch of toys, all I could remember was playing with these cool '80s boy toys. Sparks came from a robot I had—the same proportions and simplistic designs that I kept referring to subconsciously when I was drawing it. I didn't realize it until later, when I took a step back and it hit me—'Whoa! This toy reminds me of my childhood.'"

—Daniel Arriaga, character designer

Sparks, **Daniel Arriaga**, Digital, 2008

Bookworm, **Nate Wragg**, Pen, 2008

Stretch, **Nate Wragg**, Digital, 2008

Big Baby, **Dice Tsutsumi**, Digital, 2007

"I kind of modeled Lotso's former owner Daisy after a niece who, when she was very little, had a baby doll named Peggy. That doll meant the world to her. Peggy got left at a Burger King one day, but when they went back to get her, she was gone. My niece got a new doll, but it was still named Peggy. I remember thinking, 'What would the old Peggy feel like if she came back and discovered there was a new Peggy?'"

—Lee Unkrich, director

Ken & Barbie

Dice Tsutsumi, Digital, 2008

Sarah Mercey-Boose, Pencil, 2007

Storyboard, Chris Roman, Digital, 2007

27" inch

41" inch

15" inch

11.5"

15"

Jennifer Chang, Pencil/Digital, 2007

Model packet, **Kristian Norelius**, Pencil/Digital, 2008

Color script, **Dice Tsutsumi**, Digital, 2008

Model packet, **Kristian Norelius**, Pencil/Digital, 2008

Color key, **Jennifer Chang**, Digital, 2007

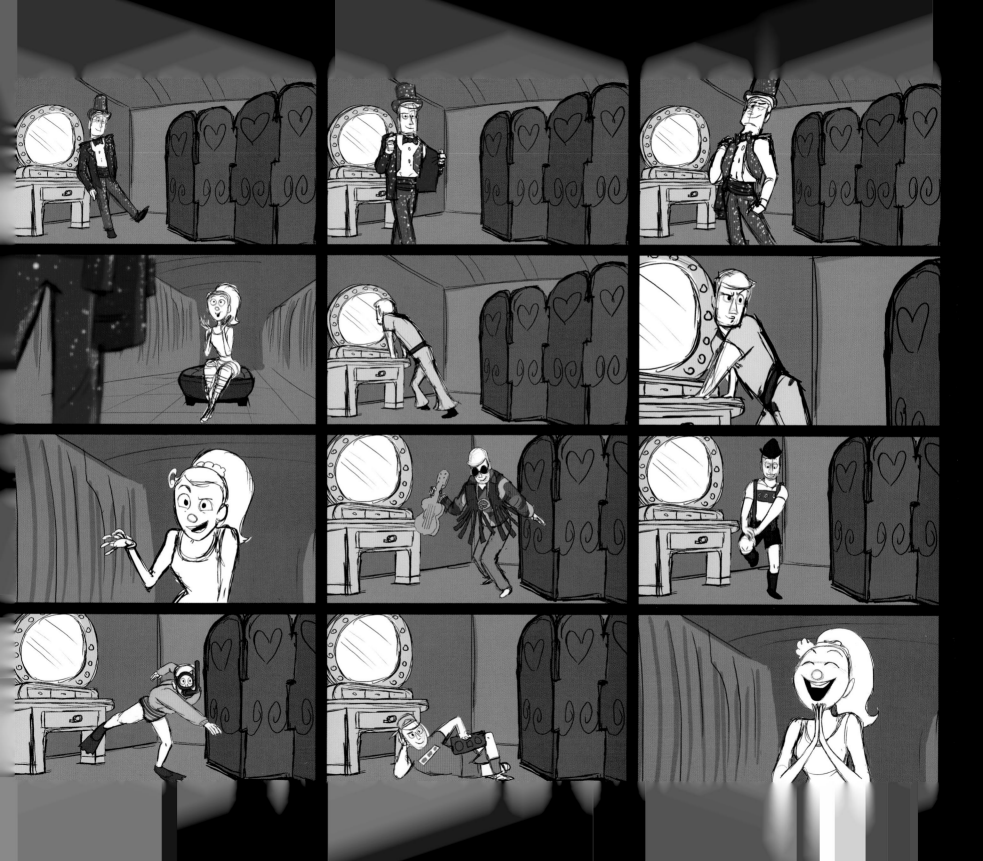

Daycare Toys

MUSIC

SOME SIMPLE PLUSH

LEARNING STACKING

PUPPETS

WOODEN

Pull Toys
SIMPLE
WOOD/PLASTIC

LITTLE PEOPLE
+ OUR BRAND

ROLLING
PULL TOYS

SIMPLE
ANIMALS

PHONE
FISHER PRICE
SECONDARY

TOPS

Bob Pauley, Pencil/Digital, 2008

ESCAPE RABBIT
OVERALL SHAPES

RABBIT DOESN'T
STAND UPRIGHT
BUT SITS ON ALL
FOURS.

Daniela Strijleva, Pencil, 2009

Marceline Gagnon-Tanguay, Pencil, 2008

Nate Wragg, Digital, 2008

Jennifer Chang, Pencil, 2008

sunflower girl

Marceline Gagnon-Tanguay, Pencil/Digital, 2008

octopus

Jennifer Chang, Digital, 2008

Jennifer Chang, Digital, 2008

Jennifer Chang, Pencil/Digital, 2008

SAME BODY

Daniela Strijleva, Pencil, 2008

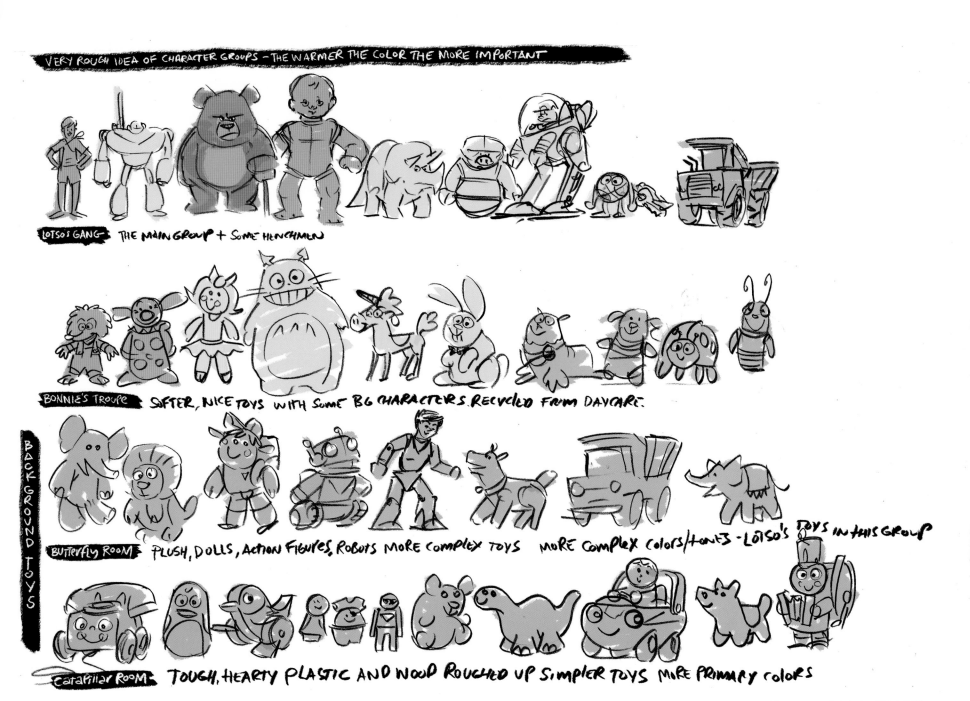

VERY ROUGH IDEA OF CHARACTER GROUPS — THE WARMER THE COLOR THE MORE IMPORTANT

LOTSO'S GANG THE MAIN GROUP + SOME HENCHMEN

BONNIE'S TROUPE SOFTER, NICE TOYS WITH SOME BG CHARACTERS RECYCLED FROM DAYCARE.

BACKGROUND TOYS

BUTTERFLY ROOM PLUSH, DOLLS, ACTION FIGURES, ROBOTS MORE COMPLEX TOYS MORE COMPLEX COLORS/TONES - LOTSO'S TOYS IN THIS GROUP

CATERPILLAR ROOM TOUGH, HEARTY PLASTIC AND WOOD ROUGHED UP SIMPLER TOYS MORE PRIMARY COLORS

Character map, **Bob Pauley**, Digital, 2008

THE COLOR SCRIPT

"My job is to set up a conceptual guideline for what the film will look like cinematically. The color script sets the tone of the film: how color and atmosphere and lighting will carry the story and the characters throughout the film. Once lighting starts, I do sequence-specific lighting studies, or color keys. Ralph Eggleston and Bill Cone did their color keys in pastels. These days, we all do it digitally."

—Dice Tsutsumi, lighting art director

Like the storyboard, the color script is a way of planning an animated film to avoid wasting time, effort, and talent. Devised at the Disney Studio around 1933, the storyboard was a way to bring order and structure to the chaotic cartoons of the era. Drawings and captions pinned to sheets of corkboard can be easily changed, allowing the director to establish the pacing, visuals, and narrative of a film before the animators go to work.

Similarly, the color script gives the director a way of establishing the emotional and visual beats of the film early in the process. Having an overview of the movie enables the filmmakers to avoid repeating ideas or missing key points.

"It's very much a storyboard for color," says Dice Tsutsumi. "The color script is an evolving thing that changes during the production of the film. If the story is not locked, the color script will change—it's story driven. One of the greatest things about *Toy Story 3* is that the story hasn't changed too much from the very beginning. It has been improved and finessed, but the structure of the story has been pretty much the same since I started on this project. That's made it easy, since I needed to help plan the visual language of the movie at such an early stage. I work very, very closely with our director of photography, Kim White. I use broad strokes to set up how color can support the story Lee is trying to tell in this movie.

"Looking at the color script allows us to catch problems early on—for example, a too-long strip of darkness. We don't want to create something that's too far from the *Toy Story* world, nor do we want to make a family movie too dark for too long," he continues. "Even within the night scenes, we vary the color palette and lighting motifs, just to make sure it doesn't go dark all the way. We want to have a nice rhythm throughout the film."

Tsutsumi speaks of the work Ralph Eggleston, Jim Pearson, and Bill Cone did for the earlier *Toy Story* films in respectful, almost awed tones—the same way Eggleston, Pearson, and Cone talk about his paintings. Tsutsumi is a relative newcomer to Pixar, having worked at the Blue Sky Studio for much of his career. At the School of Visual Arts in New York, he studied painting, rather than film, and he looks to John Singer Sargent, Anders Zorn, and Nicolai Fechin for inspiration.

"In the film industry, Ralph Eggleston and Bill Cone are two of my favorite production designers," he adds. "When it comes to color scripting, I've always looked up to what Ralph did on *Toy Story* and Bill did on *Toy Story 2*. It was my dream to take this job—to come to Pixar and follow up on the magnificent job they've done."

When Tsutsumi came to the Pixar studio, he sought out Eggleston, Cone, and Sharon Callahan, who had been in charge of lighting on the first *Toy Story* films. He spent hours talking with them about the earlier features, and he spent the most time with Eggleston, discussing color scripting.

"I talked to Ralph and Bill quite a bit about what their thinking process was, art directing *Toy Story* and *Toy Story 2*. I also talked to Sharon about lighting the *Toy Story* movies," says Tsutsumi. "Everybody was so generous with their time and knowledge and wisdom—and were eager to hear how I approached the

films I'd worked on in the past. I was expecting it to be a lot harder to join a team that's already established. They don't really need outside blood, but they embraced me as a member of the family, and I'm very impressed and grateful.

"One of the things Ralph said was to pick ten or fifteen key moments and see if you can describe the color flow of the movie with just those images," he recalls. "It's almost like key animation: You do the key drawings, and then you fill the in-betweens to make it flow better. But if the key animation isn't right, the in-betweens won't save it. As I worked on this color script, I did short versions, showed them to Lee, and got notes. Each time, I gave him more in-between images to fill in the entire movie, but I hit those key moments first.

"It's a big, big job," Tsutsumi continues. "The color script can't be just a series of images. It has to make sense as a whole—that's the challenge of it. The color script is not the place to show off your painting skills; you can do that with concept art. The color script has to make sense as one big painting. It's one painting of a whole movie."

As an example of the way the color script mirrors the emotional beats of *Toy Story 3*, Tsutsumi points to the scenes leading up to and following the climactic sequence where the toys are being threatened with destruction in the incinerator. "We're going to use red to indicate the extreme danger: it's the climax of the movie, so the whole film builds toward that moment," he says. "There are hints of red throughout the movie when there's danger, but if you look at the color script, that's the one spot where there's supersaturated red with intense contrasts of values and colors. We complement that climax in the following sequence with the opposite color—a calm, bright blue, which represents the wallpaper in Andy's room."

The color script also provides the artists with a concise visual reference as they prepare to stage, light, and design each shot. Kim White, director of photography, lighting, explains, "We look very carefully at Dice's color keys, and he and I talk a lot before we start lighting the set, so we're on the same page. We also talk with Lee to make sure we're matching what he's trying to do with the story. After that, we'll take Dice's color keys back to the team and do the master lighting on the set. If we're trying to hit an emotional moment in a particular shot, we may ask Dice to make us another color key, to make sure we hit the moment exactly as planned."

"It's not like I have all the answers, but when you have a 'big picture' structure like a color script, it helps," Tsutsumi adds. "You don't want everything in over-the-top beautiful color, because then you have nowhere to go. You won't be able to control the audience's feelings. There's always contrast in the structure of the story, and we follow that with color and lighting."

"For *Toy Story 3*, I want the lighting to be as sophisticated and as beautiful as what we've done on the other films, but it's also very, very important that it feel like a *Toy Story* movie," says director Lee Unkrich. "We sat down with Sharon, who lit the first two films, and talked about what *Toy Story* means from the standpoint of color and lighting. We went back to John's inspirational drawings and the color work Ralph Eggleston did on the first film. We use that to limit our palette and inform the kind of lighting we're doing for this film."

One of the greatest challenges the *Toy Story 3* artists faced were the conflicting demands of preserving the look of the first two films while employing sophisticated new technology and software that offer the chance to create more realistic, nuanced imagery. Every department at Pixar had to cope with this conflict, and Tsutsumi strove to achieve an aesthetic balance.

"*Toy Story* and *Toy Story 2* had certain styles, some of which they did intentionally, some of which came out of the limitations of the technology," he says. "How do we create a world that still feels like the first two *Toy Stories*, yet uses the advanced technology? The conclusion we came to is to try to make the movie John would have made if he had had this technology."

"When Dice showed me his first broad strokes for the color script of *Toy Story 3*, it was very exciting, because it was clear he really got what I was going for in the movie. It was also exciting to see him apply a rigorous visual structure to the film in terms of color and mood and tone: It helped us refine the story. Dice does things for very specific reasons: it's never arbitrary."
—Lee Unkrich, director

COLOR SCRIPT

Dice Tsutsumi, Digital, 2009

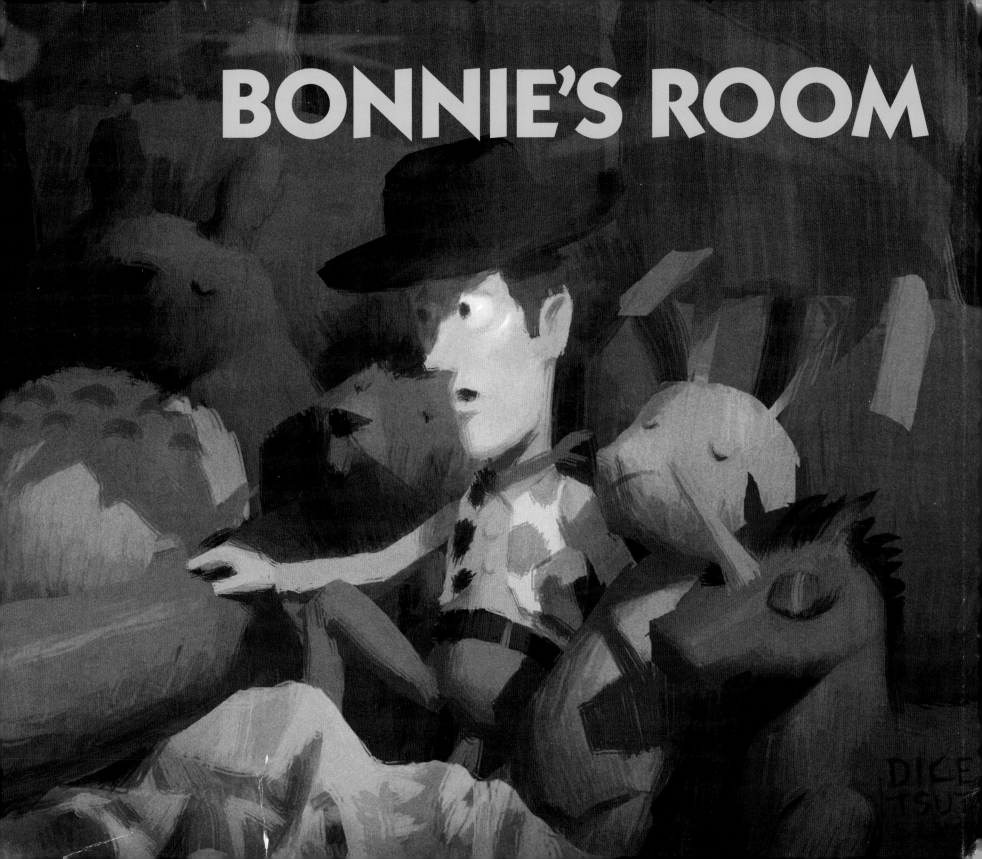

> "I wanted Bonnie's charm to come from her behaving like a real little girl. A lot of us have little kids, and we all know the kinds of innocent things they do that are intoxicatingly cute. Conversely, we've all seen movies that have children who don't act like real children. They act cute for cute's sake, which can be cloying and off-putting. We didn't want to go there."
> —Lee Unkrich, director

Above: Sarah, the inspiration and touchstone for Bonnie's design, **Lee Unkrich**, 2008
Previous spread: **Dice Tsutsumi**, Digital, 2007

Creating the character of Bonnie and her world posed singular challenges for the Pixar artists. Bonnie has to be instantly likable—engaging and funny without seeming overly cute or saccharine. The audience has to believe she would be a worthy playmate for Woody, Buzz, Rex, and the other new friends she eventually receives. Her room, like Andy's room, is a place of safety and imagination, where toys are played with enthusiastically, but cherished and respected.

The audience first meets Bonnie when the toys arrive at Sunnyside Daycare. Later, she finds Woody hanging from a tree after he's escaped from the day care on a kite. When Bonnie gets back to her room, she cheerfully introduces the cowboy to her other toys and includes him in her imaginative playtime. After years of sitting idle in Andy's room, Woody once again savors the joy of being played with, which he knows is the reason for his existence.

"Bonnie playing for the first time was a challenging sequence: you want the audience to connect with her and like her. But you don't want to telegraph the ending, so you don't want things to seem too perfect," says head of story Jason Katz. "Woody, who's thirsty for play, gets a little bit of what he's been longing for, though ultimately the trip to Bonnie's is a momentary diversion in Woody's journey home. But because we set up Bonnie's toys and their world in an appealing and funny way, in the end it feels right for Andy's toys to be left there."

To give Bonnie a personality that was appealing and uniquely her own, the crew drew on personal experiences. Story artist Erik Benson says, "Bonnie came into focus when I thought of her as my little sister, who's seven or eight years younger than I am. She was very quiet and subdued in public, but when she got home, she would let it all out. She would sing and dance and yell and play through the entire house. When Bonnie goes into her room, her imagination just explodes. She lets out everything that comes into her head, because she wasn't able to do it outside."

"My son is about Bonnie's age, so I watch him quite a bit and get inspiration from how he walks or makes little gestures," adds animator Rob Russ. "Kids often do complex things with their hands for no reason. There's some story going on in their heads, and their hands are active; even if they're just standing there, their hands are busy."

Russ discovered that, when he tried to match test animation to reference photos of a specific little girl, the results proved unsatisfactory. "We realized that the closer I matched the photos, the less appealing she got," he recalls. "It was a good exercise to show, yeah, we can hit the expressions that Lee finds appealing in a real girl, and then we can break away from them and do something that looks like a good, appealing animated character."

Bonnie is as endearing in her own way as Andy was in *Toy Story* and *Toy Story 2*. Similarly, her room exudes the same kind of warmth as Andy's does, while also reflecting her personality. It's the private realm of an active little girl with a fertile imagination, but the artists didn't want to make everything pink or stereotypically girlish. She's a girl who does a lot with a little—many of her toys are homemade, and her room reflects a creative, nurturing home life.

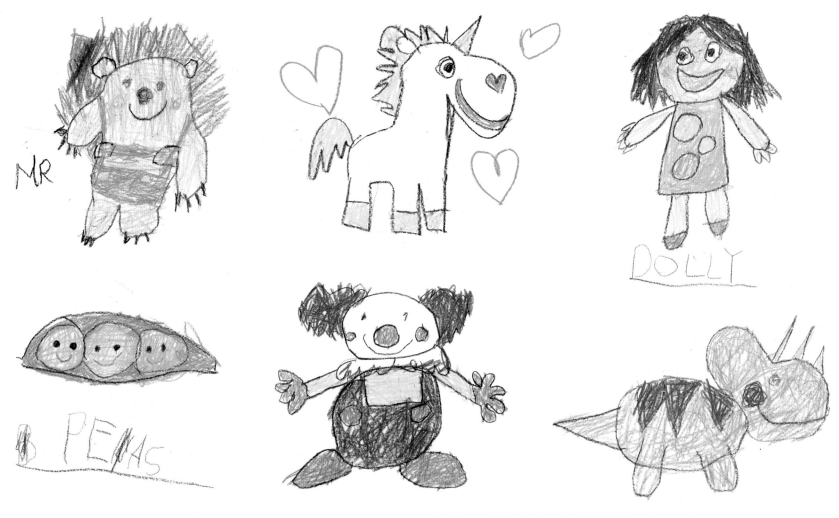

Bonnie's toys drawings by director Lee Unkrich's children, **Hannah, Alice, and Max Unkrich**, Crayon, 2009

"In *Toy Story*, Pizza Planet, the gas station, and Andy's house all had a consistent design language; so did the airport in *Toy Story 2*," says production designer Bob Pauley. "When we got to Bonnie's house, we looked to those same design shapes. Bonnie's room is a special place, because it's a new setting, so we're able to give it a little more love and push it in a way that fits into the *Toy Story* world."

In Bonnie's room, Dice Tsutsumi introduces the dappled lighting that becomes a visual motif linked to the character. It suggests that she's safe and protected, in a special, secret place of her own devising. In the real world, that kind of light might not filter through those windows, but that's not a concern.

"When a kid is playing with toys, it becomes the real world. And from the toys' standpoint, it's what they're all about," says Tsutsumi. "They're having the best time. We want to make sure that comes across visually."

Sets art director Robert Kondo stresses that Bonnie's room was designed to give the audience insight into her personality. "Bonnie has relatively little screen time, so her room is where we reveal her character," he says. "We designed a set, but it tells a story about Bonnie, her parents, and her relationship with them. The story's dialed into all the props. We chose what felt right for Bonnie.

"It's easy to focus on the world we've created in our sets," Kondo continues. "But if we do what we're supposed to, no one will notice the specific details. They'll feel it. It's great when the audience watches

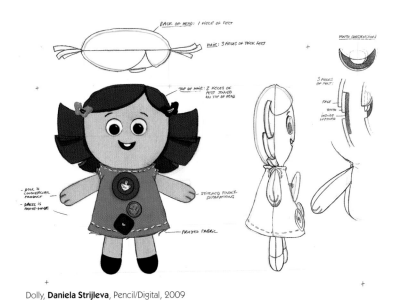

Dolly, **Daniela Strijleva**, Pencil/Digital, 2009

Mr. Pricklepants, **Daniel Arriaga**, Pen, 2008

the characters, and the world is just a believable place with the story built into every aspect."

In Bonnie's room, Woody meets a colorful group of toys that includes three green felt peas in a pod, a rag doll named Dolly, a blue and purple plastic Triceratops named Trixie, a unicorn named Buttercup, and Mr. Pricklepants, a lederhosen-wearing hedgehog. In a tribute to the great Japanese director Hayao Miyazaki, the title character from *My Neighbor, Totoro* has a cameo.

"It was a balancing act with Bonnie's toys, because we wanted the characters to be appealing and relatable to the audience, but we didn't have a lot of screen time to do it in," Unkrich explains. "The visit to Bonnie's house is really kind of a speed bump in Woody's journey back home, and we didn't want to tip our hand and reveal that we were going to return to these characters at the end of the movie. We took a lot of passes at them, and in some cases the voices helped define the characters. I knew pretty early on that I wanted Jeff Garlin to play Buttercup, the unicorn. Once Jeff started recording the lines, we began to see what we could do with the character. The ultimate goal is to

make the audience feel, when Andy's toys are left with Bonnie at the end of the movie, that they're becoming a part of a healthy, entertaining, interesting family."

Like the gang in Andy's room, Bonnie's toys had to have clearly delineated personalities and relationships. After working with them for two features, the artists know how the *Toy Story* regulars will deal with any situation and how they'll play off each other. With the new characters, the artists were starting from scratch.

"It's harder to deal with characters you don't know," says story artist Christian Roman. "With the rich history of the first and second *Toy Story* films, you know who the characters are; you can tell how they'll react in any situation. With Bonnie's toys, we weren't really sure where to go. But through the process of boarding and reboarding and re-reboarding, you start to hone in on the characters."

Story artist Adrian Molina agrees. "Buzz and Woody are an awesome team, because they play off of each other—they're opposites. We wanted that same dynamic with Bonnie's toys. We wanted the new characters to be as well-rounded and entertaining."

"The movie has new characters, both the toys that Bonnie is going to play with and the toys at the day care," continues Jeff Pidgeon, story artist. "Since I love toys so much, it was great to be able to suggest, 'Well, what about this? What about this?' Matt Luhn came up with some really great ones, a lot of Bonnie's toys."

Luhn is particularly fond of Mr. Pricklepants, the Hedgehog who's convinced he's a brilliant actor. ("Are you classically trained?" he asks Woody.) The character is based on a toy he got on a trip to Europe with his father, who owned a toy store.

"We had fun figuring out who Bonnie's toys would be—the unicorn, the hedgehog, and all the rest," Luhn says. "I took personal experiences and characters I liked that I'd seen in other movies, and then I drew up a bunch of gags for every possible scenario I could think of about a hedgehog who thinks he's a Shakespearean actor, or peas in a peapod."

"Mr. Pricklepants is a great character, because he's so specific," adds Pidgeon. "He's like a Steiff plush. But he feels so idiosyncratic, this hedgehog wearing Tyrolean clothes. It's just so entertaining in and of itself."

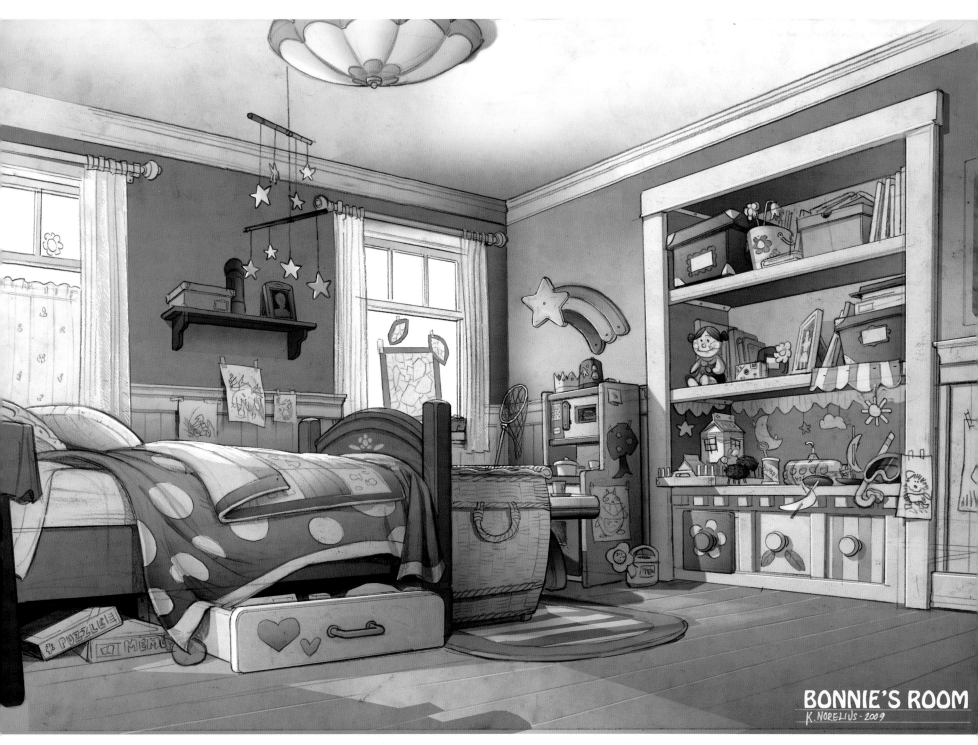

BONNIE'S ROOM
K. NORELIUS - 2009

Model packet, **Kristian Norelius**, Pencil/Digital, 2009

Bonnie

Peter Sohn, Digital, 2007

"For Bonnie, it was very important to Lee that she be a believable young child—even younger than Andy was in the first film. We've done a lot of work on the designs for all the little kids in the film, but especially Bonnie, to make them really appealing and really cute."
—Rob Russ, animator

Tom Gately, Pencil, 2008

Tom Gately, Pencil, 2007

Tom Gately, Pencil, 2008

Tom Gately, Pencil, 2008

135

Belinda Van Valkenburg, Digital, 2007

Peter Sohn, Pencil, 2007

Sarah Mercey–Boose, Pencil, 2008

Adrian Molina, Digital, 2006

Dice Tsutsumi, Digital, 2008

Shader packet, **Laura Phillips**, Digital, 2009

"We light the characters so that they're really appealing.
We want to make Bonnie as cute as possible. We want
to make sure that everyone is in love with her."
 —Kim White,
 director of photography, lighting

Bonnie's Mom

Daniel Arriaga, Digital, 2008

Daniel Arriaga, Digital, 2008

Daniel Arriaga, Digital, 2008

Daniel Arriaga, Digital, 2008

Bonnie's Toys

"Bonnie's toys like where they live. I know, it always sounds silly talking about toys like they have feelings, but they do."
—Matthew Luhn, story artist

Mr. Pricklepants, **Nate Wragg**, Digital, 2008

Mr. Pricklepants shader packet, **Laura Phillips**, Digital, 2009

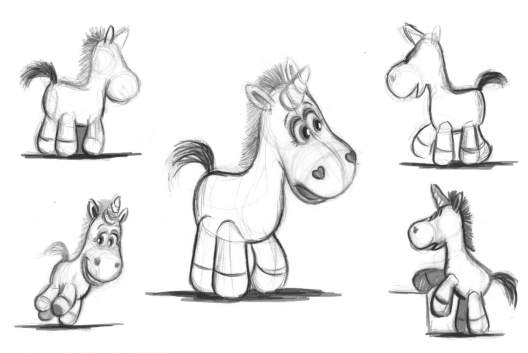

Buttercup, **Nate Wragg**, Pencil, 2008

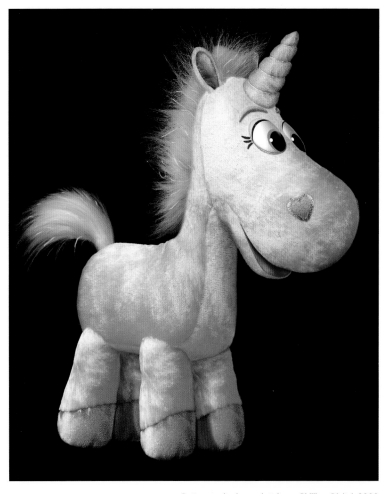

Buttercup shader packet, **Laura Phillips**, Digital, 2009

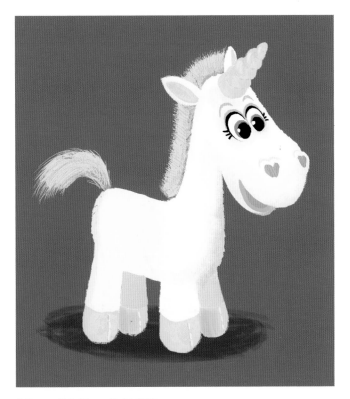

Buttercup, **Nate Wragg**, Digital, 2008

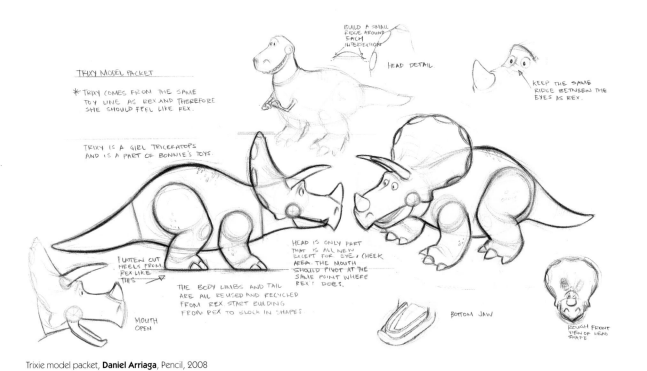

TRIXY MODEL PACKET

★ TRIXY COMES FROM THE SAME
TOY LINE AS REX AND THEREFORE
SHE SHOULD FEEL LIKE REX.

TRIXY IS A GIRL TRICERATOPS
AND IS A PART OF BONNIE'S TOYS.

BUILD A SMALL
RIDGE AROUND
EACH
INTERSECTION

HEAD DETAIL

KEEP THE SAME
RIDGE BETWEEN THE
EYES AS REX.

FLATTEN OUT
HEELS FROM
REX LIKE
THIS

THE BODY LIMBS AND TAIL
ARE ALL REUSED AND RECYCLED
FROM REX START BUILDING
FROM REX TO BLOCK IN SHAPES.

MOUTH
OPEN

HEAD IS ONLY PART
THAT IS ALL NEW
EXCEPT FOR EYE, CHEEK
AREA. THE MOUTH
SHOULD PIVOT AT THE
SAME POINT WHERE
REX DOES.

BOTTOM JAW

ROUGH FRONT
VIEW OF HEAD
SHAPE

Trixie model packet, **Daniel Arriaga**, Pencil, 2008

Chuckles, **Nate Wragg**, Digital, 2009

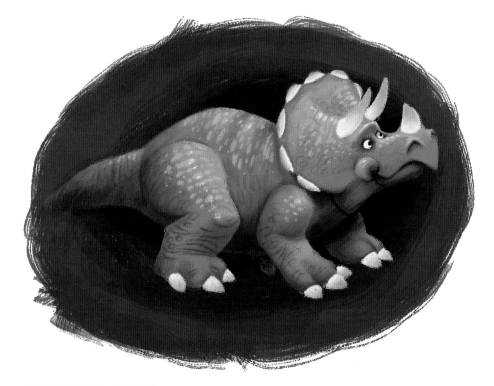

Trixie, **Daniel Arriaga**, Digital, 2008

Storyboard, **Dan Scanlon**, Digital, 2008

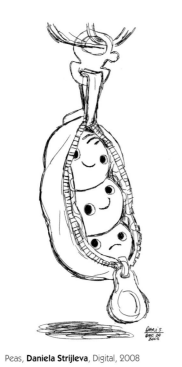

Peas, **Daniela Strijleva**, Digital, 2008

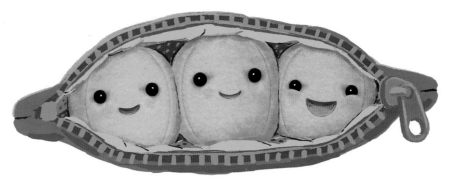

Peas, **Daniela Strijleva**, Digital, 2008

Dolly, **Daniela Strijleva**, Pencil, 2008

Dolly shader packet, **Belinda Van Valkenburg**, Digital, 2009

Soft natural light into the room. Use of dappled lights.
Gradual lighting shift to indicate time progression
without going too dark.

bonnies room architecture
only

painted plaster

painted wood

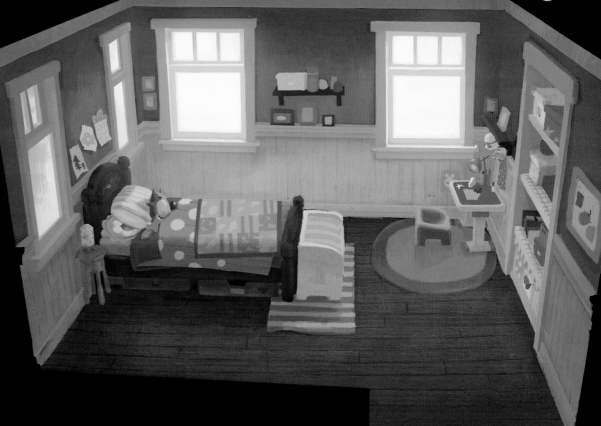

oak bed
(with
hand painted
flowers)

oak
floor
varnished

Shader packet, **Jennifer Chiang**, Digital, 2009

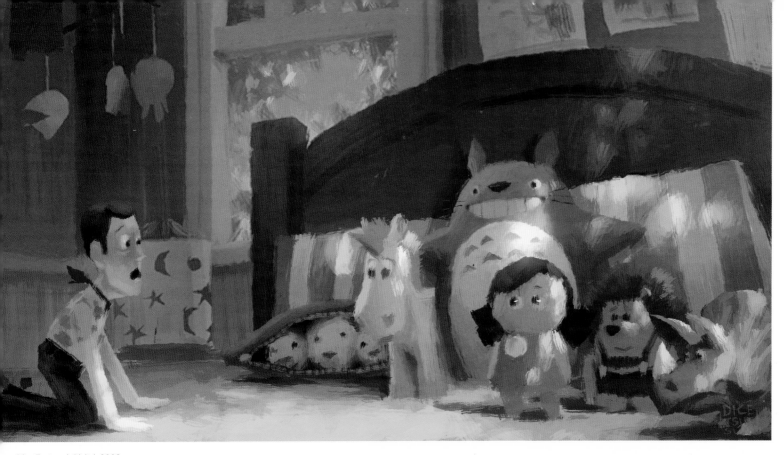

Dice Tsutsumi, Digital, 2009

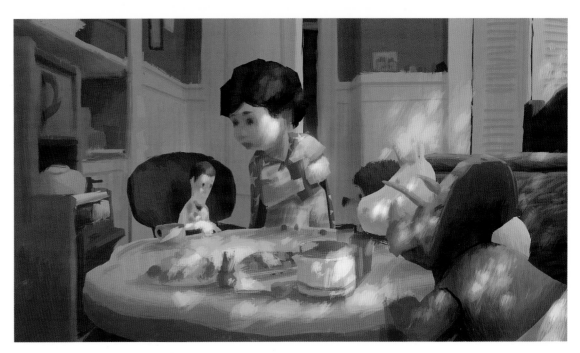

Sequence color key, **Dice Tsutsumi**, Digital, 2009

Glued on
HEARTS

PAPER PLATE BUNNY
FRAME

SEA SHELLS

Glued on buttons

Kristian Norelius, Pencil, 2009

Jennifer Chang, Digital, 2008

Bonnie's Room
Bottom & Middle Shelf

PLYWOOD
& GLUED
ON LEAVES

JAR DIRTY PAINT
WATER, BRUSH,
CRAYON

Model packet, **Kristian Norelius**, Pencil/Digital, 2009

Model packet, **Kristian Norelius**, Pencil/Digital, 2009

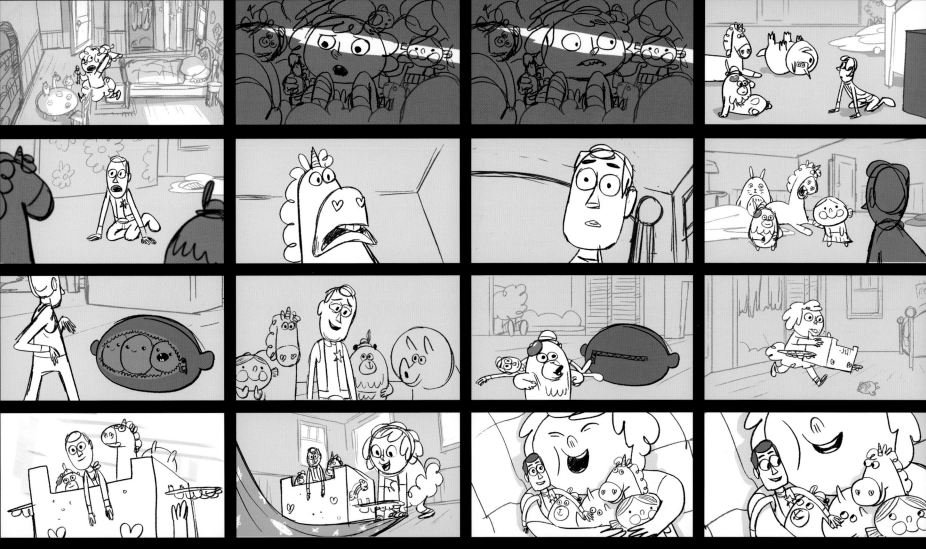

Storyboards, **Erik Benson**, Digital, 2008/2009

"You don't need one-liners when what is
actually happening to the characters is
funny—just let it be funny. Let it play. I think
the movie's funniest in Bonnie's playtime."

THE DUMP

Above: **Bob Pauley**, Photograph, 2007
Previous spread: **Robert Kondo**, Digital, 2007

"The *Ratatouille* artists went to Paris. The Paris of *Toy Story 3* is the dump, the landfill. The *Ratatouille* crew got a better deal. Eating in French restaurants has advantages over coming back from a research trip where all you want to do is shower."
—Bob Pauley, production designer

The climax of *Toy Story 3* takes place in the bleak setting Woody and the other toys fear the most: the city dump. After they fall into a dumpster trying to rescue Woody, a garbage truck transports them to a landfill, where trash is sorted and incinerated. It's the place where toys go but don't come back.

Lighting art director Dice Tsutsumi sums up the artists' feelings about the sequence and setting when he says, "The dump is the one scene out of all the *Toy Story* films that needs to feel absolutely real, believable, and scary. The audience should think, 'Oh my God, this is the end!' There were a lot of serious moments in *Toy Story* and *Toy Story 2*, but the dump sequence is one of the most intense moments in the *Toy Story* trilogy."

To research the sequence, a group of artists went on a series of field trips to a local landfill and incinerator in Northern California. Bob Pauley concedes that the trips had unpleasant aspects, but he feels that the knowledge the artists gleaned more than made up for the discomfort. "Nighttime at the landfill was awesome," he exclaims. "As bad as it sounds—and it did stink—it was exciting. Giant bulldozers in the dark with bright

lights, wind blowing, debris flying: you're on another planet! There are different types of trash and trash processing: a magnet pulls the metal out, then what remains is ground up and sent to the incinerator. It's a great setting. The soft toys look foreign and super-vulnerable in this threatening landscape."

"The designers all experienced different aspects of the dump," says sets art director Robert Kondo. "Lee and the design team went first and came back with all this research. The shots team and other groups were saying, 'Wow, this is really complex.' They soon had a chance to go and see for themselves. After the dump, everyone understood what we needed to do and was on the same page."

Creating a dump sounds like an easy assignment for the studio that produced *WALL-E*, in which the Earth was reduced to a gargantuan rubbish heap. Although that world was desolate, it only became dangerous when dust storms blew in. The title character wasn't

threatened by his environment as he converted mountains of trash into stacks of neatly compacted blocks. For Buzz, Woody, and the rest of the toys, the dump is their equivalent of Dante's *Inferno*: a grim landscape of suffering and annihilation.

The teams who visited the landfill studied different things that related to their specific jobs. "What does the dump feel like at night? How do things recede into the darkness?" asks director of photography, lighting, Kim White. "We were there at twilight and at night, studying how much color you see in the trash, how saturated is that color, how much specular [shining quality] gets picked up, what kind of details you see. There was one particular truck that was shoveling trash in front of it, and as it did little bits of trash were billowing over the top of it. How do those things catch the light?

"As the dump sequence takes place at night," she continues, "we could hide a lot of things as they recede into the darkness, which helps make it feel mysterious

and scary. The characters are passing through patches of light, and we amped up the contrasts to further the feeling of anxiety."

Director of photography, camera, Jeremy Lasky scanned the site, looking for interesting and effective camera angles. "The dump is overwhelming: there's so much of it that's dark that you really can't see; you don't know where the end is," he says. "As long as you keep the camera and framing down with the toys, you feel like you're lost in this space and eliminate any sense of safety."

Sets supervisor David Eisenmann stresses that the aim of the trips wasn't to learn how to re-create a landfill accurately. It was to discover the visual cues needed to construct a dump that was believable but more dramatic than a real one. "It's that sense of place: you're trying to grab moments and layer them together so someone has an emotional response that they under-stand or remember," he adds. "It doesn't have to be visually accurate. It needs to feel right more than it needs to be right."

Director Lee Unkrich feels that the story demanded that the toys visit the dehumanized industrial world of the dump. "My idea to have the toys end up at the dump sprang from the notion of the three films being part of a bigger life-cycle story," he says. "Woody's nightmare in *Toy Story 2* is that he's thrown away in the trash. If that's what he's having nightmares about, then I knew we needed to really throw him away at the end. He would have to face that fear head-on. We needed to throw everybody away, and lead them to the brink of not existing anymore."

Unkrich pauses and then concludes thoughtfully, "The question is, when are toys alive and when are they no longer alive? I don't know. That's an interesting philosophical question. But I do know that if they burn up in an incinerator, they no longer exist. That's the endgame for a toy."

Bob Pauley, Lee Unkrich, Robert Kondo, Jason Katz, Belinda Van Valkenburg, Photographs, 2007/2008

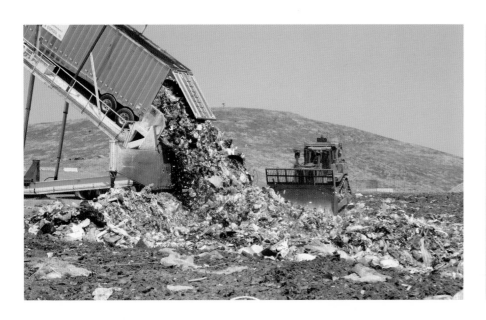

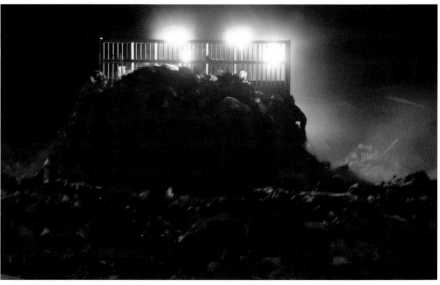

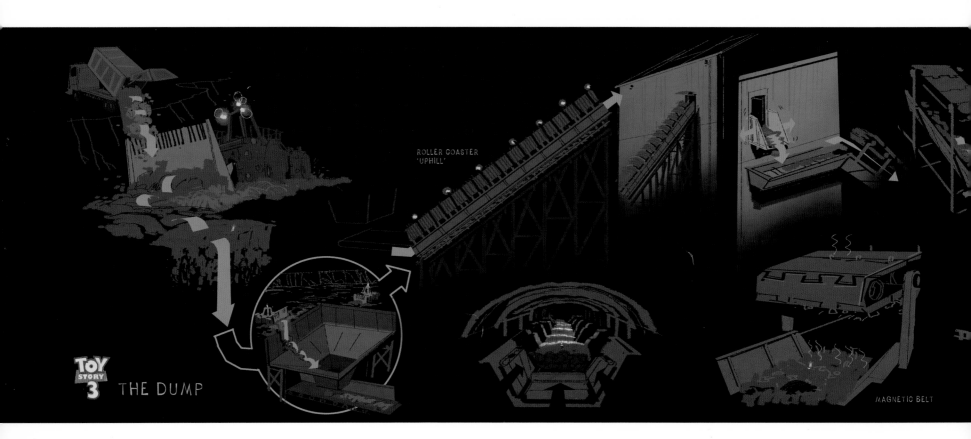

ROLLER COASTER
'UPHILL'

THE DUMP

MAGNETIC BELT

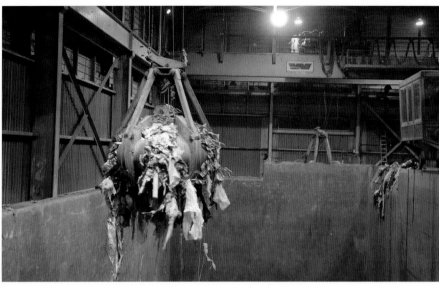

Bob Pauley, Lee Unkrich, Jason Katz, Belinda Van Valkenburg, Photographs, 2007/2008

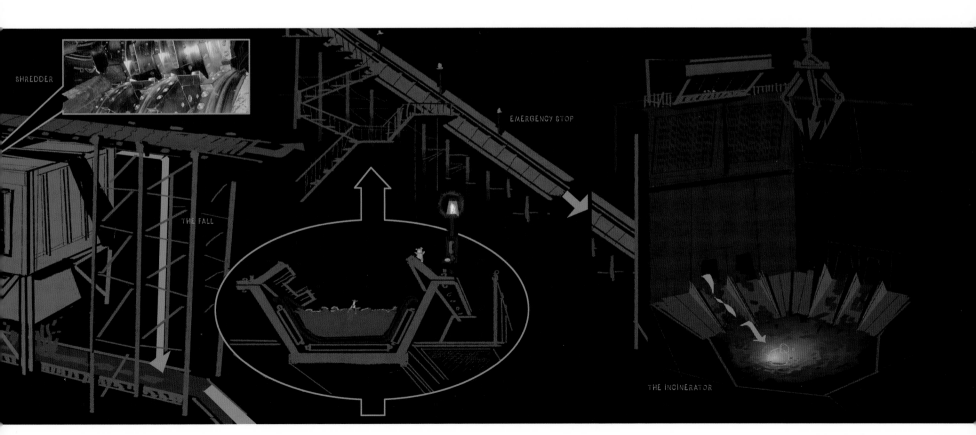

SHREDDER

EMERGENCY STOP

THE FALL

THE INCINERATOR

Dump design, Robert Kondo, Digital, 2007

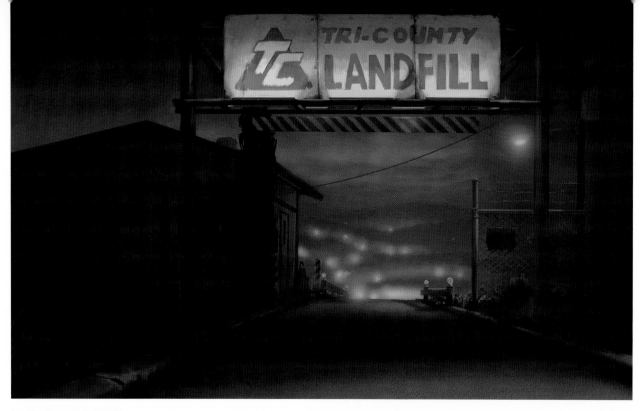

Jennifer Chang, Digital, 2009

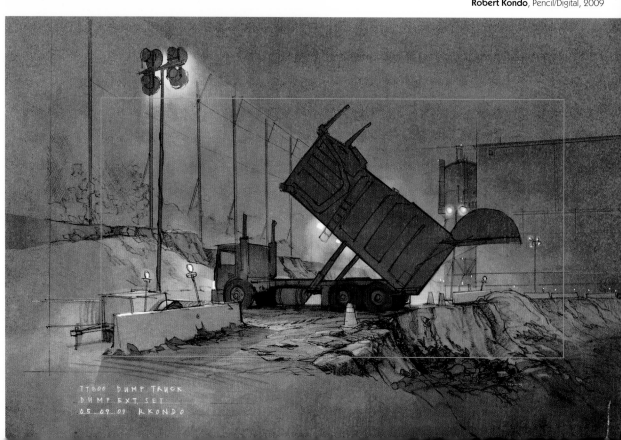

Robert Kondo, Pencil/Digital, 2009

Robert Kondo, Digital, 2007

"Nothing that exists in the world is like our dump: it has a shredder, a giant pit of fire, and a claw that goes into it. It's everything people imagine about a dump in one set. The challenge was to make it completely believable that our toys could end up here. That's what made it so much fun and so challenging to sell."

—Robert Kondo, sets art director

Entrance

Map

Exit

Caution stripe + wear

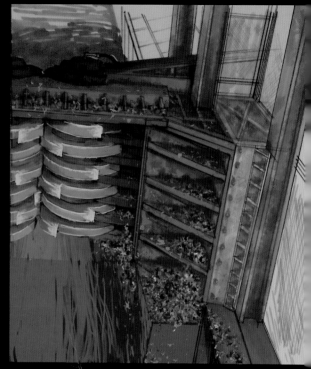

Green machine + crud

The spray out the back of
the shredder will collect
in nooks and crannies

Rusty comb except
where worn smooth
by trash/wheels

Warning light,
Corrugated hose

on all top surfaces

Edges of wheels are worn smooth,
particularly on teeth
Some rust further inside

er packet, **Willy Hwang**, Digital, 2009

Jay Shuster, Digital, 2008

Jay Shuster, Digital, 2008

Storyboard, **James Robertson**, Digital, 2008

Storyboard, **Matthew Luhn**, Digital, 2007

Model packet, **Tim Evatt**, Digital, 2008

Tim Evatt, Digital, 2009

Sequence color key, **Robert Kondo**, Digital, 2008

"When you're trying to convey a sense of place, you actually have to have been to that place. It's sort of weird to say, 'Oh, I'll look at this picture and imagine what it would be like to be there,' and then try to convey it to an audience—it's crazy."
—Chris Bernardi, sets shading lead

Sequence color key, **Dice Tsutsumi**, Digital, 2008

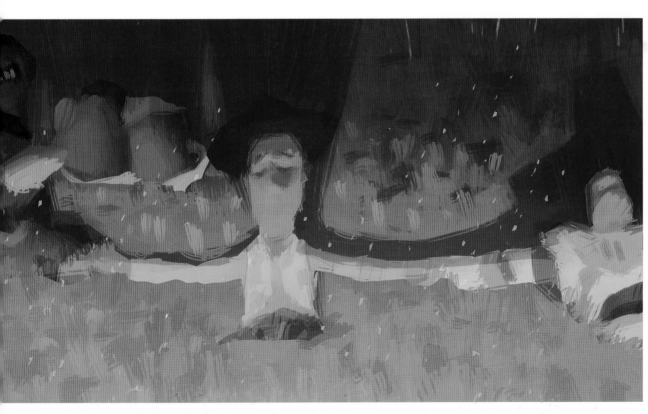

Sequence color key, **Dice Tsutsumi**, Digital, 2008

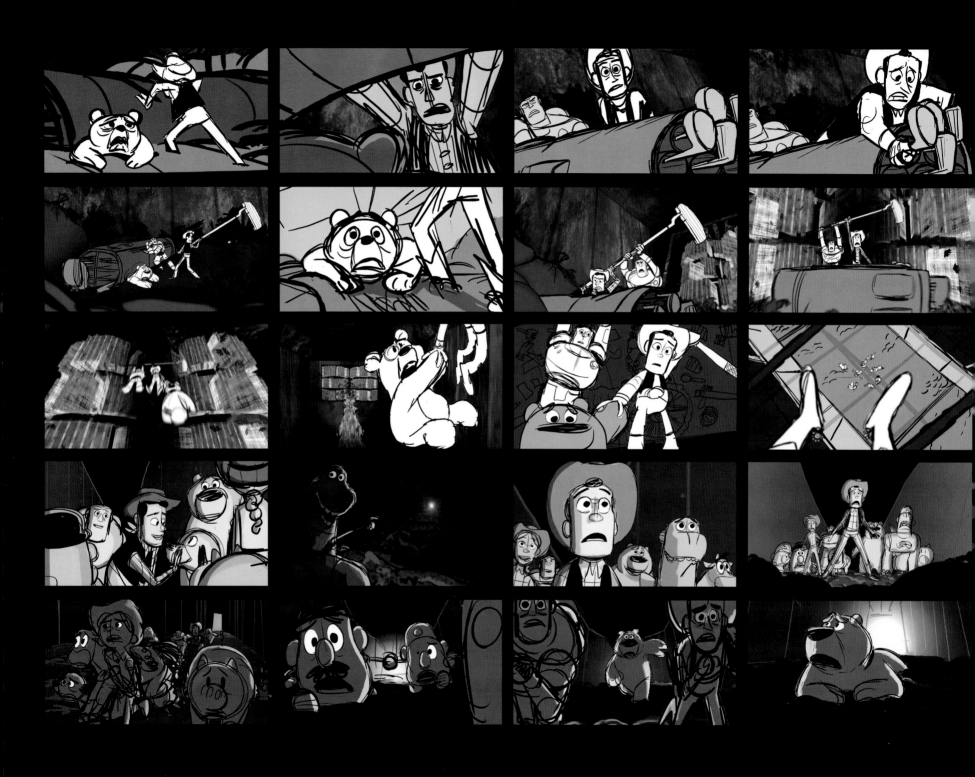

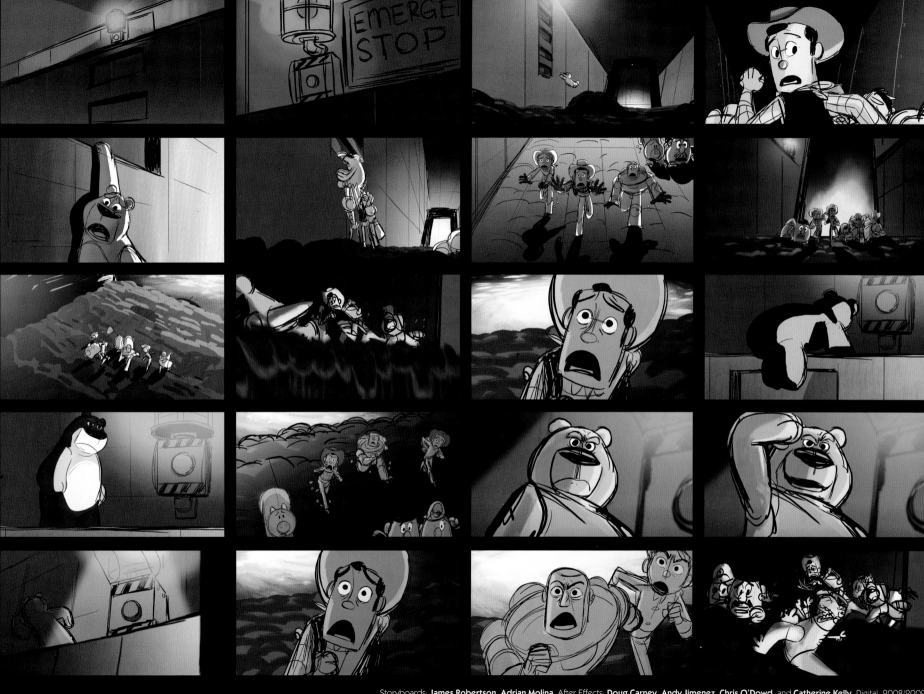

Storyboards: **James Robertson**, **Adrian Molina**. After Effects: **Doug Carney**, **Andy Jimenez**, **Chris O'Dowd**, and **Catherine Kelly**, Digital, 2008/2009

GOODBYE ANDY

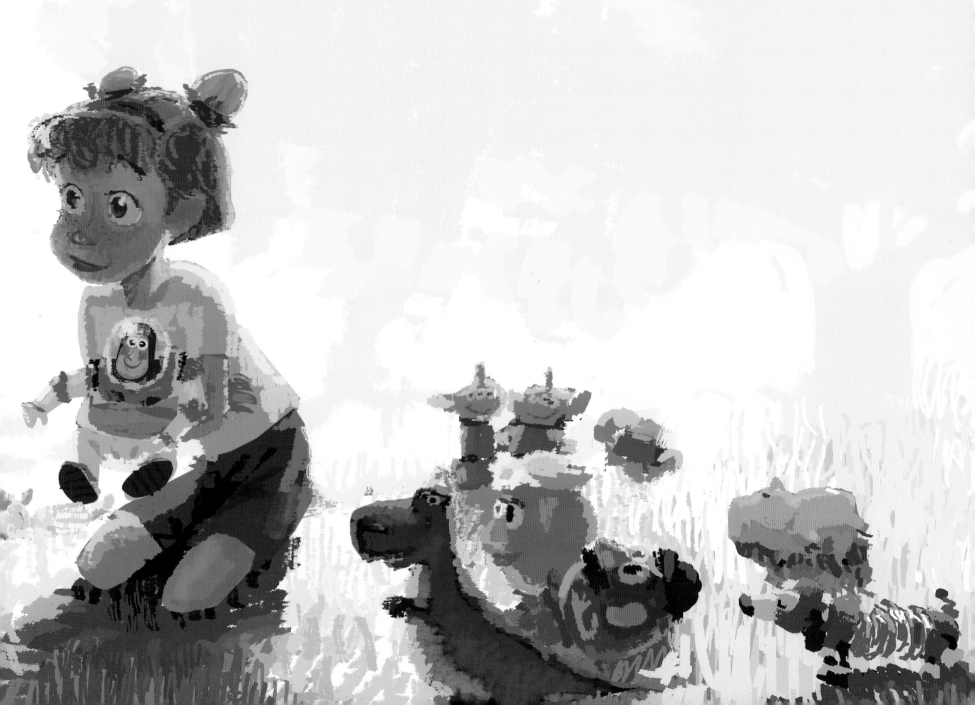

> "When Andrew Stanton read his initial treatment to us, I was crying at the end. I get choked up at every screening of *Toy Story 3*. The ending is so incredibly touching, with Andy handing his toys over to another child. I get really emotional every time."
>
> —John Lasseter, executive producer

Woody and the rest of the gang would be happy to stay with Andy forever, but Andy has grown up. He doesn't play with toys anymore. In *Toy Story 2*, Stinky Pete the Prospector scoffed at the notion that Andy would keep Woody as he got older, and Jessie recalled the heartbreak of Emily growing up and giving her away. Although Woody stubbornly refuses to acknowledge it in *Toy Story 3*, Andy has outgrown him.

The toys know that if they stay at Andy's house, they'll be consigned to the attic and forgotten. They quickly discover they don't belong at Sunnyside Daycare either, where they're mauled by rambunctious children they never get to know. They need a special person to belong to. And in the end, Woody's faith in Andy is justified: he gives his toys to Bonnie, a little girl who will treat them with as much love and imagination as he did when he was little boy. Buzz, Woody, Rex, and their friends will once again make a child happy. They'll be Bonnie's toys.

The poignant scene of Andy giving away the toys he's loved brings a bittersweet but satisfying conclusion to a journey audiences have followed through three movies over fifteen years.

"It's something Andy knows he has to do, deep down," says John Morris, the actor who's provided Andy's voice in all three films. "He knows it's important to ensure that Woody's play life continues—that he'll be loved and cared for, and not just gather dust. That's what makes it possible for Andy to transition and leave for college."

As the scene represents the emotional climax of a three-film saga, it's essential that every element contribute to the mood and the moment: writing, animation, lighting, editing, camerawork, and voice acting.

Screenwriter Michael Arndt says, "By the time I sat down to write the last scene, I had already spent many weeks watching the toys fret about whether Andy still cared about them, and listening to Woody insist that Andy did, despite all evidence to the contrary. I felt like I had lived through the toys' ordeal with them and witnessed all their trials and hardships firsthand. So when I heard (while writing) Andy hand the toys over to Bonnie, and talk about how Woody would 'never give up on you, no matter what,' it was all I could do not to fall on the floor weeping. You have to love your characters and take their concerns as seriously as they do themselves. You have to invest in what they're going through, no matter how crazy or improbable it seems. That doesn't guarantee your writing will be any good, but it does mean that it will be, at the very least, emotionally honest."

Arndt grows less serious when he adds, "Still, there was an odd moment when I finished writing the scene and walked out of my office (eyes red, cheeks wet) to find everyone else going about their business as though nothing had happened. (Andy had just given away Woody, dammit! And then driven off forever! Are you people made of stone?!!!) Of course, one year later, when the first reels were screened, I was able to watch the last scene with an air of callous detachment while people around me sobbed quietly."

When the other artists speak of that final sequence, the emotional ties they feel to Andy, to the toys, and to the moment, is clear.

"When Andy gives his toys to Bonnie, they're embraced by dappled light. We initially thought about a generic sunset light, which is often used for the end of a movie, but we felt we needed something extra special," says lighting art director Dice Tsutsumi. "We felt dappled lighting was perfect, because it makes the toys look like they're safe. It's a sacred space for Andy and Bonnie to focus on their playtime with the toys. Throughout the movie, dappled lights represents Bonnie: a new hope, a new era, a new page in the toys' life. Andy giving Woody to Bonnie is the peak of these beautiful light patterns: they're surrounded during a special moment."

As Andy explains who each toy is to Bonnie, he's also telling the toys what they've meant to him—and giving the viewers a chance to remember the adventures they're shared with the gang. "It's not just a scene between Andy and Bonnie. The cutting is different, because we hold on the toys' faces," says editor Ken Schretzmann. "We hold on Woody's face while Andy describes him, as if Woody can hear. Andy's talking to Bonnie, but he's really speaking to Woody. Playing off the faces of the toys adds to the emotion. You see what Andy's words mean to the toys."

Director of photography, camera, Jeremy Lasky adds, "It's all staged low to the ground, down at kid-eye level. We linger there to give the audience their good-bye to the toys. Woody has his moment; Rex, Hamm, Mr. Potato Head—everyone gets his turn. As an audience member, you say good-bye to them, too."

But the scene has an additional significance: when Andy bids his toys farewell, he's also saying good-bye to his childhood. He's leaving for college, for work and different kinds of play. The eager little boy who pinned crayon drawings of Woody and Buzz to the blue walls of his room is now seventeen. He's still the kindhearted, good-natured Andy that toys and audiences love, and he may still be a kid. But he's no longer a child.

"I wanted to see Andy with his guard down," says director Lee Unkrich. "His mother's not around, his sister's not around, his friends aren't around. Because he's in this safe place, with this innocent child, I could buy him allowing himself to enjoy the feelings of childhood one more time before he heads off to college. For me, the most powerful part of the scene is not when he hands the toys over to Bonnie, but when he engages in that one last playtime with her immediately after that. It's the free, unbridled play of his childhood, something that he probably won't experience again until he someday has kids of his own."

"It's a very emotional scene. There's a transition for the characters and a transition for me as an actor," adds Morris. "I was coming from a very real place, having played with these toys in the *Toy Story* movies,

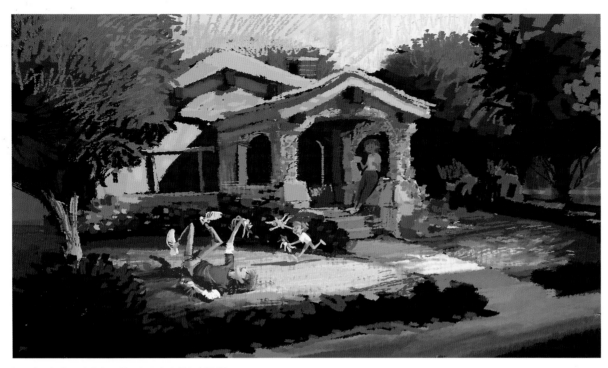

Tom Gately (layout), **Robert Kondo** (paint), Digital, 2007

then having to say good-bye myself as well. Lee's right: it really is the final moment of Andy's childhood."

Unkrich grows more animated as he expands on the changes Andy's character is undergoing. "He's a teenager who probably spends a lot of time trying to be cool and not a kid anymore, and here he's allowing himself to be a kid one last time. The toys are getting what they never dared to dream would happen again," he continues. "At the beginning of the film, the idea of Andy playing with these toys is ridiculous. He's seventeen years old. It's over. Woody spends the film insisting Andy still cares about them, sometimes sounding like a lunatic. But at the end of the film, Woody is vindicated, although maybe not in the way he thought he would be."

During the years that have elapsed between *Toy Story* and *Toy Story 3*, many of the Pixar artists have seen their own children grow up and go to college.

People with younger children recognize that they will inevitably share the experiences that Andy, his family, and the toys are undergoing.

"I think the decade that has passed allowed us to get to a place both in our personal lives and in the stories that interest us to inform decisions we've made on this film," Unkrich concludes. "Especially the premise of having Andy grow up. That's probably not a scenario we would have explored had we made *Toy Story 3* right on the heels of *Toy Story 2*."

"*Toy Story* has always been in us," says Lasseter. "So much of me and Andrew and Pete and Joe Ranft and Lee has seeped into these stories about Woody. *Toy Story 3* just continues that."

Lasseter explains that, coincidentally, development on *Toy Story 3* began when his son Ben was starting college in Los Angeles. "We took a day or two to get

his dorm room set up and then climbed in the car and started to drive away. He stood there and waved, and I broke down in tears," he continues with a catch in his voice. "It seems like yesterday he was this little guy. Every night when I got home from work, I'd throw him in the stroller and take him to one slide in our neighborhood that he loved. I don't feel like I've changed since that time: it's just a blink and he's gone. It's so powerful—you're with someone since birth, and then all of a sudden, he's going away. The timing between *Toy Story 2* and *Toy Story 3* is perfect for letting Andy grow up and tapping into these powerful emotions."

Reflecting on the changes the artists and the Pixar studio have undergone since work began on *Toy Story*, producer Darla K. Anderson concludes, "This movie can be as deep as you want it to be. It reflects what's happened with our company: People have died. Joe's gone. It reflects people moving through different passages and moving on. All the *Toy Story* movies have been about mortality. You can keep peeling that onion and go as deep as you want into it. Or enjoy it for what it is."

Ed Catmull, president, Walt Disney Animation Studios/Pixar Animation Studios, offers an upbeat reflection on the completion of the *Toy Story* trilogy. "When I think about these films, I think less about the films themselves than about the people making them. They're still here; they're thinking about the next films. So for me, it's not the end. I love the fact that we've been able to tie a bow on the series with a really emotional, funny, strong ending. But I don't think of it as the ending of anything. It's still the beginning."

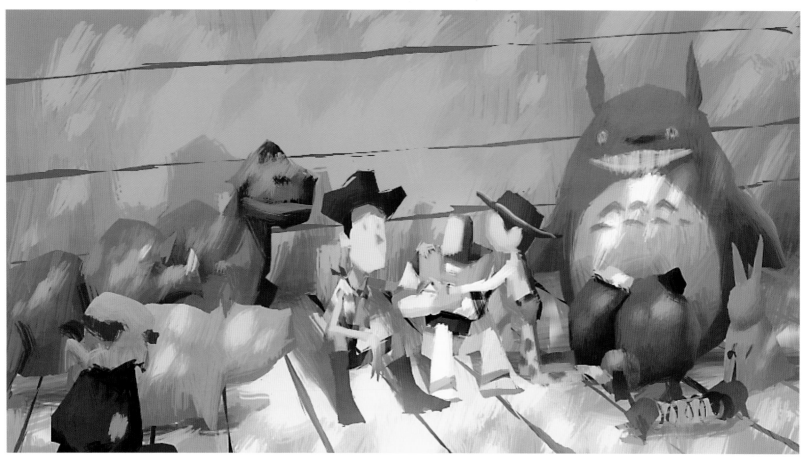

Color script, **Dice Tsutsumi**, Digital, 2008

"When we had our first screening, Lee and I invited
everybody who'd worked on the original *Toy Story*
and was still at Pixar. At the end of the movie, people
were sobbing. A lot of that had to do with it being part
of our life story. It reflects the birth of the company
and the amazing journey we've been on ever since."
—Darla K. Anderson, producer

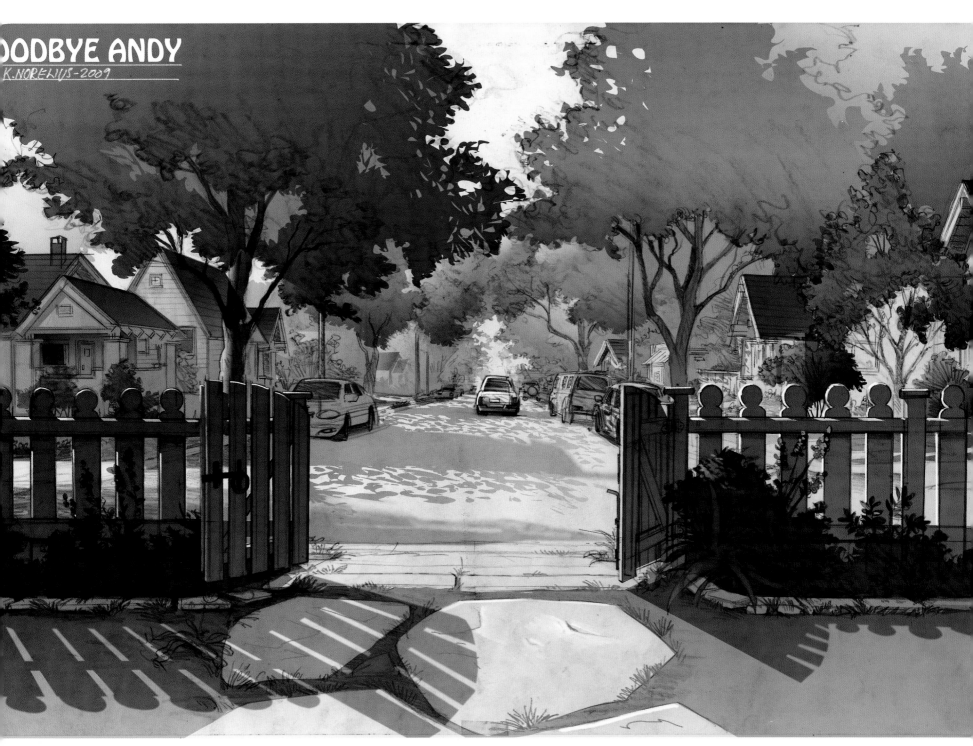

Model packet, **Kristian Norelius**, Pencil/Digital, 2009

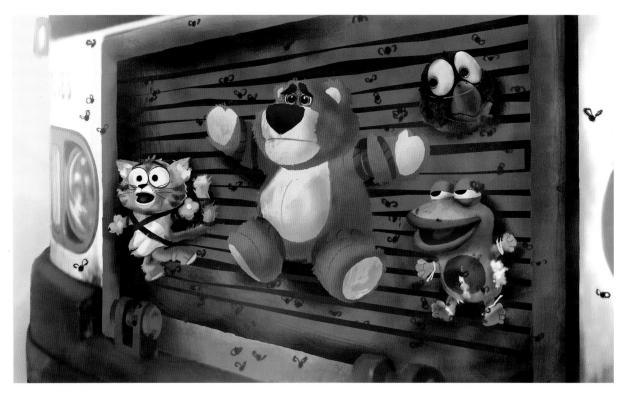

Daniel Arriaga, Digital, 2009

BIBLIOGRAPHY

Toy Story: The Essential Guide. New York: Dorling Kindersley Publishing, 1999.

Hauser, Tim. *The Art of Up*. San Francisco: Chronicle Books, 2009.

Lasseter, John, and Steve Daly. *Toy Story: The Art and Making of the Animated Film*. New York: Hyperion, 1995.

Maslin, Janice. "'Toy Story 2': Animated Sequel Finds New Level of Imagination." *New York Times*, November 24, 1999.

Paik, Karen. *To Infinity and Beyond! The Story of Pixar Animation Studios*. San Francisco: Chronicle Books, 2007.

Solomon, Charles. "Play Boys." *Disney Magazine*, Winter 1999–2000.

Turan, Kenneth. "Animation Infinity and Well Beyond." *Los Angeles Times*, November 29, 1999.

——. "Seeking the Meaning of (Shelf) Life." *Los Angeles Times*, November 19, 1999.

ACKNOWLEDGMENTS

This book really owes its existence to Leigh Anna MacFadden at Pixar and Emily Haynes at Chronicle Books, whom I met when they asked me to write it. With admirable patience, they shepherded me and the text through the necessary stages in record time. As is so often the case, the assistants and coordinators at Pixar did enormous amounts of legwork and heavy lifting: Kelly Bonbright, Erin Magill, Lourdes Alba, Duncan Ramsay, Lucy Laliberte, Sarah Boggs, Aidan Cleeland, Margot Jansen, and Leslie Pao. Production manager Michael Warch and associate producer Nicole Grindle were also an immense help. At Chronicle Books, thanks to Jake Gardner, Tera Killip, Becca Cohen, and Emilie Sandoz. Glen Nakasako at Smog wrestled the text and images into an attractive, stylish whole.

Special thanks are due to the Pixar artists, technicians, and executives, who took time from a busy production schedule to answer my endless stream of questions: Daniel Arriaga, Sanjay Bakshi, Erik Benson, Chris Bernardi, Sharon Calahan, Ed Catmull, Bill Cone, Ralph Eggleston, David Eisenmann, Brian Green, Jason Katz, Robert Kondo, Jeremy Lasky, Matthew Luhn, Adrian Molina, Randy Newman, Eben Ostby, Bob Pauley, Jim Pearson, Jeff Pidgeon, Bobby Podesta, Guido Quaroni, Rachel Raffael, Bill Reeves, James Robertson, Christian Roman, Rick Sayre, Dan Scanlon, Ken Schretzmann, Sajan Skaria, Galyn Susman, Dice Tsutsumi, Belinda Van Valkenburg, and Kim White. Two old friends at Pixar took time away from other projects to talk to me: John Lasseter and Pete Docter. Extra thanks to producer Darla K. Anderson and especially director Lee Unkrich, whose schedules must have been busier than everyone else's combined, but who were never too busy to talk to me. At Disney, Dick Cook made a point of speaking with me, and hypemeister Howard Green supplied contacts, support, and French fries. Taylor Jensen transcribed the interviews with his typically amazing speed and accuracy.

My agent, Richard Curtis, oversaw the contract and replied to my nattering e-mails. My friends continued to endure my jeremiads about writing: Julian Bermudez, Kevin Caffey, Alice Davis, Paul Felix, Eric and Susan Goldberg, Dennis Johnson, Jef Mallett, John Rabe, and Stuart Sumida, and my sisters, Ann Solomon and Marsha Francis. On the home front, thanks are once again due to Scott and Nova, once again in that order.

—Charles Solomon

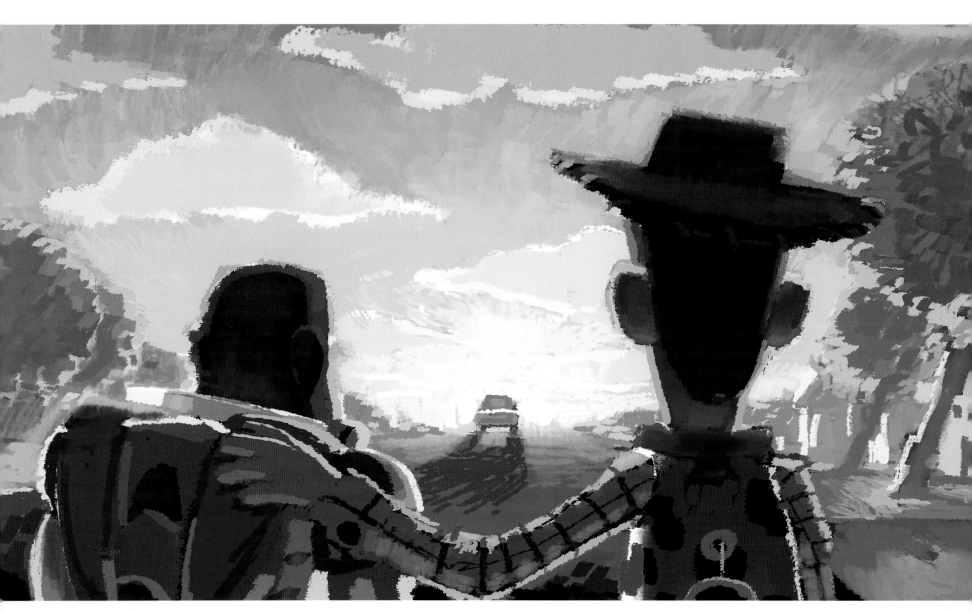

Robert Kondo, Digital, 2007